OUTDOOR PHOTOGRAPHY
LANDSCAPE, ACTION AND WILDLIFE PHOTOGRAPHY
FOR THE OUTDOOR ENTHUSIAST

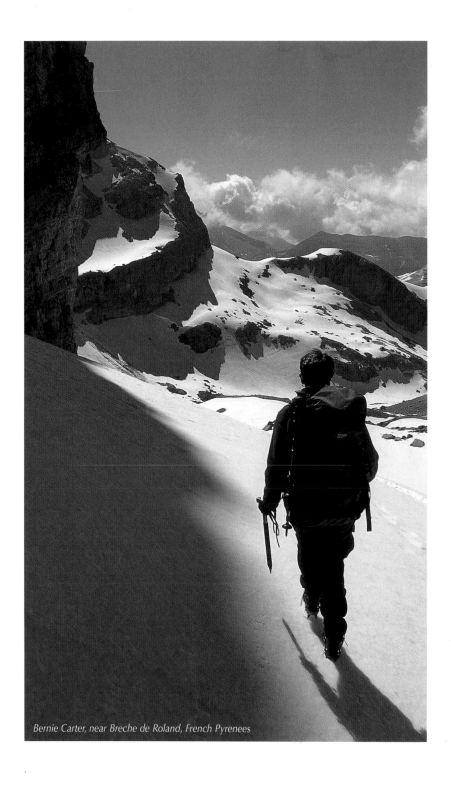

Bernie Carter, near Breche de Roland, French Pyrenees

OUTDOOR PHOTOGRAPHY

LANDSCAPE, ACTION AND WILDLIFE PHOTOGRAPHY
FOR THE OUTDOOR ENTHUSIAST

by
Jon Sparks

2 POLICE SQUARE, MILNTHORPE, CUMBRIA, LA7 7PY
www.cicerone.co.uk

ISBN 1 85284 356 X
A catalogue record for this book is available from the British Library.

ACKNOWLEDGEMENTS

'Self-taught' is a ridiculous term. Formally trained or not, every photographer stands on the shoulders of giants. For sheer inspiration, Ansel Adams and Henri Cartier-Bresson will always stand out. For some of the clearest writing about outdoor photography, as well as for his fine images, Galen Rowell deserves particular mention.

Over the years I have benefited from personal help and advice from colleagues too numerous to list. It would be unfair to single anyone out, but I must acknowledge the invaluable exchange of advice and opinion among the members of the Outdoor Writers' Guild.

I have had many years of help and advice from Reg Stoddon and staff at G. L. Robertson in Lancaster – a *real* camera shop. I'm also grateful to David Farnell and staff at his lab in Lancaster, who have processed more films than I can count, and never lost one yet.

I owe my parents a huge debt for helping to get my career started, and for keeping it going while I was off enjoying myself. Among countless others who have contributed to its development I must mention Ron Sands.

I would like to thank all those with whom I have shared outdoor experiences, especially the members of the 1990 Clwyd MC Snow Lake Expedition and, among numerous others, Judith Brown, Dave Smith, Jonathan Westaway and Julia Ganniclife.

Above all, I must thank my partner, Bernie Carter, for hanging around patiently in awkward positions waiting for the light to be right, for reading the manuscript, for her unstinting support in countless other ways, and for her company on so many trips, from Hutton Roof to the Tongariro Crossing.

Cover photograph: Village Bay, St Kilda.
Back cover photograph: On the Sgurr of Eigg, looking towards Rum and Skye.

CONTENTS

Author profile

Jon Sparks has been passionate about photography and the outdoors since childhood. A six-week trek in the Karakoram Mountains, Pakistan, in 1990 was a turning-point; the learning curve was steep, but the pictures were rewarding. Some of them are in this book. His first exhibition soon followed, and four years later he became a full-time photographer.

Jon specialises in landscape and outdoor subjects, and his picture library includes images from New Zealand, Canada, Morocco, Australia, Pakistan and fifteen European nations. He publishes Lake District cards and posters, is the author of *Car-free Cumbria*, and is currently preparing books on the Lancashire Cycleway and on scrambling and climbing in the Lakes. He was sole photographer for the *Official Lake District National Park Guide* and *The Magic of the Scottish Islands*, both written by Terry Marsh.

Jon is an Associate of the Royal Photographic Society and a member of the Outdoor Writers' Guild. He lives in Lancaster, and when it's clear can see part of the Lake District skyline from his work-room window, which makes it hard to concentrate on writing.

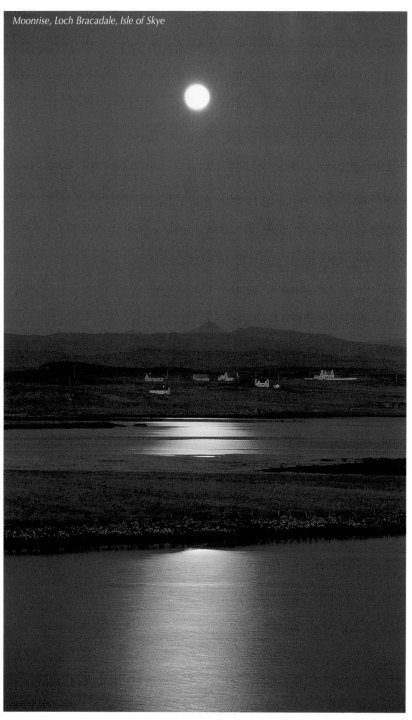

Moonrise, Loch Bracadale, Isle of Skye

INTRODUCTION

'Which comes first, photography or the outdoors?' This is like the chicken and the egg: the two are inextricably entwined. However, there's no confusion as far as this book is concerned: it is written for people who love the outdoors and, above all, for people who love doing things in the outdoors. I assume that you want your photographs to reflect that passion. It's not about winning prizes at the camera club, or impressing people with your latest slide show. It's about getting out there. You want pictures that capture what it's like and how it makes you feel.

Photography should add to, not impede, the outdoor experience. If it helps you focus your mind on the texture of a rock or the play of light on a waterfall, it enhances your experience. If all you can think about is filters and f-stops, it does just the opposite.

However, if you're serious, photography can't just be an afterthought. Ideally it will be an integrated part of your outdoor activity. If you are serious, you want to be in control of the picture-making process, and you can't control what you don't understand. Blindly relying on camera automation leaves you clueless when the pictures don't work out, and dilutes the satisfaction when they do.

A decent automatic camera should give you good results most of the time, but some understanding of the process helps you recognise when you need to take charge. This book will focus on understanding rather than 'technique'. It will use as little technical language as possible, but won't shy away from it when it is necessary. Essential concepts will be explained as clearly as possible. The basics of photography are not complicated, and certainly not rocket science.

To be an integrated part of your outdoor activity, photography must be light, fast and simple. This does not mean being casual or sloppy. Like the rest of your outdoor life, the more you put in, the more you get back. In photography, much of this input requires an investment of nothing more than time and thought, much of which can be done when you're indoors.

In the end, it's your outdoor life and they're your photographs. What you want from your pictures isn't necessarily what I, or anyone else, wants. Everything in this book is based on experience, and it works for me, but that doesn't always mean it will work for you. This much I can say: it will be worth trying.

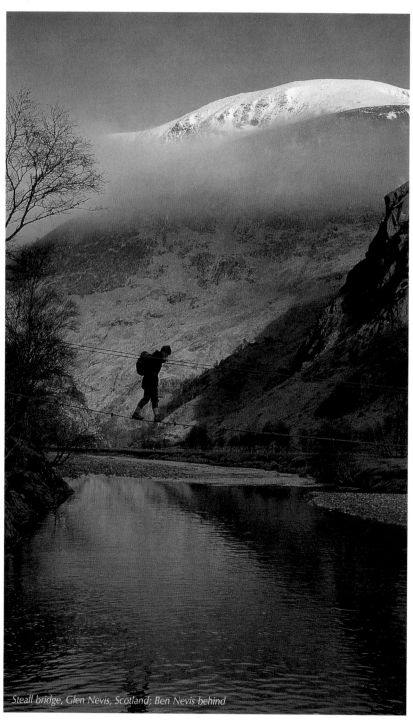

Steall bridge, Glen Nevis, Scotland; Ben Nevis behind

CHAPTER 1
Beyond point and shoot

What's wrong with point and shoot?

It sounds like such a great idea. You point, you shoot, you get the picture. It sounds like exactly what we want – light, fast and simple.

The first thing wrong is that 'point and shoot' misses out one essential first step. It really should be 'see, point and shoot'. This may seem obvious, but it does no harm to state it. Seeing is a vital part of photography, and is the main reason why we want to take pictures in the first place. And there's more to seeing than just going around with your eyes open: you need your mind open, too.

So something you see makes you want to take a picture... but what, exactly? Maybe you come around a corner on a trail and a wonderful view suddenly opens up before you. The natural impulse is to grab the camera and get a picture. But if you take a second to think about a few possibilities, you'll almost certainly get a better picture.

What is it that makes the view so wonderful anyway? If you've been walking through a gloomy forest for five hours, almost any open view might seem pretty fantastic, but the photograph can't directly convey your state of mind. A series of photographs might tell the story, but a single shot can only show the view you saw.

What you could do is use the last few trees to frame the view, which will at least give an impression of the way it opened up. However, it may be obvious that by going on a bit further, you'll open it up even more. Of course, if you then decide that the framed view would have been better, you might have to backtrack.

There may be a fabulous array of peaks filling the skyline while the foreground is pretty boring. In this case you might frame the picture so it concentrates just on the peaks. On the other hand, there could be a deep green valley drawing the eye towards those peaks, in which case you might frame the shot quite differently.

At any moment there's a huge range of possibilities. You can give a group of people identical, totally automatic, cameras and send them on the same walk and you will never get two pictures exactly alike. Even without thinking about focusing or exposure, every photograph you take is the result of a choice. Think about that choice,

Why take photographs?

Reality has four dimensions and a photograph has only two. The third dimension – depth – and the dimension of time can only be suggested in a photograph. This might seem to be a limitation, but in fact it may be a strength. 3D photography has never really caught on. Movies and video have taken their place alongside still photography without ever threatening it. Photography is irreplaceable; in its ability to crystallise an instant, it appeals to something deep within us.

Hoar frost on polypody ferns. Getting close to a subject like this keeps the picture simple

rather than just reacting and letting it happen, and your photos will be a lot stronger. So:

- *Why are you taking this shot?*
- *What is it you want to say?*
- *What kind of picture do you want it to be?*

No doubt someone, somewhere, has estimated how many photographs have been taken since the first one in the 1840s. Undoubtedly the number is in the billions; and in every single instance, there was a reason for taking the shot. However, all too often, it's far from obvious what that was. One of the principal reasons for this is that, frequently, the photographer was none too clear about it in the first place.

Another basic problem is that 'point and shoot' seems to promise that what you see is what you will get. The simple truth is that it never is. What you see through the viewfinder, or on the LCD screen, is not the same as what you see when you look directly at your scene or subject. The real world hardly ever packages itself in neat little rectangles. ◀

Forget about shutter speeds and f-stops for the moment. Suppose that the camera is clever enough to get that side of things right. At the very least you need to decide what to point at and when to shoot. Far from being trivial, these are absolute fundamentals of photography.

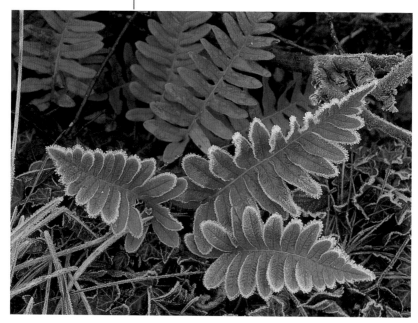

What to point at

Knowing why you're taking the shot is the first step. Knowing what you actually want in the shot is the next. And of course, what you leave out is just as important as what you keep in. This is where you really have to use your eyes properly, whether looking at the scene directly or through the viewfinder.

Seeing is something most of us take for granted, but it is more complex than we realise. The term '20:20 vision' doesn't mean you see everything. It's well worth thinking a little more deeply about how we see.

Our eyes work in a dynamic way. What we 'see' is controlled by the brain as much as by the eyes. This gives us the ability to see 'wide-angle' and 'telephoto' views almost simultaneously. When you spot a friend in a crowded room, your eye does not physically zoom in on him or her. It's your brain that does the zooming. Most of the time we're not even aware of the operation of this 'mental zoom lens'.

Suppose you decide to take a quick candid photo of your friend before you're spotted. You pick up the camera, point and shoot. All too often the result is a photo of a crowd, one of whom happens to be your friend. This is because you looked through the viewfinder but your brain was still 'zoomed in' on that one person and disregarded everyone else. What you saw – or thought you saw – was not what you got.

Seeing your friend in that particular pose gave you the potential for a picture, but the picture you actually got was cluttered up by loads of other people. If you'd stopped for a fraction of a second to look at the viewfinder you would have seen them. Then you could have zoomed in – if your camera has a zoom lens – or else physically moved closer. Of course in moving closer you might have missed the picture. But if you couldn't really get it from where you were it's not much of a loss. ▶

Seeing what's in the finder is fine, but an awful lot of time and trouble can be saved when you start to anticipate what you'll see there. This is one aspect of what's often called visualisation. This, too, you can develop easily and naturally – but only if you start by seeing.

Visualisation means that you can see your friend across the room and your brain can zoom in on the potential picture – but automatically you know that you won't actually get the shot from where you are. If you can visualise the shot and work out where you actually need to stand, without picking up the camera, you'll be a lot less conspicuous too. This does improve the chances of getting a spontaneous shot,

Practice makes perfect
Seeing what's actually in the viewfinder is a big step on the road from snapper to photographer. It doesn't demand any extra equipment, nor does it require you to learn loads of technical stuff: it just takes a bit of thought. The more you think about it, the more you practise, the easier it gets. Before too long it's practically automatic – and it's a great leveller. The 'gear freak' who spends thousands on the latest state of the art equipment but neglects this aspect will get fewer really good shots than someone with a simple camera and an engaged brain.

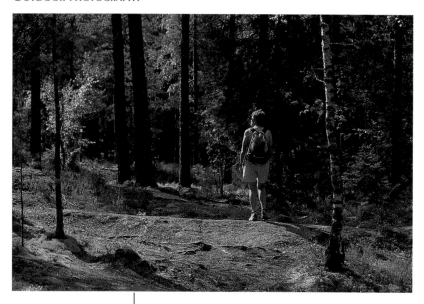

A deceptively simple shot, but precise timing catches the walker on the crest of the rock, and she stands out in sunlight against the shadowy background. (Nuuksio National Park, Finland)

rather than one of someone reacting to the presence of the camera. A crowded room may be the antithesis of the wide open spaces, but the principle is just the same whatever you are photographing.

Indoors or out, the person who gets the best shots won't necessarily be the one who spends most time looking through the viewfinder. Photographer A looks through the viewfinder, moves a few paces forward, looks again, takes a step or two to the left, looks again, crouches down a bit, looks again, moves a step back right, looks again, and so on. Photographer B looks at the scene, moves about a bit, looks through the viewfinder, makes a couple of fine adjustments to their position, and takes the shot. Photographer A may get a good shot in the end. With a relatively static subject, such as some landscapes, the extra time may not matter. On the other hand, if the sun's just about to hit the horizon, time is of the essence, just as much as with action shots.

Of course Photographer C, who is just a snapper, wonders what all the fuss is about. He sees a nice view, points, and shoots. And afterwards? 'This was a lovely view. Pity about those two idiots with tripods in the foreground, though...'

When to shoot

Most photographs are taken in a tiny fraction of a second. This ability to catch a moment in time is one of the most distinctive aspects of photography. It doesn't quite define

what photography is, since some photos may take a much longer time, but it is certainly a very important part of what makes the subject special.

So it's no accident that the photographer many people consider to be the greatest of all time, Henri Cartier-Bresson, is the name most closely associated with the concept of 'The Decisive Moment'. This is summed up in his own words:

Photography is the simultaneous recognition, in a single instant, of on the one hand the significance of a fact and, on the other, the rigorous organisation of the visually perceived forms which express and give meaning to that fact.

Most of Cartier-Bresson's images might be categorised as photojournalism, though their greatness transcends any pigeon-holing. At the moment what we're interested in is the super-precise timing that so many of them demonstrate. A moment sooner, a moment later, and the shot would have been different.

Shooting when the climber is against the sky maximises the impact of this unusual angle. (North Chimneys, Torre di Toblin, Dolomites, Italy)

You can see the same sort of timing very clearly in the best sports photography. If photojournalism seems a long way from the great outdoors, then the connection is clearer here. The key lies in another well-known phrase: 'Chance favours the prepared mind'. In a photographic context, it's important to be both physically and mentally prepared:

- *Physical preparation means having the camera ready to hand, with the right lens fitted for the sort of shot you anticipate*
- *Mental preparation means that you are actively looking for shots and thinking about the sort of opportunities that may arise. Even in landscape photography, things can happen surprisingly fast; a beam of sunlight may strike through heavy cloud, picking out a peak or lake for just a moment*

What you see is not what you get
We've already mentioned one or two differences between what the eye sees and what the camera sees, like the two 'missing' dimensions of depth and time. These apply equally to drawing or painting, but there are some other more specifically photographic factors to consider.

Sometimes the camera will see more than you do; sometimes it will see less; sometimes it will see differently. And sometimes it will do all three!

LIFE THROUGH THE VIEWFINDER

Practise using the viewfinder
Using the viewfinder properly means being aware both of the boundaries and of everything within them, and this awareness develops with practice. You can practise without wasting film: just look at the viewfinder and take a few moments to study what's actually in the frame.

Humans tend to see what they are interested in: cameras are not so selective. Sometimes the result is that your intended subject almost disappears into its surroundings – like your friend in the crowd. At other times the result can be that the subject is sitting in the middle of the frame, but is surrounded by acres of empty space.

The answer to these problems is learning to use the viewfinder. The 'point and shoot' way is to look *through* the viewfinder, see the subject, and press the button. The photographer's way is to look *at* the viewfinder and see the whole image. It is rather like the difference between looking through a window and looking at a picture. ◀

However, the sad fact is that what you see in the viewfinder isn't what you get, either. It's getting closer, but there are still substantial differences, most of the time, between what you see in the finder and what you get on film. To compound the issue further, there are different types of viewfinder, which behave quite differently.

Fortunately, it isn't too complicated. For our purposes, there are really only two types of viewfinders: direct-vision and reflex.

> • *Direct-vision finders are found on compact cameras and, with refinements, also on rangefinder cameras. (For more on types of camera see Chapter 2). A direct-vision viewfinder is essentially just a small window. The window's frame may correspond to the borders of the image you get on film, or there may be a marked area within the window to show the actual picture area. In this case, round the edges of the finder you can see stuff which won't appear in the final picture.*

Because looking through a direct-vision finder is like looking through a window, your eye can adjust to focus on close or distant objects. Whatever you look at appears in focus, so the impression you get is that everything is in focus. However, it's by no means guaranteed that everything in the final shot will be in focus: things that seemed clear in the viewfinder may be blurred, even blurred beyond recognition.

> • *With a reflex finder, you actually view through the camera lens. In a single-lens reflex (SLR) camera you look through the same lens that takes the picture. The image is relayed to your eye by a mirror that flips out of the way when the shutter is pressed. You can be forgiven for thinking, therefore, that what you see corresponds to what you'll get on the film. It does, but it's not that simple. Sometimes it gets very close, but at other times it doesn't.*

One problem is that, in most cameras, the viewfinder doesn't show you the full picture area. This is because if you shoot slides, the slide mount will actually overlap the very edges of the picture area. If you shoot print film, normal processing will print from less than the full area of the negative. The area you see in the viewfinder does, therefore, correspond at least approximately to the area you see in a print or a projected slide. ▶

There's an even more significant reason why what you see in an SLR viewfinder isn't always what you get on film. While a direct-vision finder gives you the impression that everything is in focus, with an SLR things are obviously different. You can usually see that some things are in focus

Printing from the full negative area
You can achieve this if you make prints yourself, or use a hand-printing service. If you're shooting slides for reproduction in magazines, you may want to know what will appear right up to the edges of the frame. Here, unfortunately, only a few high-end cameras will give you a true 100% view in the finder.

and some aren't. You can make them pop in and out of focus by turning the focusing ring; or, if you're using autofocus, the camera will do this for you as you shift your view so that different objects line up with the focusing sensor.

While the object that you're focused on should always appear sharp in the print or slide, things that appear out of focus through the viewfinder won't always appear the same way in the final image. The reasons for this are a bit technical, but not that difficult. It's all to do with something called *depth of field*. We'll explore this in more detail in Chapter 3, but for now, depth of field simply means what is in focus and what isn't. Put simply:

- *If the image shows one object sharply focused, with everything else out of focus, depth of field is small*
- *If, however, objects both nearer and more distant also appear in focus, depth of field is large*

Depth of field: Near and distant elements are equally important to this shot and depth of field must cover both. (Rees-Dart Track, South Island, New Zealand)

The problem is that depth of field in the final shot doesn't necessarily match the depth of field of your viewfinder image. A direct-vision finder, where everything appears in focus, gives an impression of unlimited depth of field which is rarely, if ever, matched by the final shot. With any luck the main subject is still in focus, but foreground and background objects may not be.

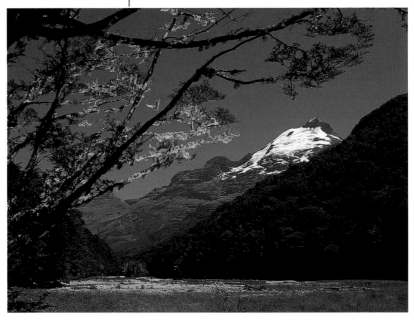

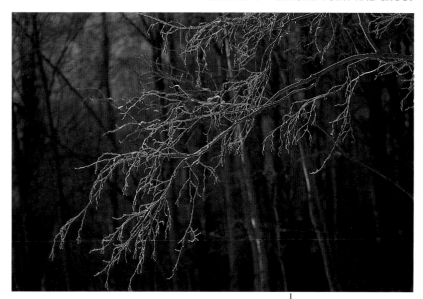

For reasons we won't go into just yet, when you look through a reflex finder, depth of field is minimal. This helps you to focus on specific objects. It also means that other objects, at different distances, are not sharply focused. Sometimes they virtually disappear altogether, making them very easily disregarded. However, when you actually take the shot, depth of field usually increases, making background or foreground objects much sharper and therefore more prominent than they appeared in the viewfinder. A common result is that your intended subject does not stand out in the way you thought it would.

With a direct-vision finder, in terms of what's in focus, you often get less in the final shot than you saw in the finder. With a reflex finder, you often get more. Of course, if you simply fail to notice things, then you can get more in the shot than you expected with either type of viewfinder!

Most digital cameras have a viewfinder of one type or the other, but most also include an LCD screen, like a tiny computer monitor, on which you can preview the shot as well as review shots you've taken. On the face of it this is a godsend since what you see should correspond exactly to the image file the camera creates. But of course it's not that simple...

Many of these screens, particularly on cheaper models, don't really match the colours you'll get on your proper monitor at home. Many of them are hard to see properly in bright sunlight. But the basic problem is their tiny size. This

Depth of field: Here the emphasis is firmly on the foreground detail. The lighting, too, helps the frosty branches to stand out. (Jyvaskyla, Finland)

may seem odd, since they're larger than any direct-vision finder or the screen of an SLR. However, physical size isn't the only consideration. The pupil of your eye is only a few millimetres across. When you look through any conventional finder it fills up most of your field of view. You can't get close enough to an LCD screen to fill your visual field to the same extent, and the resolution isn't that good anyway.

The small size and modest resolution of such screens will tend to suggest that an image is sharp when in fact it isn't, and this will also tend to suggest that depth of field is greater than it actually is. ◀

There are several further reasons why the camera may not see things the way you do. These will all be examined in more depth later, so we'll just mention them briefly here:

> - *Extremes of contrast are one reason why we may get less on film than we can see. The eye can adjust instantaneously between deep shadow and bright sunlight, but a single frame of film can't encompass such a range of brightness*
> - *Colours, too, sometimes appear different; a common example is blue flowers, which often appear purplish*
> - *Movement also appears differently. This is inevitable in a still picture! Sometimes the camera can freeze movement the eye can't follow; sometimes movement appears on film as blur*
> - *Extremely slow movements, like those of the stars, can also be recorded on film though they appear static to the eye*

TRUTH AND CONSEQUENCES

It's a very old cliché that 'the camera cannot lie'. This may even be true in some senses. However, realising that the camera may see things differently should give some pause for thought. And while the camera itself may not lie, many photographs, or images loosely described as photographs, clearly do.

Manipulation is nothing new; it didn't arrive with the first desktop computers. Various techniques, especially darkroom wizardry, have been used since the 19th century to combine, distort or alter the original image. The claimed first ascent of Denali (Mount McKinley) in Alaska in 1906 was supposedly confirmed by a photograph. This wasn't manipulated, in the sense we're talking about; it was just taken on a different peak. However, digital imaging has made manipulation more widespread than ever, and potentially harder to detect.

Digital cameras
Many professionals, especially those in fast-moving news photography, use digital cameras on a daily basis. Most of these are SLR-type cameras and the photographers use them much like a conventional SLR: in other words they use the viewfinder when actually taking pictures. The LCD screen mainly comes in handy after the action, for checking that you've got the shot and assessing which pictures to save or send to the office, and which to delete.

There are three points to consider here:

1: It's not easy

Anyone with a computer and basic image-editing software can manipulate images, but doing it well is not easy; arguably it requires just as much skill and time as photography. Manipulated images are rife, perhaps most obviously in advertising, but all too often also in news, features, and other supposedly 'factual' branches of the media. Yet, in many cases, even though the manipulation has been carried out professionally, it's still apparent. Sometimes we're not supposed to be fooled: there are many obvious 'fantasy' images. But just as frequently there are unintended clues for the alert observer; objects without shadows, or light coming from different directions in different parts of the image.

2: It's not honest

To some, this isn't an issue at all: the end justifies the means and that's that. But if you're booking the trip of a lifetime from a brochure or website, you want to be confident that El Dorado or Shangri-La really does look like that. And when you come back, you probably will want to be able to say to your friends, 'This is what it was like.' One of the qualities people value most about their outdoor experience is that it's real. So it makes sense to keep your pictures real.

Of course, it's not as simple as that. It can be argued that every photograph manipulates reality. If you go for a moorland walk in many parts of England, there'll be pylons and wind-farms scratching the skyline. What is the difference between taking these out of your shots with the cloning tool in *Photoshop*, and simply framing the shots to exclude them in the first place? It's a tough one. It might make you think twice about excluding them from your shots anyway. Like them or loathe them, they are part of the scenery. Are you taking pictures of the walk you actually did, or the walk you wish you'd done?

3: It's not photography

This argument is less clear-cut. It depends on what you mean by photography. However, we've already referred to photography in terms of its ability to catch a moment. For very many people the essence of photography is capturing what you saw, and even suggesting what you felt, at a particular place and a particular time. This view of photography certainly ties in with the way most people view their outdoor activity: it's all about being there and living in the moment.

Some artists deride photography because you can take a

shot in 1/60th of a second, or even less. This overlooks the fact that while taking the shot may only occupy that tiny space of time, making it can demand a great deal more, in terms of imagination, concentration, observation and anticipation – not to mention getting there in the first place. It's also a weak criticism because it would seem to suggest that we should judge the worth of a work of art solely by how much time and effort went into it.

But what really makes this criticism completely misconceived is that photography's 'instant' nature is its greatest strength. Even the greatest artists in other media struggle to isolate and pin down a moment as a photographer can. The skill and satisfaction lie in being able to recognise, even to anticipate, such moments. ◀

Of course, there are different types of manipulation. Cleaning up dust and scratches from a scanned image is a good example of manipulation that hardly anyone could possibly object to. Those blemishes have absolutely nothing to do with what you saw and felt at the time of taking the shot. At the opposite extreme, you could take a Chris Bonington photo of the summit of Everest and combine it with a shot of yourself taken on top of Box Hill. With enough skill you could make it look totally convincing. But it would not be honest, and it wouldn't be photography. And, as Sir Chris would be fully entitled to point out, it would also be theft.

FINAL THOUGHTS

At this point you could certainly be forgiven for feeling discouraged. On the other hand, perhaps you're beginning to understand why some of your shots don't turn out the way you expected; and understanding a problem is always a major part of correcting it.

The concept of 'point and shoot' is almost irresistible in its attraction, but the reality is always likely to be disappointing, at least until the day that the camera can actually read your mind. Even then, I suspect, some people will still get better pictures than others, because you will still need to have a clear idea of what you want your picture to say and to show.

'Point and shoot' also suggests that photography is merely incidental to your outdoor activity, rather than being an integral part of it. Investing just a little more thought and time in your photography will bring much better results, not so much because the shots are better in any narrow technical sense but because you were more involved and had a clearer sense of what each shot was about.

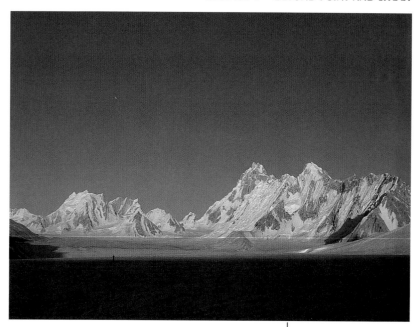

There's yet another argument. By paying attention to what you're doing, you'll get more good shots in the first place. Not only this, if a shot doesn't quite work, you'll probably have a much better idea what you need to do differently next time. And when you get a really great shot you'll have much more idea what you did right. If you never go beyond point and shoot, you'll never learn anything very much. And since cameras don't learn either, your photos will never get much better.

Leaving everything up to the camera may give you a shot that 'comes out', at least most of the time. It's less certain, however, that it will give you a shot that matches what you actually saw, let alone what you wanted to say. The key to this is understanding how cameras and film see the world, and relating that to how you see it.

The tiny figure helps to give a sense of the vast scale of this landscape. Without it the shot would be much less effective (try covering it up and see the difference). (Snow Lake and The Ogre, Karakoram Mountains, Pakistan)

CHAPTER 2
Equipment for the outdoor photographer

'Henri Cartier-Bresson is the world's greatest photographer. Henri Cartier-Bresson uses a Leica. Therefore if I use a Leica I can be the world's greatest photographer.'

There is clearly something wrong here. We could call it 'the gear-freak fallacy'. The gear-freak sees new gear as the solution to any and all deficiencies in his photographs. (This may seem a sexist comment, but the overwhelming majority of gear-freaks are male.) In fact the true gear-freak probably welcomes deficiencies in his photographs as an excuse to buy new gear.

Henri Cartier-Bresson is the world's greatest photographer because of talent, skill, vision and experience. The Leica – small, quiet, unobtrusive and supremely well-engineered – was an ideal camera for his work, as it still is for many photojournalists. But to say that Cartier-Bresson is great because of the camera he uses is almost like saying Rembrandt was a great artist because he used a particular type of brush.

The most important pieces of equipment for any photographer are their eyes and brain. Not only are they supplied free of charge, they come with regular upgrades. Most of these, too, are free. These are called education and experience.

The most basic decision is not what camera to buy, but what kind of pictures you want to take. The next most basic decision is whether you want slides, prints, digital files, or some combination of these. And what do you want to do with them when you've got them? Buying gear before you know what you want to do with it is putting the cart before the horse.

MEDIA

Prints, slides, black and white or colour, film or digital? The most significant division here is probably between conventional media and digital imaging. However, there is a large area of overlap: prints and slides can be scanned to create a digital file, and vice versa. It is also true that things are changing fast in this area.

Conventional or film-based imaging is a mature technology; this does not mean that it is stagnant, still less that it

Black and white images are often at least as effective as colour, especially for strongly graphic subjects. (Judith Brown, Whit's End, VS, Gimmer Crag, Lake District)

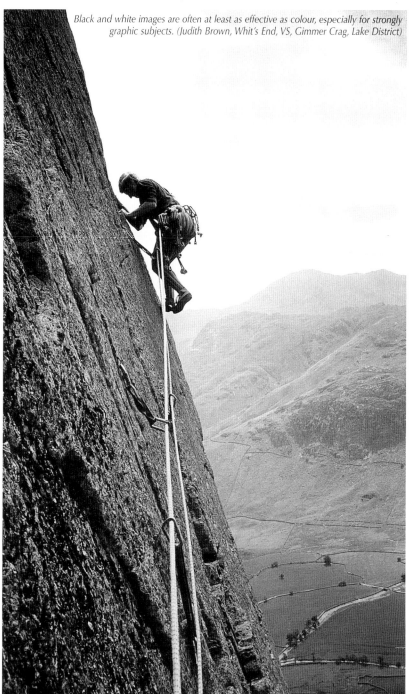

is finished. The major manufacturers are still investing in conventional materials and cameras. However, it is unlikely that these will undergo the kind of rapid development that is going on in digital imaging, any book on which is likely to be out of date even before it appears. Fortunately, the essential principles are more enduring.

Film
For film formats (sizes) – see more under 'Cameras'.

Black and white or colour?
This is a fundamental choice. Some people maintain that only black and white is 'true' photography; others insist that only colour can represent reality. This is certainly a good subject for discussion! All photographs are a very long way from 'real', and the removal of colour is just one more layer of abstraction.

The first photographs were in black and white, and it may be that the reverence that is sometimes attached to black-and-white photography has a historical basis. Still, few will deny that good black-and-white work has a beauty of its own.

Digital workers can remove the colour from an image with a single mouse-click. This isn't black-and-white photography but can be an interesting exercise. Some images that

Don't stop shooting as soon as the sun drops below the horizon. Afterglow can be the best part of the day. The lower contrast makes metering easier too. But would this shot work without colour? (Haystacks and the High Stile range, from Moses' Trod, Lake District.)

look striking in colour don't work at all in monochrome, but others may actually become stronger. Real black-and-white photography gives a great deal of scope for personal expression, but requires you to look at the world in a new way. ▶

Real black-and-white photography implies that the shot is visualised as a monochrome image at the time of taking it. This is not to say that you couldn't shoot it digitally, convert the image to greyscale, and print it on an inkjet. You can also play around with tone and contrast in a way that's analogous to the use of different paper grades and burning in in the darkroom.

Prints or slides?

For some people this will be an easy choice. If you want to do slide shows, you need slide film. Similarly, if you want prints for an album, then negative (print) film rules. Prints from slides can be good or cheap, but hardly ever both.

If you want big prints for your walls, however, it's not quite so obvious that you should shoot on negative film. Though usually a bit more expensive, prints from slides can be just as good. The Cibachrome/Ilfochrome Classic process produces exceptional depth of colour and the prints will last a very long time without fading.

There is another distinct advantage to shooting slides even if you ultimately want prints. When you take a negative, with its reversed colours and overall orange mask, to a lab, they have to make their own judgement about correct colours and so on. (Try taking the same negative to two or three different shops or labs and see how much difference there can be in the results!) When you send a slide, the slide itself serves as a reference, and any printer worth their salt should be able to match the colour balance fairly closely.

Most modern print films have considerable latitude. This means that you can get a decent print out of them even if the exposure isn't perfect. Many cheap cameras, and all of the 'single-use' (disposable) ones, rely on this latitude to give acceptable results in a range of lighting conditions. Slide films are much less tolerant of inaccurate exposure, and therefore really demand to be used in cameras with a reasonable metering system.

Fast or slow film?

The terms 'fast' and 'slow' are used in several senses in photography. These aren't always self-explanatory: a 'fast' lens, for instance, isn't one that focuses more rapidly than a slow one. As applied to films, 'speed' means sensitivity to light. A fast film needs less light to form an image than a

*Printing in
black and white*
It it is quite hard to find labs that will do good black-and-white prints, and they usually aren't cheap. Most people who are serious about it either do their own printing or work closely with a skilled printer.

Film speed

This is measured on the ISO scale, which is the old ASA scale by another name; many people still refer to ASA speeds. An ISO speed below 100 is considered slow, 100 to 200 is medium-speed film and 400 and above is fast, for instance.

slow one. This often means that you can use a faster shutter speed under given conditions. ◀

So why use slow film? There are some shots for which it is an advantage to use a slow shutter speed. Sometimes a longer exposure produces better results, as with those shots of waterfalls where the water looks almost like mist, or fireworks displays. (In both cases you'll need a tripod.) But the real reasons to use slow films are to do with the quality of the results. Slower films have finer grain, brighter colours and produce a generally more vibrant image. This is true of both slides and prints, though sub-standard printing can wipe out the differences. Slow films are often preferred by dedicated landscape photographers.

Unless your main interest is motion-stopping shots of fast action, there's nothing to be gained by using fast films most of the time. They come into their own in poor light, but may be virtually unusable with most cameras in very bright conditions. Under most circumstances, especially in the British climate, slow films require a little more care in use. However, the results should justify the extra bit of effort, especially if you want to make large prints, show your slides, or – above all – if you have aspirations to sell your work. Even if you just write the odd article for mud-surfer's monthly.

Medium speed films are sometimes called 'general-purpose' films, and that's a pretty fair description. If, like most outdoor people, your photography is a mixture of landscape, action, wildlife, portraits and more, then 100 ISO film is a sensible choice. It will adapt pretty well to almost everything, and to a wide range of lighting conditions. You're most likely to want to use something different when you want to concentrate on a particular type of shot.

Which make of film?
This is where personal preference really comes into play. It is particularly critical with slide films, where there is no printing stage and thus no second chance. We all see the world in slightly different ways: one film will seem 'right' to one person and 'wrong' to another. There is only one answer: try the different types and see what works for you. Film reviews in the magazines will help you to short cut this process to some extent. These aim to eliminate other variables by standardising processing and – where applicable – printing. For the user of colour negative film, it's where you have your shots printed that makes the biggest difference.

The processing of slide films is – at least should be –

standardised. You should get the same results wherever your films are processed. Therefore in this case the make of film is more significant, and that's up to you. However, it's worth saying a little about two particular brands, which you'll certainly come across and which are of particular significance for anyone who gets serious about landscape photography:

- *Kodachrome (made by Kodak). Kodachrome used to be made in several different speeds but at the time of writing it's being whittled down to a single ISO 64 version. Kodachrome can only be processed by Kodak, and you'll have to send it away and wait a while for the results*
- *Velvia (made by Fuji) is slower still: the official speed given on the box is 50, but many photographers find that they get better results if they set their meters to 40 or even 32. Velvia uses standard slide processing (called E6) and if you've a professional lab nearby you can get your shots back in an hour or two*

Both offer extremely fine-grained images with superb detail and definition, which means that they can stand up to very big enlargements. But two otherwise identical shots taken on the two films will nearly always be readily distinguishable:

- *Kodachrome has cooler and more subdued colours. Some people find them much more natural, others clinical or merely dull*
- *Velvia produces very rich colours and 'punchy' images. Some observers find the results gaudy and over the top, but since its introduction about 10 years ago Velvia has gained a host of admirers and is now the most popular film for dedicated landscape photographers as well as many others*

Perhaps your preference depends on how you see the world. No one can say that we all see in exactly the same way, so it may just be that for some people Kodachrome corresponds more closely to what they actually see, while for others Velvia is more lifelike. Try them for yourself. Bear in mind, however, that all slide films, and Velvia more than most, really need accurate exposure. They probably won't fare very well in a cheap compact camera. And, since they're slow, you'll need a tripod or some other camera support more often than you would with faster films.

Digital photography

Anything specific I say about digital cameras will be out of date before it gets into print. What remains constant is the need to decide what you want to do with your images before you can determine what gear you need. All this section can do is outline issues you'll need to consider. ◀

The headline issue is *resolution*. All digital images are made up of dots, called pixels. A few years ago the quality of most digital images was such that you could quite easily see the individual pixels, giving images a coarse, 'blocky' look. Understandably, a lot of effort has gone into making images finer and more detailed. The more pixels you can cram into a given area – whether it's a computer screen or an inkjet print – the finer and more detailed the image looks.

Digital vs film
One thing that can be said with certainty (which would not have been true a few years ago) is that digital photography is no longer a poor relation. Images from digital cameras can be indistinguishable from film-based ones in almost every application.

A section of a medium-resolution scan from photo on p.130, showing individual pixels.

Not long ago 'megapixel' resolution was the benchmark for digital cameras – an image of around one million pixels. Today 2 megapixels is nothing special, and 4 megapixel cameras are arriving in the consumer market. And yet, though it may seem perverse, even 2 megapixels is often more than you need.

For images that will only be viewed on the computer screen, relatively low resolution is ample. Many new

computers have 17in monitors, which can display 1024 x 768 pixels. This is less than one megapixel. Larger images can only be viewed in sections or at reduced magnification. For Web use, even this is much too big, as it will take far too long to download.

However, if you want to make prints, resolution does matter. A 2-megapixel image is quite good enough for a modest-sized print, up to 8 x 6in (20 x 15cm). Whether you'll actually get prints as good as those from a 35mm compact depends on what happens in the computer and printer. 'Photo-real' output isn't quite to be taken for granted! Most inkjet printers will produce full A4-size prints, where you'll need 4 megapixels at least to match the quality you can get from conventional film.

Resolution is only one measure of image quality – and image quality is only one measure of how good a camera actually is. The actual result from any given camera depends on the quality of the lens and the software as well as on the raw capacity of the image-capture chip, while design and layout determine whether the camera is easy and practical to use.

Another potentially misleading set of numbers relates to the camera's zoom capabilities. Often there are actually two sets – 'optical zoom' and 'digital zoom':

- *Optical zoom means the camera actually has a zoom lens*
- *Digital zoom means that part of the optical image is further enlarged by the software*

The value of digital zoom is dubious at best, since if you need to crop the image you can do it more precisely – and reversibly – on the computer afterwards. Just as with film, enlarging a section of an image entails loss of quality: you're trying to construct a larger image from a smaller amount of original information. It's worth remarking, too, that in many instances, zooming is simply a lazy alternative to getting closer to your subject (see Chapter 3).

For the outdoor photographer, there are further specific issues to consider. Digital cameras, packed full of delicate electronics, are potentially highly vulnerable to hostile conditions. However, you don't need to open up the back of the camera to change films, and the risk of dust and scratches spoiling your image is much reduced.

Digital cameras are also totally dependent on batteries, and exhaust them at a frightening rate. Some models require three separate sets! Of course, you can and should use

rechargeables, but you may need to carry spare sets even on a weekend trip.

Heavy use of the LCD screen in previewing and reviewing shots drains batteries in no time. The LCD screen is no substitute for a conventional viewfinder (sometimes called the optical finder). Using the *optical finder* makes handling more intuitive, and gives you a more direct connection with your subject. Most consumer digital cameras will have a direct-vision finder, but professional models are based on an SLR design.

Some practising professionals reckon that one of the great benefits of shooting digitally is that you can adjust the colour balance of your shots without using filters, using the LCD preview as a check. This does assume that the LCD image is an accurate guide to the colour balance you'll get in the finished shot. Again the quality of the LCD screen is usually higher in top-end cameras. ◀

One final issue, though often overlooked, is absolutely crucial. This is the time lag between pressing the shutter release and actually making the exposure. In film-based cameras and top-end digital models this delay is virtually negligible: the limiting factor is the photographer's reflexes. However, in some digital cameras the delay is substantially longer. Half a second may not sound like much but it's enough to make a camera useless for action photography. Even for family snaps, it will mean that lots of moments are missed.

CAMERAS

Camera and film formats

Film comes in all shapes and sizes. Many, like Instamatic, 110 and Disc film have come and gone. The dominant film format is 35mm, but a couple of others merit brief mention. On the one hand, there's the *Advanced Photo System (APS)*; on the other, there's *roll film*, also referred to as 120 or medium format.

Cynics say APS was introduced to boost flagging camera sales in markets where almost everyone had a 35mm camera already. It brought improvements in print presentation but these have since migrated to 35mm. For owners of capable 35mm gear there is no reason whatever to migrate, and even for the first-timer the advantages are debatable.

APS cameras, film and processing are generally a bit more expensive than their 35mm equivalents. Choice of high-end cameras, lenses, accessories, or cameras designed for outdoor conditions is very limited. There's little second-hand

Cost benefits?

Shooting digitally may have cost advantages. You'll never need to buy another roll of film. The reusable nature of in-camera storage and of Smart Media or Compact Flash cards will probably appeal to many. However, this advantage isn't so clear-cut if you want hard copies of your shots. Inkjet printers are incredibly cheap to buy, but not so cheap to run: ink cartridges, and the premium papers needed for 'photo-real' results, can gobble up your funds, especially if you print loads of shots at full A4 size or if you use up lots of sheets trying to get the colour balance on paper to match what you see on screen. (This is generally easier on Macs than on PCs.)

gear to be had, and you'll find it hard to get any film other than colour print.

APS cameras are marginally smaller and lighter than their 35mm counterparts, but only marginally. And a camera that's too light or too small can actually be harder to handle. A camera you can grip properly with both hands is easier to hold steady. A bit of weight – enough that you can actually feel it – probably helps too.

There's nothing actually wrong with APS – it will give perfectly good results, unless you want really big prints, or shoot slides – it's just hard to see how it's preferable to 35mm.

Roll film is used in a great variety of cameras, which produce slides or negatives in various sizes from 6 x 4.5cm up to a panoramic 6 x 17cm. The classic format is 6 x 6cm, also referred to by non-metricated photographers as '2 1/4 square'. These larger negatives or slides are favoured by professionals producing work for large prints or for publication, and by dedicated amateurs for whom higher quality outweighs the disadvantages of cost, weight and bulk – exactly the factors which will be crucial for most outdoor people. Even so, if you are, say, a walker, and you have a hankering to produce poster-size prints of some of the marvellous places you get to, it's worth thinking about. ▶

Compacts and SLRs

'Light, fast and simple' seems a perfect description of most *compact cameras*. There's something very appealing about a camera you can slip in your pocket and whip out at a moment's notice. Where weight and bulk are at a premium, especially where speed counts too, compacts certainly score.

In which case, it's vital to remember that there is no such thing as a 'point and shoot camera'. Point and shoot is a state of mind. Even when everything else is totally automated, the two fundamental choices remain – what to point at and when to shoot. Don't neglect these just because the camera does everything else for you.

Many more sophisticated compacts do offer some degree of control, if only in the form of a selection of exposure modes. These probably have names like 'landscape' and 'action' programme, which appear self-explanatory. However, as later chapters will suggest, there are times when it makes sense to use 'landscape' mode for action shots, and vice versa. Another common feature is some simple exposure compensation or override, such as a 'back-light' button. The typical use for this is a portrait against a

35mm wins out

For nearly all of us, the clear choice is 35mm. No other format offers such a vast range of film types, or of cameras, lenses and accessories. The cheapest cameras are 35mm – and so are some of the most expensive. If you are on a tight budget, 35mm gives you the widest choice of second-hand gear as well as the lowest running costs in terms of film and processing.

bright background, when otherwise the subject could turn into a silhouette. It can also be useful for scenes with a lot of very bright tones, such as snowy landscapes.

Many compacts have a zoom lens. This isn't always as useful as it appears; relatively few of them go as wide as 24 or even 28mm. For most outdoor photographers these focal lengths are far more use than the telephoto end. You'll be lucky if this even goes as far as 90mm, which isn't long enough for wildlife or distant action shots. Half the time the zoom is just a substitute for getting closer to the subject anyway.

The quality of the lens is much more important than a superficially impressive zoom range. The problem is that the box will tell you what the zoom range is, but not how good the lens is. However, reviews in camera magazines always examine lens quality. A particular concern is shooting into the light, when flare is all too common (for a definition of flare, see under 'lenses').

Within their limitations, good compacts are capable of excellent results. But the limitations remain: ◀

Take note
You will find in the following pages that comments specific to compact cameras are marked with a small icon: **C**

- *You can't extend the lens range*
- *You can't use filters, or at least not easily*
- *You simply don't have such an intuitive feel for the subject, through the viewfinder, as you get with an SLR*

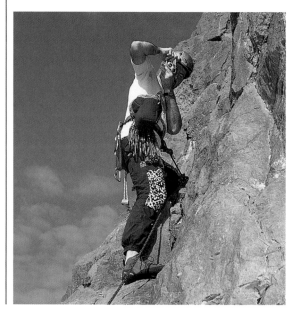

When weight counts, a compact or rangefinder camera scores. An elderly camera like this 20-year-old Olympus rangefinder is also relatively expendable.

The Single-Lens Reflex (SLR) camera remains the first choice for most serious amateur and professional photographers. The first really practical professional digital cameras are SLRs. There are powerful reasons for this dominance. While through-the-lens viewing isn't perfect, it does give a clearer feeling for what the picture may be like; 35mm film allows incredibly good quality; yet the whole package is easily hand-held and well balanced. Interchangeable lenses, and many other accessories, turn the SLR camera into the heart of a system which is almost infinitely flexible and expandable.

One of the beauties of an SLR is that it can grow with you. For those who feel daunted by f-stops and shutter speeds, or just have other things to think about, most modern SLRs can be used in a fully automatic mode, making them as easy as a compact. The difference is that when you gain in confidence, or want to experiment, you can take partial or complete control into your own hands.

The fully automatic mode means that the camera takes care of both focusing and exposure. In fact these are completely separate issues. Most SLRs will allow you to focus manually while exposure remains on auto, and vice versa. And, as we'll see later, there are very good reasons why you might do this.

There is a third category of camera. Though it seems to be a niche market, the *rangefinder* has some definite advantages which makes it well worth considering for the outdoor photographer.

Rangefinder cameras look superficially like compacts, but offer manual focusing. Unlike an SLR, you do not view through the lens, but through a separate viewfinder. A rangefinder camera has a second window on the front of the camera which produces a secondary image, superimposed on the main one, usually as a 'ghost' image in the central part of the viewfinder.

Focusing on a given object is simply a matter of aligning the two images of that object. Many experienced users swear that it is faster than manually focusing an SLR, and easier in low light. This is one reason why many eminent photojournalists use rangefinder cameras.

More significantly, the rangefinder is smaller, lighter and quieter than an equivalent SLR. SLRs are built around the reflex mirror, which is inherently prone to noise and vibration. The mirror-box increases the bulk of the camera body. The greater distance between lens and film makes SLR lenses bigger and heavier than their equivalents for rangefinder models.

Rangefinders offer full control and great quality, but the learning curve is on the steep side. Focusing is less intuitive than an SLR, though it just takes a little practice. They're certainly worth considering for landscape and for some activities such as climbing. One obvious drawback is that you can't get really long lenses for them, which limits their value for some types of action photography and even more for wildlife. ◀

Rangefinder models
The most famous rangefinder cameras are the Leica M series (beloved of photojournalists), with superb engineering and impeccable lens quality. But they are also expensive: you could buy a new SLR for what it costs to insure a Leica outfit. More affordable, but still not cheap, the leading 35mm rangefinders today are the Voigtlander Bessa series; tiny but very well made and with some great lenses.

There are some excellent medium format rangefinder cameras too, giving quality far beyond any 35mm SLR yet little larger or heavier. The Mamiya 7II produces 6 x 7cm images yet is lighter than some top-flight 35mm SLRs.

Exposure – auto and manual
There are four basic classes of exposure mode:

- *Programme (often spelt 'program')*
- *Manual*
- *Shutter-priority*
- *Aperture-priority*

Any other name will almost certainly denote some form of programme mode.

In *programme* mode, the default setting on most modern SLRs, the camera sets both shutter-speed and aperture. Many cameras offer a whole raft of programme modes, supposedly optimised for portraits, landscape, action, and so on. These generally work well, up to a point, but several concerns arise. There's a basic philosophical objection to surrendering control of your own work. More practically, if you don't know what's going on, you can't learn anything either from successes or failures. More practically still, these modes don't necessarily do what you want.

The opposite extreme is *manual* mode. Once this was all you got: with some cameras it still is. Manual puts you in control: you select both aperture and shutter-speed. In its drive to sell ever more automated cameras the industry has convinced millions of people that using manual mode is slow, fiddly and demands a higher degree in maths. Millions more, of course, have carried on using manual cameras perfectly happily.

Sadly, the design of some cameras does make manual mode fiddly to use. On traditional cameras you turn a ring on the lens to set the aperture, and a dial on the camera body to set the shutter speed. Ideally, you can operate both controls while holding the camera to your eye, and see in the viewfinder what the settings are. Some recent cameras, however, require you to hold one button while turning another dial, and only show you the settings via the LCD screen on top of the camera. This makes manual mode far less usable, and prompts the cynical thought that you aren't

really meant to use it at all. It just looks good on the feature list.

Shutter-priority and *aperture-priority* modes come halfway between these two extremes. In shutter-priority, you set the shutter-speed and the camera determines the aperture needed for 'correct' exposure. In aperture-priority it's the other way around. These modes will come in handy for most photographers from time to time, and are absolutely ideal when you want to start to take a little more control. Again, how usable they are depends on just how easy it is to set aperture or shutter-speed on any given camera. If you can't do it with the camera held to your eye and ready for action, the camera is not as user-friendly as it should be.

Metering systems

A painful lesson that everyone learns sooner or later is that automatic exposure systems don't guarantee perfect shots every time. Whatever exposure mode you use, accurate results still depend on the camera's metering system.

Almost every camera has some form of built-in metering. The main exceptions are disposable cameras and some very cheap compacts, which rely entirely on the latitude of modern colour negative films to produce passable results. These apart, virtually the only cameras now made without meters are intended for professional use; many professionals still rely on separate, hand-held meters, especially with formats larger than 35mm.

Cameras with external meters occasionally crop up on the second-hand shelves, but any new SLR or decent compact will have an internal meter, which reads the light gathered by the lens. Even so, not all meters are equal. There are three main types:

- *Centre-weighted*
- *Spot*
- *Matrix*

Some cameras allow you to switch between metering regimes.

Centre-weighted metering is usual on older SLRs, and still widely employed. The meter measures light across the entire viewing screen but with a bias to the central area, where the subject is presumed to be. This isn't always a safe assumption, especially in landscape photography! These meters will invariably be misled when very light or dark areas occupy the centre of the frame.

Spot metering is more or less what its name suggests.

This measures light from a very small area at the centre of the viewfinder. It's particularly useful in tricky situations; you only need to find a small area of 'average' brightness to get a reading. Since you'll be lucky to find this at the exact centre of your intended shot, this usually means reframing after you've taken the reading. This is easy when working in manual mode, and also if you can lock the exposure in some other way.

Matrix metering is the most sophisticated type. Different manufacturers use different names, such as Evaluative or Multi-Area metering, but the principle is the same. These meters measure brightness values in different areas and compare the pattern against an internal database of possible pictorial situations. These are certainly more accurate more of the time than centre-weighted, but still not 100% foolproof. ◀

Which system is best?
If you want to leave exposure decisions to the camera, then matrix metering is to be preferred. If you are confident about taking charge yourself, then either of the other systems can be used effectively, though spot metering has the edge in tricky situations. For more detail on exposure and metering, see Appendix I.

Focusing – auto and manual
As with exposure, everyone finds out sooner or later (usually sooner) that autofocus isn't foolproof. Simple autofocus systems normally try to focus on whatever is in the centre of the frame. In the real world your subject – or the critical part of the subject – may be nowhere near the centre.

A few top-flight SLRs have multiple focus sensors. These can improve the success rate but still don't guarantee perfect results every time. One maker (Canon) offers 'eye-controlled' autofocus. This reckons to detect where you are looking and activate the appropriate sensor. It's very clever indeed, and with up to 45 focus points on some models, a vast advance on a single central sensor. However the eye-control feature takes some getting used to, and demands that you're looking at exactly the right point when you press the shutter. Doing this while simultaneously monitoring the overall framing and the development of the action is quite a complex task. In fact it sounds suspiciously similar to focusing manually!

Manual focusing doesn't guarantee success, either. However, the first time you take an autofocus camera out of its box its focusing is as good as it will ever be, whereas manual focusing skills improve with practice. Despite all the advances in autofocus technology, many professionals whose living depends on consistently good shots of fast-moving action still prefer manual focusing.

Cameras for the outdoors
Technical features are important, but there are other concerns which you can only judge by handling a number of cameras.

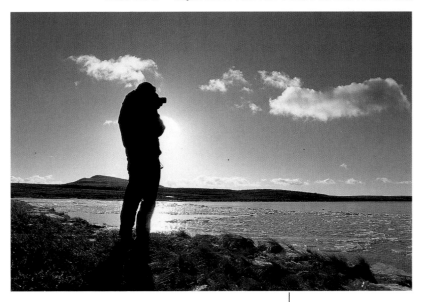

In the outdoor context, build quality is particularly crucial. While lightness is desirable, so is robustness, and there's inevitably a trade-off between the two. The more punishment your camera may take, the tougher it needs to be. This depends on what sort of outdoor activities you are involved in, but also on how careful – or how clumsy! – you are.

Even more personal is how the camera handles. To some extent this depends on factors such as the size of your hands. If you never intend going beyond the basic, all-auto, mode, then access to controls will be unimportant. On the other hand, if you intend to use the camera to its full potential – or if you just think you might try it, one day – it becomes crucial. If you can't alter aperture and shutter speed while holding the camera to your eye, it's badly designed.

Viewfinder quality is another critical area. A crisp, bright finder image is particularly important for manual focusing, but it's a very good thing anyway. It makes everything easier. It's also helpful if you can see basic information such as aperture and shutter speed in the viewfinder. Having masses of data on a separate LCD panel on the top of the camera is fine (though it bumps up battery consumption), but what's crucial is what you get in the finder. ▶

Tough conditions, such as a temperature of -15 degrees Celsius, place extra demands on both photographer and equipment.
(Bernie Carter, Whernside Tarn, Yorkshire)

If you wear glasses...
If you do, you may have difficulty seeing the whole of the viewfinder image. There's no reason to struggle, since there are lots of cameras which do allow you to see everything even with glasses on.

LENSES

Most of the marketing hype revolves around cameras, but it's the lens that delivers the image to film or chip. A 'good'

camera with a bad lens is a bad camera. It's crazy, therefore, that many 'kit' or 'outfit' deals marry perfectly good camera bodies with the cheapest possible lens.

Lenses divide into fixed focal length (for example, 28mm, 200mm) and zoom (for example, 28–70mm, 70–200mm) types. Traditionally zooms fell short in optical quality, but this is hardly true nowadays. However very cheap zoom lenses, and zooms with very wide ranges, should still be treated with suspicion.

Lenses also vary in *speed*, which means their maximum aperture (see Appendix I). The crucial point is that smaller numbers mean wider apertures: for instance, f/2 is a wider aperture than f/2.8. The difference between f/2 and f/2.8 is one stop, which means that the wider aperture admits twice as much light. We can also say that the f/2 lens is one stop faster.

Fixed lenses generally have the edge here, with apertures

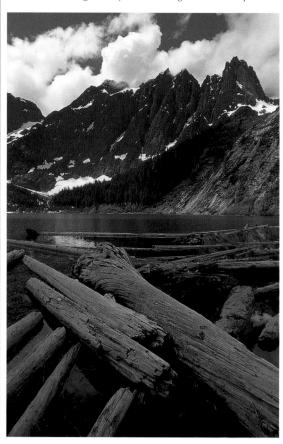

Wide-angle lenses – here it's a 20mm – can encompass large-scale landscapes and make the most of interesting foregrounds. (Landslide Lake and Mount Colonel Foster, Vancouver Island, Canada)

around f/1.8 to f/2.8 at mainstream focal lengths. A fast lens gives a brighter viewfinder image, which makes seeing, framing and focusing easier, as well as allowing the use of faster shutter speeds. However faster lenses are bigger, heavier and more expensive. C'est la vie.

Many zoom lenses alter aperture as you change focal length (for example, 70–210mm f/3.5–f/4.5). This can become annoying if you use manual exposure, especially with a separate meter. The best zooms tend to have faster apertures (f/2.8) and to maintain them throughout the range.

Speed is only one measure of lens quality. The camera magazines still concentrate on *sharpness*. Hardly any lenses now are so bad that you can't get decent 7 x 5in prints, but differences will emerge in bigger enlargements, or projected slides. Good *image contrast* usually goes hand-in-hand with good sharpness, and will make the image 'feel' sharper anyway.

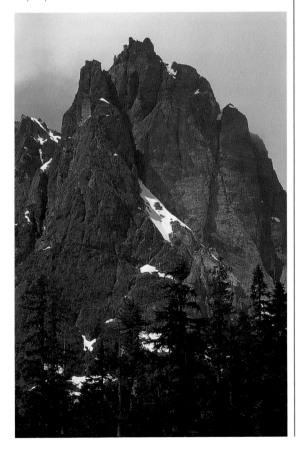

A 200mm lens can draw in and isolate specific features. The same peak, from a slightly different viewpoint, appears opposite.
(North peak of Mount Colonel Foster from Landslide Lake, Vancouver Island, Canada)

Superzoom lenses

'Superzooms' such as 28–200mm may look enticing – all your needs in one lens – but tend to be very slow, with maximum apertures around f/5.6. Such a lens only admits one-quarter as much light as one with a maximum aperture of f/2.8, making the viewfinder image that much dimmer. These lenses really aren't intended for manual focusing. Sharpness can be fair, but there's almost always distortion, at least over part of the range.

Many lenses, especially zooms, show distortion, meaning that straight lines (in the real world) appear curved on film. This is most pronounced near the edges of the frame and a serious case will be readily apparent in the viewfinder. There are more straight lines in and around the average camera shop than there are in most outdoor settings, so it perhaps isn't the biggest issue for us, but it could be the deciding factor between two otherwise similar lenses.

Some lenses are more susceptible to flare than others. With an SLR, unlike a compact, you can spot serious flare in the viewfinder. It's better to do this in the shop before you buy. You'll need a small, bright, light-source, and by far the best , on a clear day, is the sun (remember, though, don't look directly at it). If the camera shop won't let you try the lens outside, even if you leave something valuable as security, try another camera shop. ◀

Which lens to use?

It's often suggested that the 'standard' 50mm lens matches the field of view of the human eye, but in fact we can see much more, though resolution falls off dramatically towards the edge. Without even turning your head you can probably see a view equivalent to quite a wide-angle lens – it will vary from individual to individual, and may get narrower as you get older. A 28, 24 or 20mm lens will probably 'feel' right, while anything wider begins to seem unnatural.

Similarly, the point of long lenses, except perhaps really extreme ones, is not to show us things we can't see anyway. It's much more to pick out elements of a scene in a way corresponding to the 'mental zoom lens'.

While the flexibility of zoom lenses has obvious attractions, the fixed focal length of a prime lens can be a positive advantage. Using the same few focal lengths all the time certainly aids visualisation, and this means you can spend much more time not looking through the camera. The less time you spend looking through the viewfinder, the more you are likely to see.

Basically, the best lens depends on what you want to do with it. Specific recommendations for specific jobs will be made in the following chapters, but it's also going to depend on you – what you can afford, what you can carry, and how you see the world.

ACCESSORIES

Lens hoods physically protect the lens and help limit flare. Zoom lenses can be particularly prone to flare, but it's almost

impossible to make a lens hood which shades the lens properly throughout its zoom range. However, as zoom lenses are more complex and vulnerable to knocks, it's worth fitting a lens hood.

Filters fall into two groups:

- *Those that stay on the lens permanently (these are round, and made of glass)*
- *Occasional filters*

Ultraviolet (UV) or *skylight* filters are examples of permanent filters. Their main value is to protect your expensive lenses from dirt and scratches. They do have some slight effect in reducing the blue tint seen in shade under a blue sky and also on overcast days, but when this is a serious concern something stronger will be needed.

'Occasional' filters should be just that, especially in the outdoor context where 'light, fast and simple' is the motto. The most useful are *neutral density graduated* filters. This is a long name for something that does a very simple job, namely allowing you to balance widely differing light levels in different areas of your shot. The commonest example is a bright sky with a relatively dark foreground. 'Grey grad' is a much shorter name.

A warm-up filter (81B) counteracts the cold light, and a neutral density graduated filter strengthens the sky.
(Callanish, Isle of Lewis)

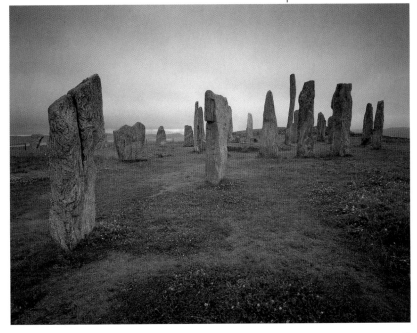

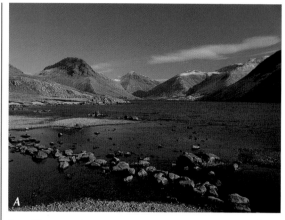

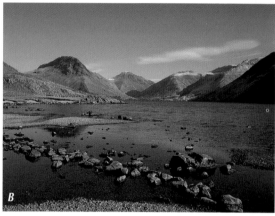

Effect of a polarising filter. A is taken with the filter, B without it. The effects include more vivid colours, and much clearer skyline and cloud detail. But which shot do you prefer? (Wastwater, Lake District)

The best occasional filters
These are square or rectangular and slot quickly into a separate holder This is especially convenient with graduated filters, which need to be used in different positions for different shots.

Sometimes you can just hold the filter in front of the lens, especially when the camera's on a tripod – and some photographers swear by Blu-Tak.

The *polarising* filter is a great standby, particularly for landscape photographers. Its main effect is to reduce reflections from most surfaces. This intensifies the underlying colours of rocks, foliage, and so on. It can also make blue skies appear much richer and more dramatic. This effect can sometimes be over the top, and it should be used sparingly. The effect is only seen to the full when shooting at right angles to the direction of the sunlight, disappearing when the sun is directly behind or in front. Leaving a polariser permanently attached achieves nothing.

If you use an autofocus camera – especially if you want it to work – you'll need a *circular polariser*. Manual focus users can happily carry on with cheaper *linear polarisers*.

The principal remaining filter which may be of use is a *warm-up*. So-called 'creative' filters are anything but. And they certainly aren't 'light, fast and simple'. ◀

Camera support: tripods and monopods

There are three main causes of unsharp pictures:

- *Poor lenses (sometimes just dirty ones!)*
- *Poor focusing*
- *Camera shake (probably the most common but often the last to be considered)*

A tripod will not automatically eliminate camera shake. If the tripod is too light and flimsy for the camera/lens combination you are using, even the vibration of the mirror and shutter could cause blurring. The worst culprits are very light tall tripods.

Under calm conditions, and using a standard or wide-angle lens, even a light tripod will enable you to shoot at much slower shutter speeds than you can possibly hand-hold.

Camera shake means that nothing in this shot is sharp. Fortunately the one I took a second later was steadier! (Striding Edge, Lake District)

45

However, it's always worth buying the best you can (a) afford and (b) carry around with you. 'Best' doesn't necessarily mean heaviest, though heavier tripods are naturally more stable. Other factors to consider are:

- *Do the head and leg adjustments lock positively and release easily?*
- *Can you angle the legs independently on rough ground?*
- *Is there any quick-release mechanism for attaching and removing the camera? For the photographer on the move this is not a luxury, but an essential*

Some designs (such as Benbo or Uni-Loc) are extremely flexible, making it much easier to get a really low camera position. This can be important if you plan on taking lots of pictures of flowers, for instance.

*Using a monopod.
(Warton Crag, Lancashire)*

A small but sturdy tripod will be less versatile, but more stable. For those with money to burn, or a serious vocation to pursue, carbon-fibre tripods can be half the weight of the nearest metal equivalent, and very rigid, but cost from £300 upward.

Monopods are extremely useful alternatives to tripods under many circumstances and much easier to carry around. Experience suggests that you gain two to three stops over hand-holding with most lenses; if 1/60th sec is your lower limit for hand-holding with a standard lens, you can manage 1/15th or 1/8th with a monopod. They are also much quicker to set up than tripods. There are many other ways to steady the camera, and these will be looked at in succeeding chapters.

Flash

This is probably a familiar scenario: a thrilling Wimbledon final goes on late into the evening, the light's getting low, and the weary umpire keeps asking spectators not to take pictures with flash. Of course in many cases they're using compacts which automatically initiate the flash when the light level drops. The sad thing is that not one of those people is going to get a picture worth having. The pros down at the side of the court, of course, just switch to faster film and keep on shooting.

Built-in flash has two major limitations:

- *Low power:* the flash simply doesn't give off enough light to reach very far – certainly not right across the Centre Court
- *Fixed position:* these units are inevitably very close to the lens axis, making their light very frontal and direct. This is just about the worst possible light for portraits, even without the additional problem of 'red-eye'. Most of the time it bears no relation whatever to what you see, though it can closely mimic the sort of lighting you get when wearing a head-torch

Built-in flash is useful for 'fill-in' lighting. As a main light source, however, it leaves much to be desired and should only be used when there really is no alternative.

A separate flash gun, even a really cheap one, probably offers more power and definitely moves the light source away from the lens axis. You can also add a diffuser to soften the harsh light. If you can take the flash off the camera entirely, with a cable connection, you'll get

A simple diffuser – a white handkerchief – will soften the harsh light from a flashgun. If the flash is being used in Auto mode it is important not to obstruct the sensor.

A simple reflector attached to a flashgun with a bounce head. The reflector attaches with Velcro and folds flat when not in use.

complete control over the angle of the light. A 'bounce head' is extremely useful indoors and in confined spaces such as tents or cave passages. Bouncing the light off a ceiling or wall (preferably white) spreads the light out and produces more even, kinder illumination.

Flashguns fall into three main categories:

- **Dedicated** or **TTL** *flashguns couple with the camera's metering and permit fully automated flash exposures. The built-in flash in most SLRs is also of this type*
- **Automatic** *flashguns have a separate sensor, effectively a small light-meter, which controls flash exposure independently of the camera*
- **Manual** *flashguns may have fixed or variable power but require you to sort out the exposure yourself* ▶

There's more about controlling flash exposure in Appendix I.

Reflectors – which can be as simple as a piece of white card – are also useful in strong sunlight to bounce light back into the shadows and reduce contrast to a level the film can cope with. The range is limited, but so is the range of a flashgun.

Carrying it all

The first rule is not to try! Just because we've reviewed a lot of gear in this chapter doesn't mean you'll need all of it for what you want to do. Most of the time most people will not need to carry more than one camera, one or two lenses, and a few rolls of film. The next most likely items are a filter or two and some form of camera support.

With this much gear, it's possible to keep it both well protected and reasonably accessible. The more you carry, the harder it becomes to maintain this balance.

A compact camera can just go in a pocket. If you're simply walking, in dry weather, an SLR can travel on a neckstrap. But this may give you neckache, and you may also get fed up with it bumping against your stomach. A better option is a padded pouch on a waist-belt. This also provides protection against showers, if not downpours. The rest can go in the top, or top pocket, of the rucksack. Spare lenses should have their own padded cases. These aren't very expensive but can be home-made to save money.

FINAL THOUGHTS

Gear is important, but not paramount. There are two basic questions: what do I need for what I want to do? How much gear can I actually manage (considering weight, time and

budget)? Sometimes they will produce radically different answers!

Being able to travel light is certainly one consideration. Perhaps just as important is simplicity. Too much gear can lead to confusion and uncertainty. Keeping it simple means you know exactly what your options are.

Never forget, either, that quality counts, not least in the demanding conditions of the great outdoors. Some differences are obvious just in the feel of a camera or lens, others only emerge when you see the results. Fortunately, it's easy to tap into the experience of other users.

CHAPTER 3
Shooting landscapes

In any outdoor activity, it's not just what you do but where
you do it that's important. Even a short country stroll will
take you to places unsuspected by those who never leave
the roads. Mountaineers, cavers, sea-kayakers all get to
places most people will never see and may never even have
dreamed of. Whether it's to show your friends, or just for
your own memories, you'll surely want pictures that capture
the special qualities of these special places.

On the face of it, shooting landscapes should be easy.
Landscape just sits there and waits to be photographed. You
don't need expensive specialised gear: an ordinary camera
and an ordinary lens will do fine.

However, shooting landscapes well turns out to be less
easy. There are a number of reasons for this. Some of them
are technical, but a lot of technically competent pictures still
don't really get the message across. Indeed, in their obses-
sive pursuit of technical excellence some people seem to
forget what the picture is actually about.

Seeing the landscape
Landscapes are big and complex. When you get actively
involved with landscape, you see much more of this richness

*Landscape photography
seeks to capture the special
qualities of special places.
(Cautley Crag, Howgill Fells,
Cumbria)*

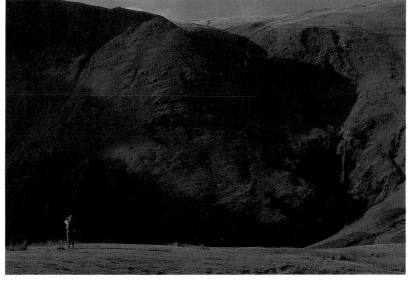

and become far more aware of its detail and texture. A kayaker will be very conscious of the way a river flows, of eddies and stoppers and calmer pools. A climber will be very focused on the fine detail of rock, its cracks and holds, the frictional qualities of its texture. A walker or a cyclist will be highly aware of gradients and path or track surfaces.

Many of these qualities are subject to change. A lake which is a perfect mirror in a windless dawn may be whipped up to white-capped turbulence just a few hours later. Landscape changes constantly. There are gross physical changes, like landslides and avalanches; trees fall and rivers change their course.

Complete stillness is a rare and usually short-lived phenomenon. Most landscapes – and most landscape photographs – have movement in them somewhere. Even

Landscapes change – how long did this boulder stay perched like this after we had moved on? (Biafo Glacier, Karakoram Mountains, Pakistan)

when there's not a breath of wind, and no running water in sight, the sun moves continually across the sky: the light is constantly changing.

These things naturally affect the way you look at a landscape and the feelings you have about it, and should influence what you want to say about it in photographs. The clearer you are about what you want to say with the shot, the better. 'What a beautiful place' is just a start. Think about it:

- *What makes it beautiful?*
- *What's special about it?*
- *Is it inviting or forbidding?*
- *Does it awe you with its sheer scale and grandeur or does it seduce you with a quiet, delicate beauty?*

FRAMING THE LANDSCAPE

Perhaps what makes landscape hard is exactly the quality that appears to make it easy: it's just sitting there. It isn't neatly parcelled up into photograph-sized chunks. With a portrait or an action shot there is usually a definite subject. Fill the frame with it, get it sharp and correctly exposed, and the subject will probably speak for itself. Landscape photography doesn't work like that. Landscape includes everything from the grass under your feet to distant mountains and the sky above. The challenge is how to pack all that into a two-dimensional rectangle.

Put it another way: how do you fill the frame with your subject if you can't say exactly what your subject is?

'What to point at' can be the hardest decision you'll have to make when taking a landscape photograph. In other words, framing is fundamental. ▶

Many books talk about 'rules of composition', especially the notorious rule of thirds – whereby if a scene is mentally divided into thirds both horizontally and vertically, the main points of interest lie where those lines intersect. This might appear to be a useful short cut but is all too often a dead end. Half of the shots given as examples of this rule conform to it very loosely, if at all. Some books tell you that the rule of thirds is the same as the golden section (a doctrine, dating back to Ancient Greece, about the most harmonious position for prominent horizontal or vertical divisions), when it demonstrably isn't. These so-called rules aren't as simple as they seem, and experience suggests that they aren't that useful either.

It's pretty hard to think about 'rules' and at the same time stay focused on the feeling and emotion of the moment.

Framing begins with seeing...

But seeing means more than just looking in the right direction. It means really being aware of what you're looking at. This is basically very simple, but simple isn't quite the same as easy. It calls for concentration and really paying attention to what you see, both directly and through the viewfinder.

'Composition' vs 'framing'
Because so many discussions about 'composition' are weighed down with rules, the word itself tends to be inextricably linked with them. This is why the word has only appeared twice so far in this book, and won't be used again. The alternative term, 'framing', denotes exactly what we're doing and doesn't carry anywhere near as much baggage.

Many of the greatest photos ever made don't conform to any known rule. Neither does landscape itself conform to any simplistic rule, so why should one be imposed on a landscape photograph? ◀

We need a different way to think about framing. Viewfinders have their limitations, but they're still an essential tool. And, like any tool, how you use it is more than half the battle. The central skill is seeing the whole picture, and it is a skill that anyone can develop with practice.

- *Try to think in terms of looking **at** the viewfinder rather than **through** it. With an SLR, this is what you do anyway: what you are actually looking at is the focusing screen. In a sense, it already is a picture. The viewfinder of a compact is much more like a simple window, but it's just as important to try and think of it as if it was a picture*
- *Consciously observe the edges of the frame, especially when you're trying different angles of view. It helps you to identify what you're leaving out, and perhaps also what you should leave out. If you use a zoom lens, objects can appear and disappear at the edges of the frame as you zoom in or out. Being aware of the edges also helps you to keep the horizon level*
- *Looking at what's contained within the frame – the picture content – is the other side of the coin. The camera can't read your mind and doesn't actually know which bits of the scene you are interested in, so it's no good blaming the camera if you get more than you thought you were getting: it's up to you to see what's there*

But looking at the viewfinder will only tell you about the picture you will get from a particular spot, looking in a certain direction, with a given lens. It won't tell you what difference it will make if you move back a few metres, or switch to a different lens. You can do this by trial and error, but if you stop to check through the viewfinder after every little adjustment, it'll take forever. Landscape photography isn't supposed to be *that* slow! This is why looking at the scene directly is just as important as using the viewfinder.

We can all anticipate, to some extent, what will happen when we shift position or change lenses. The more we do it, the better we get at it. This anticipation is one aspect of visualisation. As you develop these skills you will spend less and less time looking through that fiddly little viewfinder, and more and more looking directly at the world.

Increasingly, you will have a shrewd idea exactly where to stand, and which lens to use, before you ever raise the camera to your eye.

Visualisation means more than just seeing the raw ingredients of the shot. It also means being aware of the differences between the way the camera sees and the way the eye sees. We've already alluded to depth of field, at which we'll look again shortly, and at the way the camera deals with movement, with colours, and with big differences in brightness.

One of the most important factors remains the 'mental zoom lens.' Physically, the human eye has only very slight zoom ability; it's like a fixed focal length lens. It's the brain which can switch almost instantaneously from 'seeing' a wide-angle view to a narrow 'telephoto' one. This ability is very powerful, and very useful to the photographer.

Suppose, for instance, that your attention is caught by a beautiful, shapely tree on a nearby ridge, with a distant hillside beyond. To your eye it stands out clearly, but in the final shot the tree almost merges into the similarly coloured background of woods on the far side of the valley.

There are several ways that you could deal with this:

- *You could change your viewpoint so that the tree stands out against a different background (the sky being an obvious option)*
- *If the lighting conditions are suitable, you could wait a few minutes for the shadow of a cloud to fall on the background so that the sunlit tree stands out against it – or vice versa*
- *You can limit depth of field so that the tree stands out sharply against a background in softer focus*

There are always possibilities, but you can only exploit them if you're aware of the potential problem.

Different angles

Landscape photography essentially deals with fixed objects. We can move the odd pebble, but not a tree or a mountain. Yet landscape photographers often talk about 'organising' or 'arranging' the different elements in their pictures.

The one thing you *can* move is the camera. There are several ways to change the framing of your shot. Switching lenses, or using a zoom, is only one of these. Even with the simplest of cameras, with one fixed lens, *you* are not fixed. You can move forward, back, left, right, even up and down. Try all of these options, and observe the results carefully.

If you only have a fixed lens, and you want to make a

Original

Zooming In

Moving Closer

particular feature larger, your only option is to move closer. This does *not* have the same effect as staying put and switching to a longer lens. Zooms and telephotos are wonderful things, but they can encourage lazy photography.

There is every difference between snapping on a longer lens to take a 'closer' picture of a scene, and actually walking forward into it. If there's a tree 50m away and a mountain 10km away, zooming in will enlarge both of them equally within your frame. Walking forward 25m makes no discernible difference to the apparent size of the mountain, but halves the distance to the tree, making it look much larger. Changing the relative sizes of two objects in this way changes their relative importance in the frame, and with it the balance of the picture. ◀

Don't neglect the third dimension, either. There's no law that says every shot has to be taken from a standing position, with the camera at eye level. Scrambling up a boulder or outcrop can expand your view considerably, while getting low draws in more foreground detail. Grubby knees are a small price to pay for a really good shot.

Foregrounds and panoramas

The 'panoramic' option found on many cameras simply masks off the top and bottom of the normal frame. The print is produced from only part of the negative. This is wasteful, and means that greater magnification is required to produce a decent-sized print. If the shot needs cropping you can always do so later, either by getting a 'selective' print made, or by using a pair of scissors. It's curious that people are frequently aghast at the thought of chopping up prints with scissors, yet have no such inhibitions about using the crop tool in image-editing software.

The usual effect of chopping off the top and bottom of the picture is to chop off the sky and the foreground. What's left is usually the middle to far distance. This may satisfy those who think you can see it all from a car window, but the active outdoor person is aware of, and cares about, more than just 'the view'. The foreground is grit under your boot

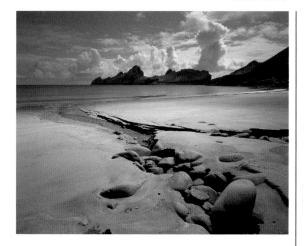

In a shot like this, with no single subject, depth of field should cover everything in view. Taken on a medium format camera with a wide-angle lens, equivalent to about 21mm.
(Village Bay, St Kilda.)

soles, the icy stream you've just crossed, the crystal glinting on the corner of a rock, a bright mound of moss campion.

If you really want to convey that feeling of 'being there', then foregrounds are vital. To make the most of foregrounds, there's no substitute for a wide-angle lens, by which we mean anything from 35mm to 20mm, 18mm or even wider. You can use these to encompass either the broad sweep of a landscape, or a large but relatively close subject. However, wide-angles have a habit of taking in things you don't want as well as those you do, so watch the whole frame.

Using a wide-angle lens draws nearby objects into the frame, and often that's the whole point. However, if the main

Valleys can draw the viewer into a picture – especially when the clouds decide to help!
(Hispar Glacier, Karakoram Mountains, Pakistan)

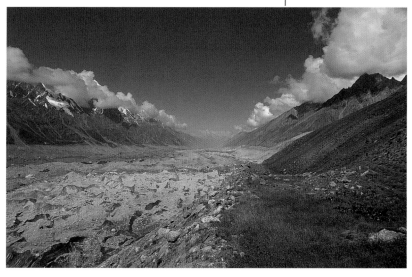

reason for using the wide-angle is to take in the broad sweep, you don't want the foreground to be *too* dominant. Tracks, rivers and valleys can 'lead' the eye into the view, but more solid objects can 'block' it, especially if placed centrally.

The wider the lens you're using, the closer you may be to your foreground objects. Even a shift of a few centimetres in your camera position can have a big effect on where or how large they appear, while making negligible difference to distant skylines. Get close, get involved, but keep looking at the whole frame.

DEPTH OF FIELD

When you look at a landscape, do you see an out-of-focus foreground? Your eyes scan the scene, switching seamlessly between foreground and background. If you want your

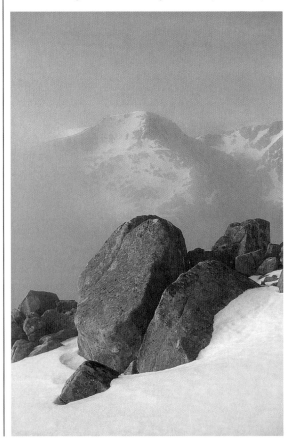

The background is softened by the mist, not by any lack of depth of field. (Stob Coire a'Chairn, Mamores)

photos to match the way you see the scene, a blurred foreground strikes a jarring note. As far as general views are concerned, a picture which is sharp throughout looks more natural.

The 'mental zoom lens', on the other hand, homes in on one particular thing. We tend to see this sharply, and discount everything else. We're all familiar with those sports and wildlife images where the subject stands out crisply against a blurred background. ▶

With a conventional landscape shot the aim is to have everything in focus, from foreground to horizon. It rarely looks that way in the SLR viewfinder. When you look through the finder to frame and focus the shot, the lens is at its widest aperture, letting in as much light as possible to give you the brightest view. However, the shot will normally be taken using a smaller aperture. The actual taking aperture only comes into effect at the last moment, after you press the shutter. In a few milliseconds, the mirror flips up and the lens is stopped down to the required aperture. Finally, the shutter opens to expose the film.

This is crucial, because depth of field increases at smaller apertures. When you look through the viewfinder, with the lens wide open, depth of field is at a minimum, helping you to distinguish clearly between what's in focus and what isn't. However, if the picture's taken at a smaller aperture, other objects, both closer and more distant, come into focus. So:

> - *How do you know what will be in focus?*
> - *How do you control it?*

Traditionally, every SLR had a *depth of field preview*, a small lever which manually stopped the lens down to the required aperture. This made the viewfinder image darker, but it was helpful in giving at least an indication of the effect on depth of field.

Relatively few SLRs now incorporate this feature. This is especially true with autofocus cameras. The lack of a depth of field preview makes mock of the promise that what you see is what you'll get. Either you just accept that most of your shots won't match the viewfinder image, or you'll need to use some imagination in combining what you see through the viewfinder with what you see directly. You'll need, in fact, to develop a mental depth of field preview.

Fortunately, some lenses – especially manual focus ones – have depth of field markings. There may also be printed tables in the handbook that came with your lens.

'Depth of field' or 'depth of focus'?

Depth of field simply means what is in focus and what isn't. The term 'depth of focus' would be more self-explanatory, and many people do use this. Unfortunately this is strictly incorrect; depth of focus has been appropriated for a different, though related concept. Nine times out of ten when people say depth of focus they mean depth of field, but in more technical literature it's used correctly, so beware of ambiguity.

Depth of field is influenced by three main factors:

- *The **aperture**. Depth of field is smallest at the widest aperture, and increases as you stop down. There's much more depth of field at f/16 than at f/4*
- *The **focal length** of the lens. The wider the angle (in other words, the shorter the focal length), the greater the depth of field. A 20mm lens has much greater depth of field than a 200mm*
- *The **distance** to the object you're principally focusing on. Depth of field is greater when you're focused on more distant objects. In real close-up work there's hardly any depth of field* ◀

Making the most of depth of field

As the sidebar explains, focusing on infinity doesn't make the most of depth of field. Clearly it would help to focus closer – but how much closer? This depends on both the aperture and focal length of the lens, so there's no single figure for all circumstances. But there are ways to make a good estimate.

If your lens has depth of field markings on the barrel, you can use these. For each aperture there are two marks indicating the near and far limits of depth of field. If you line the 'far' marking up with infinity, everything from infinity to the distance indicated by the 'near' mark should be sharp. The lens is now focused at what is called the *hyperfocal distance*.

However, there's one more complication. Things that appear sharp in a postcard-size print may not appear quite so crisp in a larger one, especially if you look at it closely. In other words, there seems to be less depth of field in the large print.

Strictly speaking, a lens will only focus light at one distance, no matter how small the aperture. Objects either side of that distance are never perfectly focused. The more they diverge from that distance, the more obviously out of focus they are. Depth of field really describes the range of distances within which objects *appear* to be in focus. This makes it sensitive to the scale of enlargement – and, indeed, to how critical the viewer is.

It may be easier to look at this in practical terms. The table following gives some sample values for the hyperfocal distance, for use with prints up to 7 x 5in (18 x 12cm).

Approximate hyperfocal distance (metres)

Aperture	f/2	f/4	f/8	f/16
24mm	6	3	1.5	0.8
50mm	25	12.5	6.25	3.12
100mm	100	50	25	12.5
200mm	400	200	100	50

For prints up to twice the size, which is 10x enlargement from a 35mm negative, we should double these distances. This is probably good enough for most purposes, since larger prints are rarely viewed so closely as smaller ones. It will probably suffice for slide shows, too, since only a very good projector will show such super-fine detail – and most people sit well back from the screen anyway. However, if you're very critical, or your work is for publication or high-powered competitions, it pays to assume that the hyperfocal distance is still further off.

Even if you treble the distances given, the hyperfocal distance is still a lot nearer than you might expect, at least with 'standard' and wide-angle lenses. For a 50mm lens at f/16, for instance, it's 9m. With the 24mm lens at the same aperture it's only 2.5m.

When you are focused on the hyperfocal distance, the nearest object that will be sharp (by the same criteria) is at half that distance. For that 50mm lens at f/16, it's 4.5m away. And remember, this is for the hypercritical person aiming to produce really big prints.

Let's assume the largest print you'll want on a regular basis is 15 x 10in. Now take a look at these sample values:

Lens	f/11 Hyperfocal Distance	Depth of Field	f/16 Hyperfocal Distance	Depth of Field
24mm	2m	1m–infinity	1.4 m	0.7m–infinity
35mm	4.5m	2.25m–infinity	3m	1.5m–infinity
50mm	9m	4.5m–infinity	6m	3m–infinity

C How do you control depth of field with a compact camera? Few compacts let you control the aperture, or tell you what aperture is being used. You can find out what the widest aperture is; both focal length and aperture are generally inscribed around or alongside the lens itself. If not the information can generally be found in the instruction book. A typical fixed lens compact will have something like a 38mm f/5.6 lens: it may say 1:5.6 on the mount. This will actually give fair depth of field anyway, and you can make the most of it, even on an autofocus compact, by using the hyperfocal principle.

With a standard landscape shot, the centre of the frame – where most compacts focus – is usually a distant area. For a 38mm lens at f/5.6 the hyperfocal distance is between 5 and 10m depending on the size of print you may want. Many cameras will focus when you half-press the shutter button, and then hold it until you fully press the shutter (the instruction book will tell you). Aim the camera at something about the right distance away then reframe your shot while keeping light pressure on the shutter release.

Using the hyperfocal principle, a 24mm lens at f/11 or a 35mm lens at f/16 will give depth of field extending from touching distance to infinity. And with good light and 100 ISO film, you can easily hand-hold a 35mm lens at f/16. Who says you need a tripod all the time?

In most cases, the easiest way to use the hyperfocal principle is by focusing manually. Some sophisticated autofocus cameras do have a 'hyperfocal' mode, but in many cases the name isn't strictly accurate and all the camera does is set a small aperture, which is what basic 'landscape programme' modes do anyway. Since you can't actually tell the camera what are the nearest and furthest things that you want in focus, these modes offer only rough control over depth of field.

Focusing manually is easier, and gives far more control. You can still leave exposure control to the camera if you wish. The best way to do this, if the camera offers it, is to use *aperture priority* mode, where you determine the aperture and the camera sets the shutter speed accordingly.

Using the hyperfocal principle can be disconcerting, since it means that distant things, which may be an important part of the scene, won't appear totally sharp in the viewfinder. The point is that they will appear sharp in the final picture, and so will the foreground. ◀

Limiting depth of field

You might conclude that longer lenses, with their more limited depth of field, are less suitable for landscape work, or that you need to stop them down to f/22 every single time. However, you don't always want everything in focus.

It's worth remembering why we said that landscape shots need good depth of field. It's to match the way that we see broader views, which gives the impression that everything is in focus. On the other hand, looking at landscape can also engage the 'mental zoom lens'. Small slices of a distant scene, or single prominent objects, can engage our attention. Long lenses help us to take photos which correspond to what we see in this way.

The selective nature of the 'mental zoom lens' means that the limited depth of field of the long lens isn't necessarily a problem. In fact, being able to isolate the subject by throwing everything else more or less out of focus can be a godsend for this kind of shot.

LIGHT AND THE LANDSCAPE

Lighting is important in every photograph, but never more so than with landscape. Visit a favourite location at different

times of day and observe how the light changes. Dedicated landscape photographers plan their outings around the light. When photography is only one part of your outdoor activity, you can't always do this, but you can sometimes factor it in. You could do a particular route clockwise rather than anti-clockwise, or start early or stay out late (which is also a good way of getting the hills to yourself).

Landscape photographers work unsocial hours compared to their counterparts in the portrait business. The received wisdom is that early morning and late evening are the best, if not the only, times for landscape photography. Low-angled light at the ends of the day picks out much more of the form and texture of the landscape. The colours are often much more interesting, too. The lower the sun, the more its light shifts towards orange or red, while shadows are lit by the deepening blue sky. This creates strong contrasts of colour which can add vibrancy even to relatively mundane scenes.

Some books would suggest that you might as well pack your camera away while the sun is high. This is all very well for the dedicated landscape photographer, but it's not much help if you're on a walk or a trek, when you may have no choice but to pass some of the best spots in the middle of the day.

Fortunately, this is sometimes the best time. Deep valleys and forest clearings may only get sun for an hour or two

Although the sun is high, strong outlines and colours still make this shot attractive. (Rum and Skye from the beach at Gallanach, Isle of Muck)

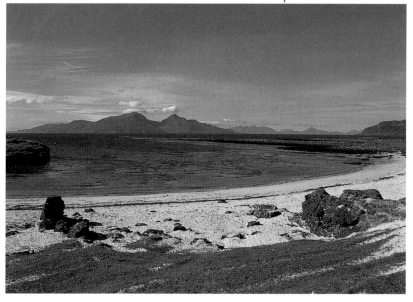

around midday. A west-facing crag or mountain slope will catch the light at an oblique angle from around midday; the evening light, though warmer in colour, will hit it face on, which tends to flatten details and structure.

This whole discussion tends to assume that there's uninterrupted sunshine. As any outdoor activist knows, this is not always the case! Broken cloud can create fast-changing and dramatic light. Even on the dullest days there can be occasional shafts of sunlight. These dynamic effects can come and go very quickly. Sometimes landscape photography feels more like action photography.

If you limit yourself to dawn and dusk, all your shots may end up looking like 'A Landscape Photograph'. This is fine if your sole aim is to do well in landscape photography competitions, but (apart from possibly getting a little boring after a while) doesn't do a great job of reflecting your wider experience of the outdoors.

If you're there and it looks good, why not shoot it? Lighting conditions should never stop you taking a shot, but they will certainly affect how you take it.

Natural light

In practical terms, there is only one significant source of natural light: the sun. Moonlight, after all, is reflected sunlight. The only other forms of natural light you're ever likely to be concerned with are lightning and firelight, both

Warm evening light certainly helps this shot, but the sun's almost behind the camera and the shot would be relatively flat without the cloud-shadows which help to pick out the intermediate ridges. The clouds and their shadows were moving quite quickly and other shots taken around the same time were less effective. (Helvellyn range from Low Scawdel, Borrowdale, Lake District)

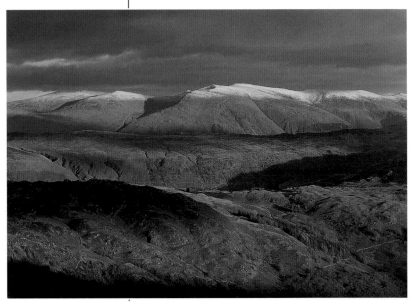

Sunlight and shadow add complexity, and the contrast is very high. Some of the shadows are impenetrable, while sunlit areas are burnt out.
(Near Coniston Water, Lake District)

A passing cloud transforms everything; the contrast is within manageable limits, and the whole thing is clearer.
(Near Coniston Water, Lake District)

of which can make great shots on occasion. But for at least 99% of landscape shots, the sun is the light source.

The sun itself doesn't vary much, but sunlight is interesting and immensely variable because of what happens to it in the last stages of its 150-million-km journey to the surface of the Earth. It gets filtered, diffused, refracted and reflected in an endless variety of ways. One of the rewards of photography is that it can lead to a much greater appreciation of light itself.

It is easy to see the different quality of light between a bright sunny day and an overcast one. Under direct sunlight we see strong shadows, but they are never completely black: even a cloudless blue sky throws some light into the shadows. Our eyes adapt constantly, allowing us to see detail in both brighter and darker areas.

However, the difference in brightness between sunlight and shadow can sometimes be too great for film to cope with. In the final picture the shadows may appear solid black, or the highlight areas totally burnt out and white. Both

can happen in the same shot! Sometimes this can create an effective picture, but often the result is harsh and unpleasant. Photographers refer to this as 'hard' or 'high contrast' lighting.

In the opposite scenario, with an even overcast sky, the entire sky effectively becomes one huge light. The light is gentler and shadows are barely noticeable, and this is called 'soft' or 'low contrast' lighting. This is much easier to manage when we want to see detail throughout a scene, but may produce pictures which seem flat or dull, or where the main subject doesn't really stand out from the background.

Soft light doesn't always lend itself to broad landscape views, unless there are very strong outline shapes involved, but can work beautifully with more intimate aspects. A flower meadow, full of strong shapes and colours, can become a hopeless visual muddle when strong sunlight throws criss-crossing shadows into the mix.

Soft light is much the same whichever direction you are facing. It's rare for light to be totally uniform, but it can be near enough to make little practical difference. The harder the light, however, the more your results will be affected by the angle you shoot at. You can't quickly change your angle of view to distant objects. If the light's 'wrong' for a distant peak, only time will change that. But you can change your viewing angle for nearer objects. Next time you're confronted with a strikingly shaped dead tree or highly textured rock, take a little time to walk right round it and see how the light changes on it.

- *With the **light directly behind** you, objects look relatively two-dimensional. There may be few shadows. When everything's illuminated, contrast is relatively low. This kind of light can allow you to concentrate on pure colours and shapes. Shadows can still appear – your own, for instance. This may or may not be welcome. If you're on a ridge, then the ridge itself may cast a shadow over the valley. Contrast can be much higher, especially when the sun's low*
- *Light **from the side** creates strong shadows, which emphasise the three-dimensional form of objects. As you move either side of a 90-degree angle to the sun, the balance of light and shadow shifts significantly*
- ***Shooting into the light** creates some of the most variable conditions of all. They can be tricky, challenging most metering systems, but they have the potential for some of the most exiting results you'll ever get*

Lighting really does make some shots. The slanting light picks out every fold of the ground and seems to illuminate every clump of vegetation individually. (Jebel Sahro, Morocco.)

Shooting directly into the light, especially when the sun itself is in the frame, creates extremes of contrast. Solid objects often turn into silhouettes. This is usually undesirable, as they don't usually look that way to the eye. Most metering systems are liable to give underexposed results. Switching to manual, using exposure compensation, or metering from a different area and then reframing, are all options to overcome this.

Shooting into the light. The contrast is extreme, turning the nearer headlands into silhouettes. But the intense brightness of the sea could have pulled the exposure down even further. A meter reading from the sky ensured a compromise exposure. (Looking towards South Uist from the Isle of Skye)

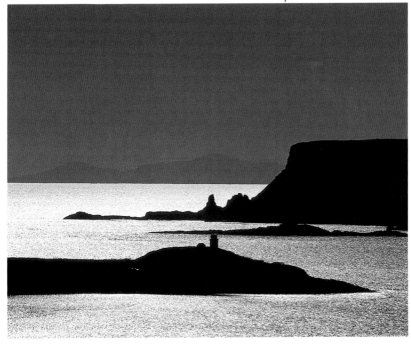

Shooting in hazy conditions

Haze lowers contrast to more manageable levels. Hazy conditions can be very dull for shots with the sun behind or to the side, and shooting into the light may be the photographic salvation of such days, especially when the sun gets lower.

However, the silhouette effect can work very well with some subjects. It's easier to tolerate smaller, broken areas of solid black than great blocky masses. It can work well with a leafless tree, less so with a mountain peak. With small (and close) subjects, a reflector or fill-in flash can turn a silhouette into a semi-silhouette. ◀

Shooting into the light also carries the risk of *lens flare*, or just 'flare'. This can take various forms but all result from reflections off various surfaces within the lens. One obvious form is a whole string of little coloured blobs, often hexagonal, lined up as if radiating out from the sun. This is often used in films and TV to emphasise how bright or hot the sun is. Almost invariably, when someone's struggling thirstily

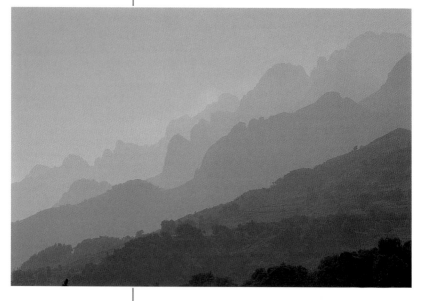

Shooting into the light can produce magical results on hazy days when things look impossibly flat in all other directions. (Eastern Massif of the Picos de Europa, Northern Spain)

across a desert there'll be flare-filled shots towards the sun. In digital imaging, you can get software which will actually add flare to your images! However, when you want your shots to reflect what you saw, flare is a distraction. You may see it in an SLR viewfinder but you won't with the naked eye.

If the sun's actually in the frame, there may be little you can do. It may disappear, or at least diminish, when the lens is stopped down. Otherwise you can only think about reframing the shot or hiding the sun behind some object such as a tree. Flare sometimes goes away if the sun is dead centre in the frame.

When the sun isn't in shot, you have more options. A good lens hood is an essential, but few lens hoods provide

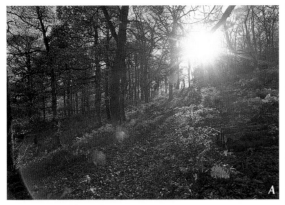

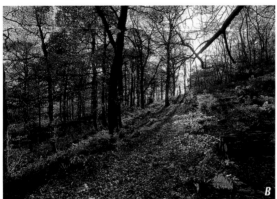

A – Shooting into the light carries the risk of flare.

B – A very small shift of camera position meant that the sun was masked by a branch, and transformed the shot.
(Near Thornthwaite, Lake District)

C Shooting into the light will stretch the metering systems of most compacts, especially when the sun is in the frame. The usual result is that apart from the sun itself, or very bright areas such as reflections on water, every-thing looks far too dark. A 'backlight' button or other form of exposure override can help, or you can try the usual trick of aiming the camera slightly away from the direct sun and then keeping half-pressure on the shutter while you reframe the shot.

With a compact, you can't see in the viewfinder whether flare is present. You may get flare in the finder when there's none in the lens itself, and vice versa; experience is your only guide. Shading the lens can help, but it's a matter of guesswork. If you know the angle of view of your lens then at least it can be informed guesswork.

as much protection as they should and it's especially diffi-cult with zoom lenses – you'd really need a zooming lens hood too. You can provide further shading with a piece of card, a map, or even your hand. This is easiest with the camera on a tripod; otherwise it requires one-handed shooting. If you've got someone with you, you can always ask them to help. They can actually see when the shadow of their hand or card falls across the front of the lens, while you check that the object itself isn't in shot.

Never look directly at the sun either with the naked eye or through the camera. ▶

The colour of light
Colour doesn't just belong to objects. Light itself changes colour. Sometimes it's easy to see, like the warm orange or red light of sunrise and sunset. You can even see different colours at the same time. Shadows aren't just darker than sunlit areas, they're also a different colour. If the sky's blue, so is the light in the shadow areas.

69

The reddened light of evening is often seen at its strongest on high mountains, where it is known as alpenglow. (Les Drus, Chamonix)

Other variations are subtler and less obvious to the eye. Under overcast conditions, the colour of the light is essentially uniform and the brain is easily tricked into seeing it as 'normal'. Film is not so readily fooled. Often, under such conditions, the light becomes distinctly cold (blue), which is generally perceived as unattractive, and this is what the film will see. It's very hard to assess such colour shifts just by looking, but you can make an educated guess.

Try and visualise what's happening above the clouds. When the sun is low, its light glances off the cloud tops and the light which comes down through them is mostly from the blue sky above. This light will be very cold indeed, as

Contrast: the shadows are almost completely without detail. A strong graduated filter would have been one answer, but finding a reflective patch of ice was another way of filling the 'hole'. (Vignemale from Oulettes de Gaube, French Pyrenees)

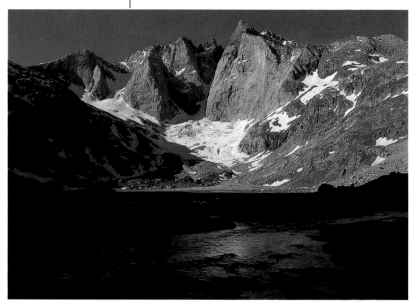

well as quite dim. If the sun is higher, more of its light diffuses down through the clouds and the light at ground level is both brighter and relatively warmer.

Sophisticated digital cameras offer the option to adjust 'white balance', which will compensate for the coldness. If you're shooting on negative film there's some scope for compensation at the printing (or reprinting!) stage. The problem is most acute when shooting on slide film, and the only answer is to use a 'warm-up' filter. These come in various strengths, but an 81B or 81C is a good compromise. 'Skylight' filters have a very slight warm-up effect but it's barely noticeable, and is not why we use them. ▶

This isn't to say that you can't shoot without a filter under overcast skies – of course you can. Just be aware that the result may look cooler, colour-wise, than the scene appeared at the time. It can still be effective – especially if you want to convey a mood of desolation. If your next shot is taken when the sun breaks through, the contrast between the two may help to underline the way the sun lifted your spirits.

Should you use a filter?
If in doubt, and the picture's important, take one shot with and one without the filter. Study the results afterwards, and with practice you will get better at assessing the probable colour of the light.

The question of contrast
We've already alluded to the problems posed by hard lighting conditions, which can create contrast beyond the range of any film. Digital sensors may do better, but still have their limits. The annoying thing is that such conditions are frequently very exciting for photography.

The first question is how to recognise high-contrast situations. Practice helps. Big differences in meter readings between different areas (more than three or four stops between sunlight and shadow) are a giveaway. If you need to take your sunglasses off when you go into the shade, that too suggests the light is hard.

There are a number of options for dealing with high contrast but all have their limitations.

Contrast: at high altitude there is less scattered light from the sky to lift the shadows. While the sunlit areas appear correctly exposed, the shadows are black and featureless. (Sim Gang, Karakoram Mountains, Pakistan)

The snow acts as a giant reflector providing fill-in light in the shadows. (Snow Lake, Karakoram Mountains, Pakistan)

- **Graduated filters**. You can get these in all sorts of hues, but a 'grey' (properly, Neutral Density) grad selectively darkens part of a scene without distorting colours. These are usually employed to lower the values of a bright sky relative to those in the foreground. A really strong sky, especially the very deep blue skies you get at high altitudes, won't need a graduated filter. A sunlit landscape with a blue sky should look pretty good without one. These filters are often more useful on overcast days, when the whole sky becomes the light source. If you have matrix metering, a reading with the filter in place should work well enough
- **Reflectors or fill-in-flash**. These throw extra light into dark areas, albeit with a very short range: they only work on foregrounds. A reflector lets you see the effect before you shoot: flash requires you to make some simple calculations or trust to automation
- **Reframing**. Sometimes you can just 'lose' a troublesome area by adjusting your viewpoint or shooting angle. This may be the best way of dealing with a large block of black shadow. If the sky's very much brighter than the foreground, it may appear virtually white in the picture. Try reframing with the horizon high in the frame

- **Biasing the exposure**. *Ultimately you may have to sacrifice something. If you have a strikingly shaped tree against a vivid sky, you might forget all about shadow detail and just let it record as a silhouette. On another occasion it may be the shadowed area that's most important, and you'll just have to accept that the background may be overexposed. In such cases you might also reframe to fill more of the frame with important stuff*

Extraordinary light

When the light's doing wild things, challenge and reward are at their greatest. Unless you're very confident with a light meter this may be the time to *bracket* your exposures, especially with slide film. This means taking two, three or even more shots with slightly different exposure settings. In manual mode this is easily done. In other modes you'll need to employ the exposure compensation or override feature. If the camera doesn't have one (are you sure? have you checked the instruction book?) you can imitate it by changing the film speed setting. Just remember to change it back again afterwards! Some cameras have an auto-bracketing feature, which automates the whole process.

Extremely bright areas, even small ones, tend to over-influence the exposure, even with matrix meters. An obvious example is when the sun itself is in frame, or when its light

Contrast. The exposure was biased towards the distant cloud, which retains rich colour. The trees become virtual silhouettes but with their strong and open shapes this is not a problem. (Nadi, Viti Levu, Fiji)

is glaring off water. Everything else in the shot looks darker than you wanted – it's underexposed – and so you need to give more exposure. In manual, widen the aperture or lengthen the shutter speed. In other modes, select exposure compensation with a plus figure. Alternatively, set a slower film speed than the one you're actually using.

Small dark areas, even when totally black, don't have the same tendency to pull the exposure out of kilter. Large dark areas obviously will influence the meter. In this case the question is whether you want them to look dark, or not. When the dark areas dominate the frame, the meter will tend towards an average result. This isn't always what you want. For instance, a shaft of sunlight may create a small patch of glowing colour surrounded by gloom. To preserve this effect it's important to keep the dark areas relatively dark. In this case you need to give the scene less exposure than the meter is likely to suggest. Use minus exposure compensation, or set a faster film speed.

Lightning is like flash, but on a much larger scale, and beyond your control. All you can do is point the camera in the right direction and hope to catch a burst while the shutter's open. In daytime, even under storm clouds, you can't keep the shutter open for more than a fraction of a second, so the chances of catching a flash are tiny. The odds improve at night, and of course the lightning flash will stand out much more anyway.

Use manual mode; no known form of automation will give the desired result. Set a fairly small aperture. With ISO 100 film try f/8 for distant lightning, f/11 if it's closer. Set the shutter speed dial to B and hold the shutter open until one or two flashes have occurred in the right area. If the storm goes on, vary the aperture and try holding the shutter open even longer, letting a whole series record themselves on film. The camera needs to be very firmly supported. A cable release helps to keep the shutter open without joggling the camera. This method also works for fireworks displays. A full minute is not too long a time, provided the sky is really dark.

Fire can also give stunning pictures. Again, in bright daylight the flames may be barely visible and it's better to wait until dusk or dark – but not if it's a serious forest fire! As the daylight fades and the fire begins to look brighter you can start shooting. At dusk, auto-exposure may work well enough, though it could make the scene look bright as day; a little minus compensation may be in order. When it gets really dark, the fire itself becomes the main source of light. The illuminated area will be small and the light levels low. To get a shot of the campsite by firelight will require a very

long exposure and the fire itself will certainly 'burn out', appearing as a vague white area. There's not much you can do about this, except perhaps hide the fire itself from direct view of the lens.

Rainbows seem magical but are actually quite predictable. We all know that they appear when there's both sun and rain. Fewer people realise that we can also predict where to look: a rainbow is centred around the antisolar point, which simply means the point exactly opposite the sun. If you're looking for rainbows, you need the sun behind you.

Further, a rainbow has a radius of 42 degrees, which probably won't surprise readers of *The Hitch-Hiker's Guide to the Galaxy*. Two things follow from this.

- *If the sun is more than 42 degrees above the horizon, the rainbow will be entirely below horizon level and you won't see anything unless you are on an elevated place. The lower the sun, the higher the rainbow*
- *A complete (semicircular) rainbow will fill the field of view of a 18 to 20mm lens. Unless it's very intense, it may look disappointingly thin and weak. If it is really intense, there will probably be a secondary bow, but this is even wider and you'll need a 15mm lens to fit it all in. Usually you will want to use a normal or tele-photo lens and concentrate on a section of the arc*

Rainbows appear to move when you do, so you can put them where you want them. The rainbow could easily fade before the ferry reached the right position, so I ran along the beach to line them up.
(Quadra Island, British Columbia, Canada)

EQUIPMENT FOR LANDSCAPE PHOTOGRAPHY

We've already noted that an ordinary camera and an ordinary lens will serve. If you're travelling light they'll probably have to. The specialist landscape photographer may carry large, heavy cameras and tripods – or employ porters! – but this is hardly feasible for most people.

So what else do you need? If landscape is your main priority, then slow film is definitely recommended to do full justice to colours, textures and fine details. You might consider one or two of filters discussed. A longer lens may be useful to isolate small or distant features, but remember that many can be picked out simply by walking closer to them.

And that's about it, except for one thing. Slow film for quality and small apertures for depth of field means using slow shutter speeds much of the time. This inevitably points to the need for some form of camera support.

Keeping it steady

Tripods and landscape go together like granary bread and mature Cheddar: very well indeed, but not inseparably.

One reason for using a tripod is to ensure that the camera stays really still. Occasionally you may want to move the camera during a shot (see Chapter 4), but this is (a) exceptional and (b) something you should do deliberately. Unintended movement of the camera results in blurred pictures. Sometimes the effect can be quite obvious, but often it just means that the shot isn't quite as sharp as it should be. ◀

Just the way you hold the camera really counts. This applies especially when long lenses are in use, but it makes

It's not essential...
The rule 'always use a tripod' is neither necessary nor practical. A monopod is a practical alternative, but if even that's too much weight or hassle, there are still many strategies for improving stability.

Keeping it steady: the lens is supported by the left hand and a handy rock provides extra solidity. (Pat Cossey, Biafo glacier, Karakoram Mountains, Pakistan)

sense to get in the habit of always holding the camera properly. It may feel awkward if you're used to doing it differently, but with a little familiarisation it will soon become second nature.

Virtually every camera is designed to be used right-handed. There's no great dexterity required from either hand, but some people would feel much happier if they could use their left eye. This is possible, but your nose does get in the way, forcing you into a somewhat twisted position. If you can manage right-eyed, you'll probably find it easier once you get used to it.

The left hand should be underneath the lens, palm up, thumb forward. This gives maximum support to the lens, and lets you reach zoom, focusing and aperture rings easily. You should be able to reach all three without major readjustments to your grip. The right hand grips the right side of the camera body, with the index finger over the shutter release, and the other main controls easily at hand. On a traditional camera this just means the shutter speed dial, but more modern designs may have one or two 'input dials' which control various functions. In any case, they should be operable without major readjustments to your grip.

With an SLR, the pentaprism surround above the viewfinder usually rests against the bony ridge above the eye, while the back of the camera is in contact with the nose. This all helps to keep the camera steady. It also helps to keep your elbows in at your sides. Do all this gently: gripping the camera too tightly, or clamping your arms to your sides, creates muscle tension, which is uncomfortable and can induce vibration.

Think about how to stabilise yourself in a variety of positions:

- *When standing, use a nice stable position with legs about shoulder-width apart*
- *If sitting or kneeling, you can brace one or both elbows against a knee for extra support. Shooting from a sitting position often allows you to use a shutter speed one notch slower than when standing*
- *Lying, with both elbows on the ground, turns your upper body into a kind of tripod, and this is even more stable*
- *Bracing against a tree, a wall or anything else at hand can be a huge help*
- *Summit trig points can provide a solid, level camera platform. Rucksacks, piles of stones: the possibilities are almost endless*

Details, like this wave-worn driftwood, can say as much as sweeping panoramas. A low viewpoint helps to emphasise the shape, but with many tripods it's hard to get down this low. In this case the shot was – very carefully – hand-held. (Rebecca Spit, Quadra Island, British Columbia, Canada)

Setting up the tripod
Using a tripod doesn't guarantee a shake-free shot. Too flimsy a tripod can be worse than careful hand-holding. Light tripod and heavy camera and/or lens is a recipe for disaster. Such a top-heavy combination is easily knocked or blown over, which can really spoil your day (and make you wish you'd thought about camera insurance). Almost any tripod will be less stable with its legs fully extended. Hanging your rucksack from the tripod may improve stability. Using a cable release or the camera's self-timer will reduce vibration.

The other reason for using a tripod is that it slows you down. That's no mistake. It's a good way to make yourself think – the antithesis of 'point and shoot'. If you have to unpack a tripod, you'll want to be sure the shot is worth taking, and then think carefully about how best to tackle it. You may not want to carry the extra weight, or have time to set up a tripod for every shot, but you can still do the thinking part. Thinking shouldn't slow you down noticeably, and it certainly doesn't weigh anything! ◀

FIGURES IN THE LANDSCAPE

Some people hate to see figures in a landscape shot. This even applies to pictures of intensely popular locations like the Lake District. But this smacks of wishful thinking, of photos that confirm a fantasy rather than express a reality. Figures can give a sense of scale and help the viewer identify with the feeling of being there. Sometimes a very tiny figure, seemingly almost incidental, can make a crucial

difference to the meaning of a shot. The question arises: when does landscape with figure(s) become figure(s) in the landscape? This is a highly subjective issue, and there's clearly more to it than just the sheer size of the figure(s).

As the figures become larger, the boundary between what's still primarily a landscape shot and an activity or action picture is increasingly blurred. This doesn't really matter most of the time, unless you want to enter a 'landscape' competition, or you're writing a book about photography and have to decide where best to mention certain points!

Where you place the figure in the frame is important, and becomes more so when the figure's relatively large. Placement alone can make all the difference between whether the viewer perceives the photograph as a landscape shot or a shot of the person or activity. If the figure's fairly central it's more likely to dominate than a same-sized figure near the edge of the frame. A central figure can 'block' the view beyond. For those 'summit view' shots it's generally best to have the figure(s) well to the side and probably looking towards the centre of the frame. If they're looking the other way the viewer will wonder what's out of shot that's more interesting!

When moving figures are involved, it's usually better if they're moving into the frame rather than out of it. Some pundits will tell you it's better if they're moving from left to right because this is the way we read, but this seems far from

Figures in the landscape: figures are often less obtrusive when they are obviously admiring the landscape themselves. (Froswick, Lake District)

convincing – after all, other cultures read from right to left. And in the real, outdoor world you can't always choose which way your participants will be moving. But it does help if they're looking around at the scenery rather than down at their feet.

FINAL THOUGHTS

A good photograph is not a good photograph because it conforms to the rule of thirds or any such formula. It is a good photograph because it makes its point clearly; because it tells the story you wanted it to tell. From time to time you probably see a picture that makes you go, 'Wow!' It's highly unlikely that this will ever be because that shot is a great example of the rule of thirds. In fact it's probably the last thing you'll think about.

It follows that the starting point for a 'wow' shot is not a rule, or technique, but a feeling. The starting point is a place that makes you go, 'Wow' or, for that matter, 'Ugh!' And if your photograph makes other people respond the same way, it's a success. In the end, which is the greater accolade to a photograph? 'What a great shot!' – or, simply, 'What a beautiful place'.

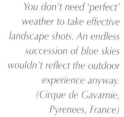

You don't need 'perfect' weather to take effective landscape shots. An endless succession of blue skies wouldn't reflect the outdoor experience anyway. (Cirque de Gavarnie, Pyrenees, France)

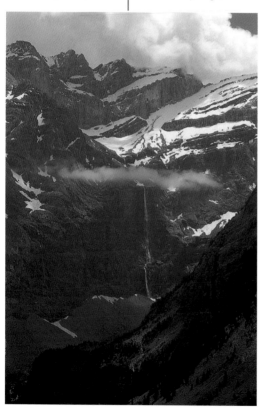

CHAPTER 4
Shooting action

Action photography may seem to be the preserve of highly skilled professionals armed with bagfuls of long lenses, but it ain't necessarily so. Test cricket, for example, may demand a lens as long as your arm (and costing an arm and a leg), but this is mostly because photographers aren't allowed on the pitch. As an outdoor activist you're actually part of the action. For most purposes we can (with apologies to the gear-freaks) forget about those huge lenses.

Action photography doesn't just mean sports photography. Fell-walking is not considered a sport per se, but it clearly involves action. Anything that moves can be the subject of an action photograph – people, animals and birds. It's also worth remembering that landscapes are full of movement: running water, breaking waves, trees swaying in the wind.

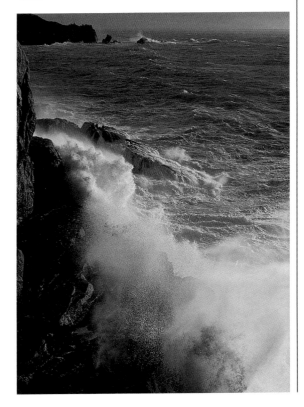

Movement in the landscape. (Sennen, Cornwall, looking to Land's End.)

So, how do you represent movement in a still photograph? It seems paradoxical – something that should not be possible – and yet it clearly is. Even though we get so much news and information from TV, many of the most enduring images of sporting and other events are stills. Action photography works.

Examples are easily found. Most outdoor enthusiasts collect books and magazines about their chosen field. The sports pages of the daily papers are another likely source. If you have a few books of landscape pictures, it's worth studying these too for examples that show movement.

It's clear that there's more than one way of conveying a sense of movement in photographs. Sometimes you can indicate movement with a degree of blurring; on other occasions you can totally freeze all action yet still give a strong sense of movement. It depends on what's going on. In a totally frozen shot of motor-racing, for example, you can't tell whether the car is doing 300kph or is parked.

With real sports this is rarely a problem. If you photograph a runner, posture alone tells us that they are running. The clinical detail of a totally frozen shot lets us appreciate the straining muscles, the agonised expression, the mouth gasping for air.

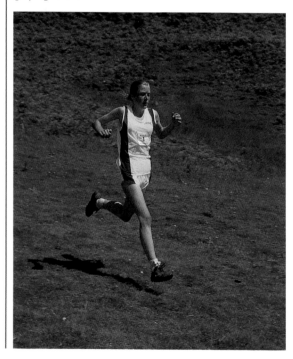

The action is frozen, but the shot still conveys a strong sense of movement. (Ambleside Sports fell-race, Lake District)

If sheer speed is what you want to suggest, as it might be with downhill skiing, a degree of controlled blur may be ideal. But of course you can take a frozen shot of a skier or a blurred shot of a runner and they can be equally effective.

EQUIPMENT FOR ACTION PHOTOGRAPHY

As already observed, long lenses aren't necessarily required. You can do a great deal with 'ordinary' focal lengths. It depends very much on the type of action you're shooting, something you'll have to assess in the light of the specific examples in this chapter and Chapter 6. Sometimes, of course, long lenses are useful, if not vital (see Chapter 5).

While long lenses aren't always needed, fast lenses are a real blessing. They make focusing easier, and allow you to exploit a wider range of shutter speeds.

It also helps greatly if your camera lets you control shutter speed. Direct control – through manual or shutter-priority modes – is best. In its absence some indirect control is usually possible. This is enhanced if the camera at least tells you what shutter speed it is setting (as many SLRs will when used in aperture-priority or programme modes).

A motor-drive or auto-winder is also extremely useful. Most new cameras do have a built-in winder. The main advantage is not the ability to fire away at five frames per second. This burns up film at a frightening rate, and shooting indiscriminately means you'll still miss the decisive moment. The great advantage of a winder is that you're ready for the next shot much sooner, and there's no need to remove your eye from the viewfinder. ▶

Getting to grips with action

When you photograph fast action, it's often hard enough just keeping the subject roughly centred in the viewfinder, without having to think about exposure or focusing too. This may suggest that you should rely on automation, but – though certainly a possibility – this doesn't necessarily follow. What it does suggest, above all, is thinking ahead. The more decisions you make in advance, the fewer distractions you'll have when the action's happening.

Life is easier, too, when you're photographing an activity you know and understand, giving you more chance to anticipate what your subject's about to do. A lot of action photography involves at least a modest element of 'setting-up'. When you're with a group of walkers, you may want to dash ahead to photograph them coming up a slope, or hang back to catch them outlined against the sky.

Should you use digital?
Many digital cameras are highly unsuitable for action photography, either because they lack a decent viewfinder (crippling), or because of extended shutter delay (fatal). However, the best ones, mainly SLR models, are highly capable.

The best shots can't always be left to chance; there's often an element of cooperation. This may simply mean asking someone to walk this side of a certain rock rather than the other, or to look in a particular direction. It may mean much more, like asking a climber to repeat a move several times. If your companions lose patience with repeated requests, you may have to scale down your ambitions – but you could point out that it would be a lot worse if you were shooting film or video!

Speed and movement

How do you represent movement in a still image? A prime factor is the speed of the movement, but it isn't just a question of absolute speed. It can be easier to get a sharp photo of an express train doing 300kph than of a cyclist doing 30. Because the cyclist is much smaller than the train, you need to be a lot closer to get a frame-filling image. This means that they can cross the frame much faster than the train does.

So it's *relative* speed that matters. We could call it *angular* speed, meaning the speed of movement across the frame of the image. The size of the subject, its distance, and the direction of movement are all significant. A subject moving directly towards or away from the camera is effectively slower than one that's moving across the field of view.

So how do you judge the angular speed? Partly it's just common sense. An extra clue is how hard you have to work to keep the subject centred in the viewfinder.

If angular speed is the main consideration on the subject side, the key control on the camera side is *shutter speed*. The interplay of these two factors determines how movement will look.

Because of this interplay, 'action' or 'high-speed' programme modes are crude tools at best. An 'action' programme aims to keep the shutter speed as fast as possible. Sometimes, however, the shutter speed set will be faster than necessary; a slower speed might freeze the movement and allow you to use a smaller aperture to improve depth of field. Conversely, if you actually want to see some blur, the selected speed will probably be far too fast.

With so much else going on, you probably won't feel like setting both shutter speed and aperture manually. Though it should be said that when the light level is consistent, you'll only need to make this decision once, and it will then be good for a whole series of shots.

However, if light levels are fluctuating, because there's broken cloud, or because your subject keeps moving from sunlight to shadow, it can be impossible to keep up with the

constantly changing exposures needed. One solution is just to 'hold fire': you could, for instance, only shoot when the subject is in the sun. This works with steady action, like a fell-runner toiling up a long slope. It's often best for pictorial reasons too. If you're photographing a cross-country skier on a Finnish forest trail, shooting when they hit a patch of sunlight will make them stand out against the shadowy surroundings.

Holding fire is less appropriate with episodic action. You can't ask a slalom canoeist to hang on a second, or repeat a particular gate, just because the sun went in at the wrong moment. You want to shoot at a precise moment, sun or no sun. In such cases most people will want some form of auto-mated exposure, to keep up with the fluctuating light.

Many SLR cameras offer a *shutter-priority* mode, usually indicated by an 'S' on the control dial. In shutter-priority you select the shutter speed and the camera sets the aperture accordingly. This is your best bet to ensure satisfactory expo-sure while remaining in charge of the crucial variable.

This isn't just a question of congratulating yourself for being more creative. It means you can actually experiment and learn something – provided you remember, or keep a note of, the shutter speed you used for a series of shots. If you like the results you'll be able to do the same again. If you don't like the results, you'll know that you need to do something different next time – and you'll have a good idea whether you need a faster shutter speed or a slower one. ▶

Movement and shutter speed
What is the 'right' shutter speed? There's no simple answer: it depends on a number of factors. However, if you regularly

C While many SLRs give you the option of using shutter-priority mode, very few compacts do. If you're lucky there'll be an 'action programme'. This should give you a sporting chance of freezing most action, most of the time. Shutters in compacts don't usually run to such high speeds as SLRs anyway, so they'll still struggle with really fast movement. Action photography is one of those areas where compact cameras just can't match the versatility and flexibility of the SLR.

However, it's not all bad news. Many outdoor pursuits are relatively slow-moving anyway. Climbing is a good example. Climbing photography has its difficulties, but freezing movement isn't chief among them. Light weight and the possibility of one-handed operation also makes a compact an attractive choice for climbing.

A shutter-speed of 1/500th sec. freezes the movement in this waterfall. (Val Marcadau, French Pyrenees)

photograph one particular activity, you will quickly be able to work out what works for the type of shots you want to take. Practice really counts. Studying the images in this chapter, and in photo magazines – which usually give shutter speed information – will help you work out where to start

Here are a few hints to get you going:

- *1/1000th sec will freeze most movement in a wide range of general action shots. It won't be fast enough for real high-speed events like downhill skiing, or for close-range shots of very fast movements, be they the feet of a fast-pedalling cyclist or the wings of birds approaching your bird table*
- *1/125th sec is quite adequate for slower movements, like people strolling*
- *By the time you get down to 1/30th sec, most movement will show obvious blurring*
- *A really long exposure, a full second or more, can mean that moving subjects virtually disappear. A lot of early (mid 19th century) photographs make streets look deserted, not because towns were empty but because exposures lasted minutes or hours*

Movement in the landscape: a 10-second exposure gives this waterfall an almost misty look. (Scaleber Force, Yorkshire)

Many people love those shots of waterfalls where the water looks more like mist. To get this effect you'll need an exposure of several seconds at least. Use slow film – and be

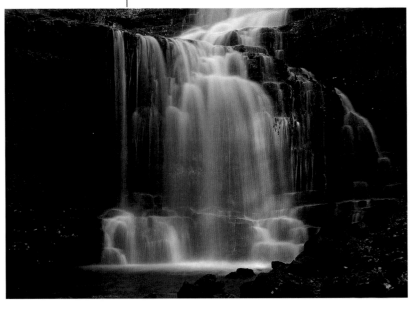

thankful so many waterfalls are in shady spots! An exposure measured in hours will record the movement of stars across the night sky.

This is just the beginning, and there's no substitute for practice and experimentation. If you have to photograph an unfamiliar sort of action, look for points of comparison with familiar ones – and, just as you might bracket exposures in tricky lighting, be prepared to bracket shutter speeds. ▶

Focus questions

Automatic exposure, especially shutter-priority mode, is extremely useful for action photography. You might assume that autofocus would also be a godsend, but it's not that simple.

How does the camera know what you want it to focus on? The vast majority of compacts, and most SLRs, will simply focus on whatever is in the centre of the frame. While this is frequently dead wrong for landscapes, it may seem a better bet for action shots. But just imagine that your shot is of two runners battling up a hill. The centre of the frame may be a patch of sky or distant hillside between them. If the camera focuses on that your two subjects will be seriously out of focus.

Be prepared

If you're going to photograph a one-off event it's especially helpful to have things worked out in advance. If it's a fell-race, try a few practice shots of runners a week or two ahead. But remember that on downhill sections fell-runners can be travelling faster than any sprinter, while on steep uphills most will only manage walking pace. The uphills may also be a good place to shoot as you'll get lots of agonised expressions!

Minimal depth of field means that only the rider's face is sharp. A central focusing sensor would have focused on his armpit. This shot was pre-focused. (Prutour cycle race, Trough of Bowland, Lancashire)

Frame-filling shots of a single figure mean either shooting from close range, or using a long lens. Either way there probably won't be enough depth of field to keep every part of the figure in focus. People usually look very odd if the face isn't in focus, but it's rare for the face to be exactly in the centre of the shot.

Manual focusing isn't always easy, especially with fast action, but it will improve with practice. An autofocus camera, on the other hand, is never going to get any better.

Three things make manual focusing easier:

- *A good, bright, clear viewfinder. Some viewfinders have central split-screens and/or micro-prisms, which are supposed to assist precision focusing, but these are rare in cameras intended primarily for autofocus. They're little help if the reason you switched off autofocus was to focus on an off-centre subject. If the viewfinder's good enough you should be able to focus on the plain screen*
- *A fast lens. This makes the viewfinder image brighter, which helps focusing anyway. It also gives minimal depth of field, so the image snaps in and out of focus much more obviously*
- *Familiarity with your equipment. Do you know, without thinking about it, which way to turn the ring to focus closer?*

It's also easier when the action's not too fast, and when it's predictable. The better you know the activity, and the more communication you have with the participants, the more predictable it gets.

Film speed

Fast shutter speeds suggest faster film. However, just as there's no advantage in using a faster shutter speed than needed to stop the action, there's little to be gained by using a faster film than you really need. It only means that film grain will be coarser and colours less vivid. In good light, 100 ISO film allows you to shoot at 1/1000th sec at f/5.6 – fast enough for most needs. An f/2.8 lens means you can go up to 1/4000th sec in good light, and keep shooting at 1/1000th even when it gets a bit dull.

If you're out in the field, you only have ISO 100 film, and the light deteriorates so you can no longer use a fast shutter speed, what do you do? Pack up and go home? Not necessarily: you could accept that there'll be a degree of blur in your shots from now on, and try and use it positively.

Or you could, if your subject's fairly close, start using flash.

Or you can *push* the film. If you're loaded with ISO 100 you can reset your meter to 400 and then ask the lab to do a 'two-stop push'. This is modified processing which has the effect of increasing film sensitivity. It usually costs a bit extra, but if you want those shots, it's probably worth it. The quality you'll get from a 100 ISO film pushed to 400 is little inferior to that of a straight 400 film.

High Street one-hour photo labs will probably be baffled by such a request. The need is less acute with print films anyway: you will often get a passable, if not brilliant, print from a negative that's been underexposed by two stops. But when a whole roll of film has been underexposed, accidentally or deliberately, it's worth finding a professional lab to push-process it for you.

With slide films you can't get away with two stops, or even one stop, underexposure, so push-processing is much more useful. If you bought the film process-paid you may still be able to get it pushed when you send it back, perhaps for a small extra charge. If you take it to your local professional lab you'll have to pay the full processing charge, and maybe a bit extra for the push.

As the exposed films will look the same when you get home, make sure you can identify any rolls you want push-processed. This may just mean putting them in a different pocket. If you know in advance that you may want to push the film, you can come prepared with labels. ▶

Digital considerations
You can't change film speed in mid-roll. Digital cameras have an advantage here, in that you can change the sensitivity – the equivalent to film-speed – at any time. Many digital cameras, especially the better ones, have a sensitivity range up to the equivalent of ISO 800 or faster. The image produced at the highest setting usually shows slightly flatter colours and a bit more 'noise', nicely matching the results from faster films.

TECHNIQUES FOR ACTION PHOTOGRAPHY

It's all about movement, but there's more than one kind:

- Movement of the **subject** is generally considered a good thing – after all, it's what action photography is all about
- Movement of the **camera** is generally not such a good thing

However, there are circumstances in which controlled camera movement can be used to great effect. The key word, of course, is 'controlled'.

Tricks of the trade
There are various techniques, all worth exploring. 'Exploring' can mean going out and shooting off loads of film in a frenzy of experimentation. This can be great fun, as well as instructive, if you can afford it. But 'exploring' can also mean

studying action shots in books or magazines and trying to work out what techniques were used, which results you like and which you might try to emulate.

Follow-focus. The name is fairly self-explanatory. This is probably the hardest technique to master, though it's easier with most outdoor pursuits than with games like football – it is at least possible to predict the direction of movement! Obvious examples would be walkers, cyclists or skiers on a trail, or a climber working up a crack.

Both speed and direction of movement are significant. A subject moving across the field of view is at a more constant distance, requiring much less adjustment of focus. Follow-focus is much harder with subjects coming straight at you.

Follow-focus calls for speed, and autofocus is faster than manual. However, it isn't necessarily more accurate – unless you're sure it's focusing on exactly the point that you want it to. ◀

C Follow-focus with a compact is subject to all the limitations of autofocus, made worse because most compacts' autofocus systems aren't as fast as good SLRs. All you can do is try and keep the subject centred, and live in hope, but don't expect miracles.

*You don't always need long lenses: this shot was taken with a 35mm lens. Pre-focusing still helped, and a touch of fill-in flash mellowed the hard shadows. This shot would be perfectly possible with a compact.
(Bernie Carter, Gisburn Forest, Lancashire)*

Pre-focusing. For the average mortal this is a much safer bet: you focus on a particular spot and wait for the subject to reach it. You can do this with an autofocus system, if there's a focus lock – or, often, just by maintaining half-pressure on the shutter release. Quite frankly, though, this is definitely one instance where manual focusing is easier.

Strictly speaking, especially where depth of field is minimal, you have to press the button just a fraction of a second beforehand: there is a tiny delay in the camera itself, but a more significant one due to the limits of human reflexes. In practice it is easier to master this anticipation than to master follow-focus.

Pre-focusing goes hand-in-hand with planning the framing of your shot, and anticipating crucial moments, such as a fell-runner leaping over a stream, or a slalom canoeist negotiating a tricky gate. ▸

Peak of the action. Think of a pole-vaulter clearing the bar: there is an instant of apparent stillness before the inevitable descent. This allows you both to pre-focus and to use a relatively moderate shutter speed. Examples aren't quite so obvious in the outdoors, but there are a few, such as a mountain biker taking off over a bump, or a windsurfer getting flipped when the wind gets under the board.

Together or separately, peak of the action and pre-focusing both require a degree of anticipation, always easier with activities you know something about. With both techniques you can think in terms of single shots, rather than blasting away with the motor-drive. ▸

Panning and blur-panning. Panning is the classic exception to the convention of keeping the camera still. The aim is to follow a moving subject so that it remains basically sharp, while the background becomes blurred by the movement of the camera. This is easiest when the subject is moving across your field of view, at a roughly constant distance from the camera. It's also easier if you aren't too close, so you don't have to pan too fast. With human-sized subjects, a moderate telephoto between 100 and 200mm usually works best.

With panned shots, you can use much slower shutter speeds. Exact results still depend on the speed of the subject, length of the lens, and so forth: some experimentation is needed. A good starting point is 1/30th or 1/60th sec. Smooth panning is easier if you use a monopod or tripod, but it's perfectly possible to hand-hold. The important skill is to maintain a smooth swinging motion before, during and after the exposure. As far as possible, hold the

C How do you pre-focus with a compact, when you can't switch off autofocus? Some compacts will allow you to lock focus on a particular point by maintaining half-pressure on the shutter release. Check the instruction book. Since you can't see the subject come into focus in the viewfinder as you can with an SLR, pick a clear reference point, such as a bump in a trail. Shoot when the subject reaches this point. This method also allows you to reframe the shot with the subject off-centre.

C The relative stillness that occurs at the peak of the action gives the autofocus systems of the average compact much more of a chance. If you are using a compact it's definitely worth looking for these moments; they could give you your best chance of getting some really strong shots.

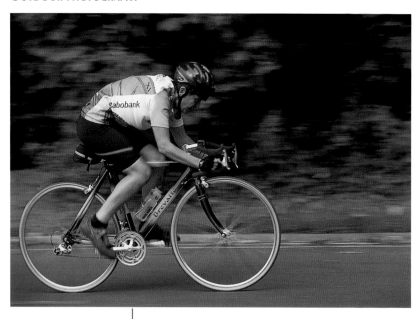

Panning. The shutter-speed was 1/80th sec. and the rider was travelling at about 25 kph. Note the blurring of spokes, feet and legs.

C You certainly can try panning with a compact camera, especially one with a zoom lens. With no direct control of shutter speed, try 'landscape' mode if there is one, which should set a relatively slow shutter speed. 'Action' modes will set a much faster one, which rather defeats the object of panning.

camera normally, and make the panning movement from waist and hips. This helps to keep it smooth, and avoids unwanted jiggling up and down.

Sometimes there's a tendency to stop panning when you press the shutter, especially on an SLR where the image blanks out momentarily. This is why the 'follow-through' is important. ◀

Blur-panning is a further refinement. It means that parts of the subject are blurred, not just the background. A cyclist's head and torso, and the bike frame, may look sharp, while feet and spokes are blurred by their rotary movement. When you think about it, most panned shots will actually be blur-pan to some degree. Even when a cyclist is freewheeling the wheels still rotate. One case where you might get a 'pure' panning shot is of a skier on a gliding section, holding a very stable body position.

Runners display much more upper-body movement than cyclists, so you'll get more general blur even at moderate shutter speeds.

The slower the shutter speed, the harder it is to pan smoothly, and the more benefit you'll get from a monopod or tripod. With a tripod, by locking all the other controls but leaving the pan-head slack, you can get a very smooth horizontal panning movement. Here you may find it easier to keep your eye away from the camera – like shooting a pistol rather than a rifle.

Just a blur. You can also use slow shutter speeds without panning. If you lock the camera on a tripod then stationary elements stand out clearly in contrast to blurred movement: grasses waving in the wind against a wall, for instance.

Or you can go wild and hand-hold at 1/8th sec and see everything start to blur. This is an unpredictable technique, and all too often the results are just a mishmash. However, it can be used to great effect. It will probably take a lot of trial and a great deal of error before you start to get even vaguely consistent results, but if it appeals and you can afford the film, go for it.

So how can you distinguish a blurred subject from a blurred background? Sometimes, as with blur-pan, they may be blurred in different ways. Even so you probably need some other form of contrast between them, such as a clear difference in colour, or if the subject's in sunlight and the background's in shadow. Think about this beforehand, as it may determine where you shoot from. ▶

C With a compact, it's unlikely that you'll be able to set a low enough shutter speed to get really blurred results. You can try, by using the slowest film you can get your hands on, but many compacts will automatically switch over to flash mode when they think the light is poor, and you may not be able to override this.

Pure blur. The camera was hand-held while walking, at a shutter-speed of 1/4 sec. Contrasting colours ensure that the figure still stands out against the background.

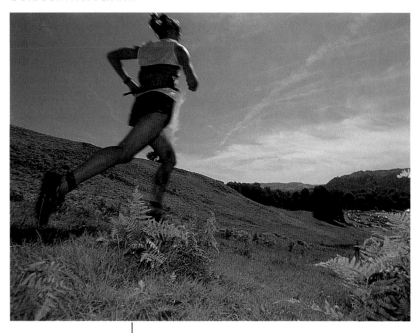

Mixed flash and daylight The image of the runner is part-blurred, part-sharp. The low viewpoint helps her stand out against the sky, but means that the flash has illuminated some nearby bracken. (Ambleside Sports fell-race, Lake District)

C If your compact has a 'fill-flash' mode, try this. It may work surprisingly well. But get close to the action. The flash simply won't have the power to reach more than a few metres.

Blurred and sharp. This is not as paradoxical as it sounds. By mixing a slowish shutter speed with a burst of flash you can have both a sharp image and a hint of motion-blur. Because flash has a limited range, you'll need to get fairly close to your subject. It's more than usually important to ensure that your subject knows what you're doing, and doesn't object. An unexpected flash at close quarters could be extremely annoying, not to say painful, for a climber making a hard move!

You may want slower film for this, unless you try it when the light deteriorates, as you'll want a slowish shutter speed and a medium aperture (try it at f/22 and the flash will have a very limited range!). Some cameras automatically set 1/60th or so when you attach a flash so look for an override, probably called a slow-sync setting, or go to manual mode. What's called *rear-curtain synchronisation* is a further refinement which can give more natural-looking results if available: check the instruction book to find out.

Automatic exposure systems often handle mixed flash and daylight very well. Even built-in flash can give decent results at close quarters. With a separate flash gun, full automation is only possible if it's 'dedicated', allowing through the lens flash metering. With a more basic gun, or a manual-only camera, you'll need to supply a bit more input (see Appendix I). ◀

Test cases: a couple of examples

Climbing is an activity where movement is relatively slow, most of the time. Many climbing photos are basically static, yet still effective and impressive. Perhaps what such shots convey isn't movement at all, but poise. But even on easy climbs there are moments that are more dynamic, while individual hand movements, like snatching for a hold, can be extremely fast. On harder routes, especially overhanging ones, the climber frequently has only one, or possibly no, points of contact. Even if every detail is frozen, these poses naturally look dynamic. Timing clearly counts, for both climber and photographer.

If you're a climber, too (and even more if you know the route), you'll usually have a shrewd idea where your subject is going next. This helps you to anticipate moves that will

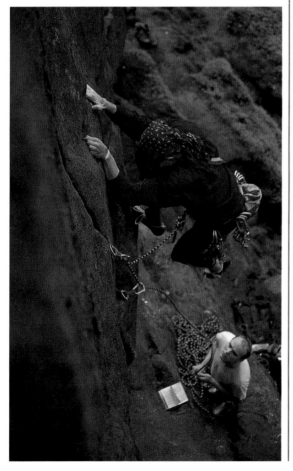

Many climbing photos are quite static, but dynamic moves can occur even on relatively easy climbs. Depth of field is slender, concentrated on hands and head. The feet are distinctly unsharp.
(Jonathan Westaway, Pickpocket (VS), Rylstone, Yorkshire)

Although the climber is the ostensible subject of this shot, the main action is really below! The framing gives the wild sea plenty of room.
(Matt Treml, Ochre Slab (Severe), Bosigran, Cornwall)

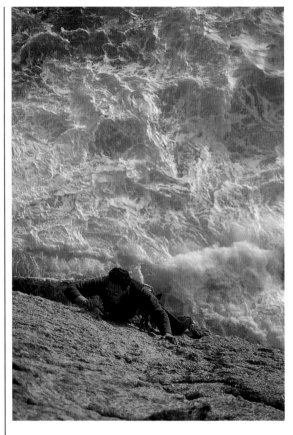

make good shots. Although movement is relatively slow, it can seem fast enough with a frame-filling climber coming directly towards you. Pre-focusing can still be helpful.

Of course the unpredictable can still happen. Falling off implies rapid acceleration! ◀

C Because movement in climbing is mostly relatively slow, compacts can work very well here. Being able to shoot one-handed is often helpful, too. But using a compact doesn't mean falling back into 'point and shoot' mentality. It's possibly more, not less, vital to think about your shots. To ensure that the camera focuses on the climber, make sure to keep them centred in the frame.

Cycling involves much higher speeds, especially on the road and in downhill mountain biking. Panning, rarely (if ever) used for climbing shots, comes into its own, especially to give a sensation of speed. However, blurring the background does mean you give a less clear impression of where the shot has been taken.

When shooting riders coming towards you, pre-focusing is very effective. On a bumpy MTB downhill you can pre-focus at a spot where riders may leave the ground, and combine pre-focusing with 'peak of the action'.

If you look at cycling magazines you'll also see a lot of pictures which mix flash with daylight for a 'blurred-sharp' effect. At high speeds, to keep the blur within limits, a

relatively fast shutter speed is still needed, but not all cameras allow flash-synchronisation at 1/125 or 1/250 sec. ▶

There's more about these sports, and others, in Chapter 6.

FINAL THOUGHTS

Action photography can be a demanding and highly skilled area, but it's not always that hard. We've referred to filling the frame, but you don't always have to. A really tight shot of a climber may tell you a lot about that individual, and about one particular move, but give very little indication of how big the crag is or what the surroundings are like. If you pull back a little, you usually get much more sense of

C It's going to be tough to get great shots of fast cycling action with a compact. Panning shots are probably your best bet for a real sense of speed. Otherwise, look for moments when the action slows down, such as the top of a steep climb (assuming you can get there ahead of everyone else!).

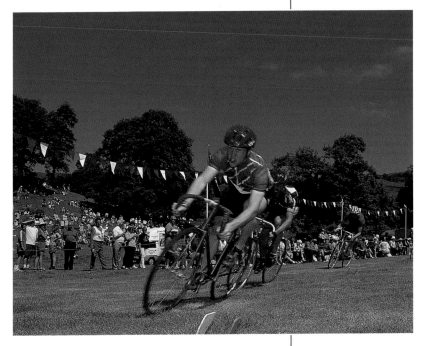

where things are happening, and in outdoor pursuits that's always part of the story. Pulling back, making the figure less dominant in the frame, reduces angular speed. This gives you more leeway, both over focusing and depth of field, and over shutter speed.

In the landscape chapter we asked the question, 'When does landscape with figure become figure with landscape?' Now the question is inverted. When does pure action become action with background, and when does that become just an incidental part of the scene?

With a wide-angle lens you can get really close to the action. Flash was used mainly for fill-in but does help to give a sharper image of the leading rider. (Grass-track cycle racing at Ambleside Sports, Lake District)

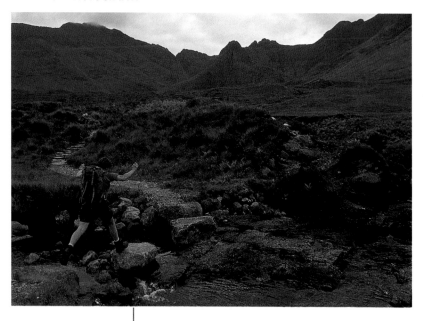

Timing. There was nothing very difficult about catching the figure in mid-leap. The movement was easy to anticipate. The relatively small size of the figure made it possible to freeze the movement at 1/250 sec. Off-centre position and movement into the frame invite the viewer to follow. (Allt Coir a' Mhadaidh, Cuillin Hills, Skye)

There is no simple answer, and most of the time it doesn't matter. It's up to you to decide what sort of shot you want to take. The distinction between landscape and action is helpful in focusing attention on different approaches and techniques, which makes life easier for people who write books, but ultimately there is no clear dividing line.

CHAPTER 5
Shooting wildlife and close-ups

Outdoor folk enjoy far more encounters with wildlife than their unenlightened brethren. For most of us, it's a big part of the appeal of the outdoors.

Many of these encounters are very fleeting. We've all missed seeing something through being a few strides behind a companion at the time, or because we'd glanced in the wrong direction. You can't eliminate the element of luck, but you can be prepared.

Soaring gannet. The bird was riding an updraught just out from the cliff edge, virtually hovering. A fast shutter speed was still required and with little depth of field, focus is on the head. With a wingspan of almost two metres, this is Britain's largest seabird species. A 200mm lens was adequate for this shot. (Hermaness, Unst, Shetland Islands)

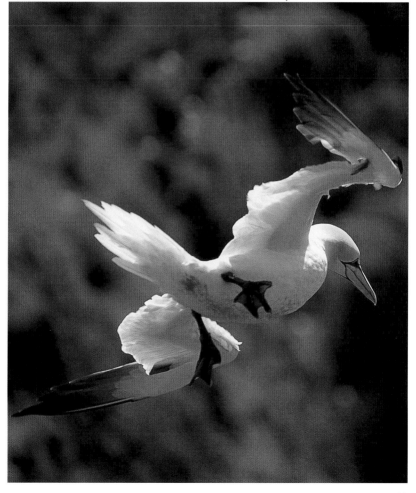

Even close encounters often aren't that close. Being prepared means having a long lens fitted to the camera and ready to hand. This may be all right for short periods, if there's a really good chance of a sighting at a particular spot, but most people won't want to walk all day with a camera and hefty lens round their neck or slung at their hip. Still less run, climb or cycle.

If the long lens isn't ready when that snow leopard finally appears, what do you do? Start digging around in your rucksack? For the professional, missing that shot might be a tragedy. For you, missing the encounter in the attempt to get a shot could be a worse one.

This might be an extreme example, but most of the shots you see – even of familiar British species – are taken by professionals, or dedicated amateurs, who are willing to hike all day with a 600mm lens on one shoulder, or to sit in a cramped hide from dawn till dusk, if that's what it takes.

Let's face it. Wildlife encounters are part and parcel of the outdoor experience, but they just aren't always going to translate into great photos. However, there are many other things which are much easier to photograph. Your shots still can reflect your feelings about the beauty of the natural world.

The diversity of a natural meadow is suggested by this shot. Selective focusing with a 200mm lens isolates just a few plants from what could have been a confusing mass (Gait Barrows National Nature Reserve, Cumbria)

Photographing wildlife can also involve profound ethical issues. The welfare of the animal or plant concerned, and of other creatures, is always more important than getting a particular shot. The meadow pipit is one of Britain's commonest birds, but it's still not acceptable to trample on its eggs, even for the sake of the best shot of a snowy owl ever taken.

Many species are protected by law. In the UK, there are over 80 species of birds (including those as familiar as the hen harrier) that may not be photographed at or near the nest without a special licence – even if you just happen across the nest on a walk or a climb.

There are easier subjects in wildlife. Puffins often seem totally unafraid of humans. It's even been suggested that they like having us around because we deter predators such as black-backed gulls and skuas. (It's still advisable to approach puffin colonies very carefully, possibly by crawling, because it's all too easy to put your foot through their nest-burrows.)

Many other species will sometimes approach closely, especially if you sit quietly and are patient. Maybe the time to fit the long lens is when you stop for a rest, a drink, or a meal.

Some subjects are static anyway. Flowers are not noted for running away at the first approach of humans. They do move about in the wind, but at least you can take your time and maybe wait for a lull. Fungi don't even wobble in the breeze, unless it's an absolute gale, and neither do pebbles or driftwood.

An 'easy' subject. Puffins are as approachable as they are photogenic. Not wanting to presume too far, I still used a 300mm lens. Depth of field is minimal but the picture is sharp where it matters most.

(Lunga, Treshnish Isles, Inner Hebrides)

Fungi give the photographer plenty of time to think about the shot. (Silverdale, Lancashire)

The real challenges are posed by subjects which are either small, or far away. In either case, there comes a point at which decent results are unattainable without specialist gear.

DISTANT SUBJECTS

Distant subjects demand long lenses. But what do we mean by long or, indeed, distant?

Lenses such as 135 or 200mm, which seem dramatically different from standard, can suddenly become awfully disappointing in a wildlife context. These lenses correspond to the 'mental zoom lens': they allow you to pick out a relatively small part of the whole scene, just as your brain can do. Such lenses produce images which still feel quite natural, but when it comes to wildlife the effect can be paradoxical. That buzzard which seems so close can actually seem further away when you look through the lens. ◀

Even a 400mm lens doesn't compare with a half-decent pair of binoculars. Some wildlife subjects really do demand extreme lengths: 600 or 800mm, or even longer. These have very specialised uses; they are also extremely expensive, very heavy, and need some serious support. All in all, hardly practical when you're on the move, let alone trying to combine photography with other activities.

This doesn't mean that there's no point in carrying a long lens, but the best subjects will still be relatively large and

Photographing birds
The largest bird you'll ever see wild in Britain is the white-tailed sea eagle, which can have a wing-span of 2.5m. With a 200mm lens, the fully extended wings would fill the frame at a distance of about 15m. It's not that rare to see sea eagles in certain parts of the Inner Hebrides, but you'll be lucky indeed to get that close to one, even for a moment. And with smaller birds you'll need to be that much closer.

reasonably approachable. And every now and then you may just get lucky.

The longest lens most people will go for will be in the 200 to 300 mm range, usually as part of the range of a zoom lens. Some of these lenses are surprisingly light, compact, and affordable. Their main drawback is that they are slow, with a best aperture of f/4.5 if you're lucky, more often f/5.6.

Some species will come to you, especially if they think you could be a source of food. This female mallard was easily captured with the long end of a 70-200mm zoom lens
(High Dam, Lake District)

A shag in breeding plumage. The 300mm lens throws the background out of focus, minimising distractions.
(Lunga, Treshnish Isles, Inner Hebrides)

Teleconverters
A lightweight and inexpensive solution. A 2x converter, fitted between lens and camera body, doubles the focal length of the lens. But it also cuts the lens speed by two stops: your 135mm f/2.8 becomes a 270mm f/5.6. This combination is lighter than most 300mm lenses, can be hand-held with care and allows a fast shutter speed.

The average low-cost 70-200mm lens already has a best aperture of f/5.6 at 200mm. A 2x converter makes this a 400mm, but with an effective aperture of f/11; this is almost impossible to hand-hold, and even then only with fast film. The viewfinder image will be very dim, making manual focusing tricky to impossible. A lot of autofocus systems won't like it either!

Cheap teleconverters may not produce the sharpest images. Some makers produce 'matched' converters for specific lenses, which produce optimum quality but aren't much cheaper than new prime lenses.

This can make manual focusing difficult, though a lot depends on the quality of your viewfinder. Really cheap ones may not produce the sharpest of images, either.

If you're serious about your wildlife shots, especially if you'll be focusing manually, it's well worth looking at fixed focal length lenses. There are relatively few of these in today's market. At 200mm your choice is limited to the camera makers' own model(s). Several independent makers produce 300mm f/2.8 lenses but the typical price is around £2000. You can pick up a 300mm f/4 for about a quarter of that. On the second-hand market 135mm and 200 mm lenses, especially manual focus, can be almost ridiculously cheap. There's a distinct price jump to 300mm, which is a shame as this is getting to be a really useful length for wildlife, but it's still a lot cheaper than buying new. ◀

Using long lenses

Long lenses are heavy, and therefore harder to hold; they also magnify every wobble of your hands. The slowest shutter speed at which most people can reliably hand-hold a 300mm lens is 1/500th sec, and with a 400mm lens 1/1000th. Even then, it's more important than ever to hold the camera and lens properly (see Chapter 3). Remember, too, that this is only a rule of thumb. If you have exceptionally steady hands, and good technique, you may get away with a slower shutter speed, with a reasonable success rate. But when your hands are not so steady these guidelines may seem wildly optimistic. A buffeting wind can make it virtually impossible to hand-hold a 300+ lens at any shutter speed. It can be hard enough just keeping it trained on the subject.

This all suggests using a tripod, which isn't always practical. Tripods slow you down, which is no bad thing with

Getting down to it. The arms and head almost serve as a tripod.

contemplative landscape photography but hopeless when you're trying to react to animals or birds that appear for brief moments – unless you can predict where they are likely to appear. Many birds may have a regular perch, for example.

A long lens has to have a sturdy tripod, too, especially when there's a breeze. If the wind's strong enough to make hand-holding tricky, it's going to test the stability of your tripod. Sturdy tripods are not light, and when you've already got a chunky lens to carry, this can be bad news.

This is where the various alternatives come in very handy indeed. Monopods – both lighter and faster – are certainly worth considering. So is a bean-bag, which only needs to weigh 200 or 300g and can cost virtually nothing. You can improvise something nearly as effective with hats, gloves, and so on, packed fairly firmly into a small stuff-sack.

Long lens supported on a bean-bag. It's important to support the lens, not just the camera.

Using long lenses, unless on a really rigid tripod, does mean using higher shutter speeds. So does the fact that your subject may be moving quite fast. This might suggest using 'action programme' or shutter-priority mode. A simple alternative is to use aperture-priority with the lens at its widest aperture. This will keep the shutter speed as high as possible. What's the advantage? Suppose you're using a 400mm f/5.6 lens, and 100 ISO film. If the light's good, the shutter speed will be around 1/1000th sec. If you use shutter-priority, and set 1/1000th sec, the result is the same. But if the light deteriorates, the camera may well start blinking or bleeping at you and may even lock up, because it can't set a wider aperture. If you're in aperture priority it will simply adjust the shutter speed and keep on shooting. 1/500th sec with a 400mm lens isn't ideal, but if the camera's properly supported, at least a proportion of your shots will be sharp. If the shutter speed creeps lower still, it's probably time to

think about switching to faster film, or pushing the one you've got. You'll rarely be close enough for flash to come into play.

WILDLIFE PHOTOGRAPHY IN PRACTICE

The use of long lenses, and the need to react fast or miss the shot, mean wildlife photography and shooting action have much in common, at least at the technical level.

At f/2.8 the sharp zone is very narrow, but it does ensure that the flower stands out from the background, helped too by the lighting. (Cuckoo-flower, Isle of Rum)

The best wildlife photographers are very skilled photographers, but what really sets them apart is patience, dedication, and a great knowledge and understanding of their subject. You can make a decent job of photographing most sports without being an expert in the sport – though some knowledge certainly helps – but you'll never be a wildlife photographer without knowing a lot about wildlife. Taking photos is also a great way to learn.

Stalking

If you're serious enough to be into serious stalking you'll probably want to read one or two of the specialist books recommended at the back of this one.

But where do you draw the line between stalking and just walking quietly? People who walk alone have far more, and closer, encounters with wildlife than those who walk in groups – though lone walkers who talk to themselves, or

sing, may do less well than a group of Trappist monks. It follows that you can improve your chances still more by taking a leaf or two from the stalker's book.

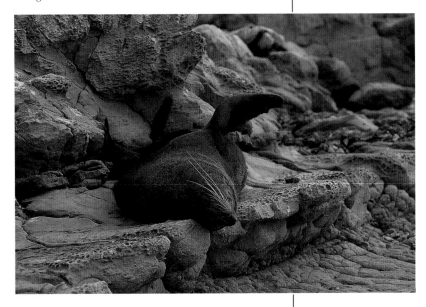

However, you can't stalk the same way in every case. A basic distinction is between birds and mammals. When stalking birds:

- *Be aware that birds, as a rule, have very good eyesight and pretty good hearing, but relatively poor sense of smell*
- *Most birds – owls being the obvious exception – have their eyes set on the sides of their head, giving them a much wider visual field than human beings*
- *The prime requirement is to stay out of sight, the next to be as nearly silent as possible*

When stalking mammals:

- *Most mammals have a sense of smell far keener than our own. It is essential to approach from downwind (a secondary consideration when stalking birds)*
- *Mammals typically also have very good hearing*
- *Sight may be less important, but it still makes sense to be inconspicuous. Don't wear bright colours, avoid sudden movement, and stay off the skyline*

A very laid-back New Zealand Fur Seal; it was well aware of us and didn't seem at all bothered. We probably could have gone closer still but didn't want to push our luck, and the shot was taken with a 200 mm lens. (Kaikoura, South Island, New Zealand)

If you plan to do some stalking, then come prepared:

Keep as quiet as possible
The essence of stalking is silence. Some terrain is easier than others. It's a little like climbing – each foot placement requires careful thought and execution. It can be equally absorbing, too.

- *A hat that shades your face will make you less conspicuous. Some stalkers cover their faces with a scarf or balaclava. A midge-hood is also a possibility*
- *Anything shiny could be a dead giveaway, so taping over metallic parts of the camera can be a good idea. Don't let the sun shine on the lens*
- *There's little you can do about your own scent, but don't add to it artificially with aftershave or deodorant*
- *A harder choice could be whether or not to wear insect repellent: if it's an absolute necessity look for types made from natural ingredients* ◀

If you think you may have attracted attention, freeze. You may be lucky. If you're sure you've been spotted, you may get away with it if you move off sideways and avoid looking at your quarry. It may conclude you haven't seen it. It'll still be a while before you can try getting closer again.

With all the skill and luck in the world, you still may not have much time. You can't afford to waste it fiddling with the camera: it needs to be ready for action. If and when you do get close enough, the one remaining thing on your mind should be smoothly and silently getting into a suitable shooting position.

If you can't get close enough to an individual, groups of animals or birds can make equally effective shots, like these Barnacle Geese. (Loch Indaal, Isle of Islay)

Always remember the ethical and legal issues. If a creature keeps moving off before you can get close enough, you're probably disturbing it. Never let the chance of a good shot lead you into disregarding your own safety. Since stalking means looking closely where you're putting your feet, it's unlikely to lead you into a fall, but there are other dangers. In the UK context, you're more of a danger to wildlife than the other way around, but this isn't necessarily so in other parts of the world. If you can get a good shot of a grizzly bear with a 300mm lens you may already be too close and far from thinking about how to get closer you should be thinking about getting further away! ▶

Hides

This leads neatly on to the subject of hides, but this really is getting into the specialist area. You may casually come across public hides or other concealment such as shooting blinds. Rocks or bushes may provide natural cover. Setting up your own hide, however, is strictly for the specialist.

A tent, however, is much like a hide and may give you some great opportunities. This may influence where and how you pitch, not just wild-camping, but even on some valley sites. In other respects it may be delightful to have the evening or morning sun shining in through the tent entrance, but if you want to be inconspicuous it's best to keep the interior in shade as much as possible.

SHOOTING CLOSE-UPS

Very small subjects can be mobile too. 'Stalking' butterflies can be one of the most maddening occupations known to man. The smaller the subject, the closer you need to be to fill the frame with it. That seems a truism, but it's not quite as simple as that. You'll get a larger image by using a longer lens. That seems obvious, too; but again it's not quite that simple.

Longer lenses give greater magnification but often don't focus quite as close as shorter ones. Suppose you have a 28mm and a 135mm lens at your disposal. It's by no means a foregone conclusion which one will let you photograph the smaller subject. It is, however, easy to find out.

With most normal lenses, a suitable test subject will be something roughly the size of a postcard. Try each lens in turn, set it to its minimum distance and then move to and fro until the image is sharp (switch off autofocus – it's easier, honestly!). You'll immediately see which lens gives the largest image. In a couple of minutes you've established several things:

Ways of getting closer
You can get closer to many creatures on horseback than you can on foot. It's a sad comment on our species that biped equals danger. It probably also explains why people in boats, especially kayaks, often get closer encounters than those on foot.

C You can't do any of this close-up work with a compact. Somewhere in the instruction book it will give you the minimum focusing distance. With minimal depth of field at close distances, there's little leeway. You could carry a ruler around with you – or, slightly more realistically, tape a piece of string to the bottom of the camera to use as a guide. Try this at home first to make sure the stated distance is accurate. It will normally be measured from the film plane, which is a few millimetres in from the back of the camera.

- *The smallest subject of which you can get a frame-filling shot*
- *How close you need to be to it*
- *Which lens to use*

Incidentally, you've also sampled a useful focusing technique. ◀

SLRs have a massive advantage for real close-up work. However, a cheap, manual SLR from the second-hand shelves will do most of it extremely well.

Macro lenses

Many lenses, especially zooms, claim to offer 'macro' capability. This may mean no more than an ability to focus, well, fairly close. Sometimes it means that at one end of the zoom range you can switch the lens into macro mode and focus rather closer.

Strictly speaking, macro capability means at least 1:1 reproduction. This means that an object can be reproduced life size on film. Since the actual image area of a 35mm slide or negative is 36 x 24mm, a £1 coin would just fit within the frame while a £2 would be slightly too big.

No ordinary zoom lens can do this. The best most 'macro' zooms can do is 1:4, which makes the image of the £2 coin 7mm across, or precisely fills the frame with an image of a postcard – the standard UK size for postcards is

Even with a relatively flat subject like this corn-marigold, depth of field does not extend to the tips of the petals. Focusing on the right part of the subject is essential. A 50mm macro lens was used, but many 'macro' zooms would have done well enough: the image on film is less than one-third life size. (Balranald National Nature Reserve, North Uist)

6 x 4in (150 x 100mm). Many prime lenses, especially 'standard' 50mm lenses, can get close to this without making any hyped-up claims to 'macro' capabilities.

1:4 reproduction is quite good enough for many purposes, especially when close-up photography is just part of your outdoor life. It allows impressive shots of many types of flower, for instance, as well as many creatures that might sit still long enough to be photographed (such as toads).

If you want to photograph things much smaller than this – smaller flowers, individual crystals in rock, insects – then you need true macro capability.

There are several ways to achieve this. The cheapest is a *reversing ring*, which screws into the filter thread of your lens, allowing it to be mounted 'wrong way round'. This gives much closer focusing, often well beyond 1:1 macro, but loses all automatic functions. You'll even have to stop down manually to the desired aperture. You'll be limited to manual exposure, or possibly aperture priority. Obviously this is relatively fiddly, but the fact that you can buy an old SLR, standard lens and reversing ring for well under £100 and launch straight into real close-up photography has got to appeal.

Two further options are *extension tubes* and *close-up lenses*. Extension tubes fit between the lens and camera body and the more sophisticated (but expensive) types will retain all the camera's functions such as metering and focusing. Close-up lenses are small supplementary lenses, attached to the front of the lens like a filter. Again, there's no loss of automatic functions. Convenience, plus low weight and bulk, make close-up lenses very attractive to the outdoor user, but the results may not be quite as pin-sharp as those from extension tubes.

The final option is a dedicated *macro lens*. This will give at least 1:1 reproduction. True macro lenses are nearly always prime lenses and are made in various focal lengths from around 50 to 200 mm, though something around 90–100mm is most common. Which length is best depends on the kind of subject you're interested in. Longer ones are probably better for mobile subjects, since shooting from further back gives less chance of disturbance. A macro lens will also serve perfectly well for shooting normal subjects, so you might want to consider where it fits alongside your existing lenses. A 50mm macro can double as a standard lens, for instance.

Snail. The image on film is between half and one-third life size. Depth of field is minuscule; all that's sharp is part of the shell and the nearer eye-stalk. 50mm macro lens. (Isle of Tiree)

TECHNIQUES FOR CLOSE-UP SHOOTING

The main technical concerns are, as ever, focusing and exposure. But there's one other issue which ought to be mentioned first, and that is finding the subject. The postcard-sized things that you might shoot with a 1:4 macro will usually be perfectly obvious as you travel through the outdoors. The slower you travel, the more you'll see.

Dealing with even smaller subjects is more time-consuming, both because it can take time to locate the subjects themselves and because photographing them gets a bit more involved. It's probably best suited to the solitary walker, but can fit in well on longer trips when you're spending time at camp-sites.

Focusing
An essential fact about close-up photography is that depth of field is minuscule, even if you stop down to f/16 or f/22. At magnifications greater than 1:1 depth of field seems virtually non-existent; even at 1:4 it's pretty minimal. This isn't a great problem with flat subjects, like that postcard, as long as you shoot absolutely perpendicular to it. However, most of the subjects of interest to us in the outdoors are three-dimensional. The question is no longer one of keeping the subject sharp, but *which bit of the subject* is sharp.

This makes autofocus less useful for close-up work than you might expect. You can't expect the most interesting bit

of the subject to line up with a central focus sensor every time. Even multi-sensor focusing is of limited assistance. When the subject itself is in constant motion you can't even lock focus and reframe. Most flowers, for instance, move almost continually. The slightest breeze, or sometimes even your own breath, is all they need.

Manual focusing really does score in close-up work. The usual things, like a good viewfinder, make it easier, and true macro lenses typically have maximum apertures around f/2.8, which is much better than the f/5.6 of many 'macro' zooms. There are some useful refinements of normal focusing technique, which really boil down to a form of pre-focusing.

To obtain the largest possible image of a small subject you want to get as close as you can. Preset the lens to its minimum focusing distance and then get the image in sharp focus by moving the camera. If the exposure allows you to hand-hold this is relatively easy, but with a tripod it can be quite a fiddle; a monopod can be an excellent compromise here.

With moving subjects there's a further refinement. When flowers wobble in the wind they rarely wave around completely at random but oscillate along a fairly regular path. You can pre-focus at a point on this path and wait for the image to come into focus. The mid-point is where the flower will be moving fastest, whereas at either end there will be an instant of stillness. This is analogous to the 'peak of the action' approach (see Chapter 4). However, since the flower's movement isn't completely regular, it won't stop at exactly the same point every time. Patience is required, and an element of luck.

Specialist flower photographers often erect windbreaks, even complete transparent or translucent tents, to shield subjects from the breeze. A lot of detailed flower shots are actually done in a greenhouse or studio. Without such facilities, we can only be realistic. A calm day is obviously best, and some flowers wobble more than others. Violets, with their drooping flower-stems, are worse than most. ▶

The importance of correct alignment
Minuscule depth of field makes your alignment relative to the subject crucial. With a relatively flat subject like lichen on a rock or the spread wings of a butterfly, you can make the most of the limited depth of field by shooting at right-angles to it.

Exposure

If autofocus is of dubious value in close-up work, automatic exposure is much more helpful. It won't work with a reversing ring or basic extension tubes, but should work happily with more sophisticated tubes, close-up lenses, or macro lenses.

When working manually, be aware that many lenses get physically longer when focused very close. This can alter the effective focal length and aperture. This effect is even more

Trade-offs
Close-up photography is full
of trade-offs. While you
might want a small aperture
to maximise depth of field,
you may have to
compromise to get a
workable shutter speed. If
you shoot in programme or
aperture-priority mode, keep
a close eye on the shutter
speed that's being set.

marked with extension tubes. This is no problem if you take your meter reading with the lens already focused at the shooting distance. It's more difficult if you use a separate exposure meter, and also makes the 'Sunny 16' (see p.163) rule a less accurate guide. The effect is moderate at 1:4 but much more pronounced at true 1:1 macro.

In all these situations the effective aperture is smaller than the figure shown on the lens barrel. A slower shutter speed will be required than for a distant shot in the same lighting conditions. This increases the risks of blur from both camera shake and subject movement. ◀

Using flash

Flash is a great boon for close-up work. Much extreme close-up work, beyond the 1:1 macro range, is practically impossible without it. What's more, with such small distances from flash to subject, low-powered flash units are ideal. Even a £10 flashgun is usually powerful enough to allow you to shoot at f/16. Using flash also relieves most worries about subject movement causing blur.

The built-in flash found on most SLRs is far from ideal. The fixed direction of the light, close to the lens axis, gives ugly results combining harsh shadows with little or no texture. At extremely close range such units can actually 'miss' the subject entirely. This probably isn't a problem at 1:4 range, but may well be at 1:1.

In serious close-up work it's essential to be able to take the flash off the camera. This requires a connecting cable, called a *sync lead*. A basic one isn't expensive, but for full automatic control you'll need a *dedicated sync lead*, which is. However, even basic flashguns and sync leads are quite easy to use. Cheap flashguns may have fixed output, but if you use it at a consistent distance from the subject you can use the same settings every time, for example f/16 at 1:1 macro.

A single flashgun still gives quite a harsh light, and many dedicated close-up workers use two. The main problem is that you need more than one pair of hands! The usual solution is a special bracket which holds both flashguns at the required distance and angle. This does aid consistent results but is too cumbersome for most people.

One partial solution is to use one flash and a reflector, which can be propped up in an appropriate position. This can be as simple as a piece of white card, or a special fold-away type. You can also soften the light from a single flashgun in various ways (see Chapter 2).

A *reflector* is also useful for less extreme close-ups.

Strong sunlight, especially at an acute angle, can create very high contrast in small subjects. Hard shadows can be confusing. A reflector can help, and the great advantage over flash is that you can clearly see the effect.

PORTRAITS

The wildlife chapter seems as good a place as any to say a little about portraits. Many action shots will be partly portraits too, but here we really mean something a little more static, if not posed.

For head and shoulders portraits a moderate telephoto lens, around 100mm, is usually favoured. Going in close with a wide-angle lens can feel confrontational, and exaggerates the size of nearer bits of the face, giving caricature-like results.

In hard light a reflector or fill-in flash is often useful to reduce contrast. Alternatively, portraits are another of those things that work well on more overcast days.

Portraits aren't technically difficult, and automatic exposure usually works very well anyway. It's the personal element that makes most of the difference. Candid shots can work fine, but a better approach for outdoor portraits is often the semi-candid. This is not a fully-posed shot but is taken when the subject is occupied with something else – sorting climbing gear, reading a map, lighting a fire. Get everything

If it's details you're after, get in close and cut out surrounding clutter. Wetting brings out much more of the crystal structure of many rocks, like this granite. (Near Sennen, Cornwall)

sorted out and then attract their attention. Taking the picture as they look up keeps it spontaneous but ensures eye contact.

FINAL THOUGHTS

A little learning can be a dangerous thing – not so much for you as for the animals and birds you're pursuing, as well as other species that may get 'in the way'. If in doubt, back off. You don't need that shot; your life doesn't depend on it. Theirs might.

This above all is an area where you have to be realistic. Truly frame-filling shots of most wild animals and birds are hard to get. Some subjects are much more approachable, and every now and then you may get lucky.

Serious close-up work also requires a degree of specialisation. The investment in equipment can be modest, but it does demand time, patience, and a willingness to learn and experiment. Beyond a certain point it is no longer just a part of the outdoor experience; it starts to become the dominant part.

If we don't wish to go beyond that point, we have to keep our ambitions in check. While the 'twitchers' may spend all their time pursuing rarities, for the rest of us wildlife and close-up photography is mostly about the commonplace. There is no better way to remind ourselves that common plants, animals and birds are no less beautiful than rare ones.

Anything can be a subject. Focusing on the water surface makes this shot almost abstract. (Rio Arazas, Ordesa, Spanish Pyrenees)

CHAPTER 6
Shooting at the edge

We're talking about extremes here: extreme sports, extreme conditions, or ultimately both. These present real photographic challenges. More than ever, this suggests thinking ahead. These are not the times to be fumbling with unfamiliar equipment; gear and techniques should be tried and tested on easier ground first.

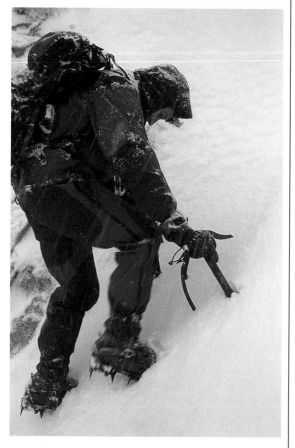

Shots taken in really foul conditions have a rarity value. The low light levels demanded a shutter speed of 1/30 sec. Note the long streaks of the falling snow, and the movement of the right foot.
(Bernie Carter, Blencathra, Lake District)

Shooting at the edge emphasises the distinction between participant and observer. In some cases there is no choice. In sport-climbing, hardly anyone carries a camera. Photography here is the preserve of the observer – though on occasions you may need to be a pretty good climber your-

self to get to the best positions. In Alpine mountaineering, and the Greater Ranges, the opposite is true. Above the hut or base camp there are no mere observers – occasional exceptions like the Eigerwand and Aiguille du Midi apart.

Going to the edge puts greater stress on you. Time, energy, concentration, and load-carrying capacity are all stretched. Photography has to fit in around the demands of completing the course, getting to the top, or simply surviving. The mantra 'light, fast and simple' becomes doubly relevant. You may have very limited carrying capacity for gear or film; you may only be able to free one hand to take the shot. In really extreme situations, your own safety and that of your companions must be paramount. However, really extreme situations (provided you survive them!) make great memories, so you'll want a record if you can possibly get one.

EXTREME CONDITIONS

One person's 'extreme' is another's 'bracing'. If you enjoy getting really muddy on a mountain bike, or battling up a Scottish gully through spindrift avalanches, you're going to want shots that reflect this. However, conditions beyond the norm – whether cold, wet, windy, hot or dusty – pose extra problems for cameras as well as for photographers.

Wet

Rain is the commonest concern in Britain. Any lover of the outdoors in these islands can hardly avoid going out in the rain. Sometimes it clears up, sometimes it doesn't. Those folks who head for the pub at the first spots of drizzle probably think you're mad. Wouldn't it be great to have some shots that showed just how beautiful things can be in the rain?

Great landscapes – and more – can be done in the wet. Long-range views may be flat, if visible at all, but in compensation you get a different look at the near and middle ranges. Colours of foliage can be at their most intense and the crystal structures of rock are much more clearly revealed. Drifting rain acts like fog, veiling the outlines of trees or rocks in mystery.

But rain on the lens can blur your pictures and rain in the works can wreck your camera. Use a lens hood and keep the camera angled down when not actually shooting. Even so, especially when the wind's in your face, it can get spattered in seconds. A dry, clean cloth or tissue is worth its weight in gold. And you'll be wiping the water off the UV or skylight filter that you fitted after reading Chapter 2, rather than off the lens itself. ◀

Keeping it dry
A few seconds' exposure to rain won't harm most cameras, but do try and keep it to a minimum. Know what you want to do before pulling the camera from its case. Good old-fashioned mechanical cameras are usually much less vulnerable than their all-electronic counterparts. That old mechanical camera probably won't fetch much in part-exchange anyway, so why not hang on to it for use on foul days? If it does pack up, you can console yourself that you haven't ruined your new, expensive, state-of-the-art SLR.

It's not obvious, but it was raining steadily when this shot was taken.
(Far Easedale, Lake District)

Top-line cameras, especially professional ones, should be well sealed against the weather. Small print in the specifications should tell you what level of inundation the camera's supposed to cope with. But don't take anything for granted. Keep it in its case, or inside your jacket, as much as possible (assuming these are reasonably waterproof!).

If you want to take lots of shots in the rain, the camera itself needs a jacket of some sort. This can be anything from a simple plastic bag to a full underwater housing, which is quite likely to cost more than the camera itself! A good standby for the average SLR is a simple 'rain-guard' which is just a stout plastic bag, open at the bottom, with a rubber collar in one side that fits around the lens. This should cost less than £10, though you can cobble something together with a large plastic bag and a rubber band. A rain-guard should suffice for all but the heaviest downpours, but if you're into climbing up waterfalls or kayaking down them you'll need a bit more protection.

Camera and rain-guard. The lens-hood provides some protection to the front of the lens.

C There are a number of compacts sold as 'waterproof' or 'weatherproof'. 'Weatherproof' is probably best taken to mean 'showerproof'. These can be a good bet for general wet-weather work, kayaking, and so on. Unless they're declared suitable for underwater use, they aren't. Bear in mind that hanging around in waterfalls, as you may do when canyoning or caving, exposes you and your gear to water under pressure. This really should be considered as underwater use!

Proper waterproof housings for SLRs start at around £100, which is a lot cheaper than replacing your camera every few months. On the other hand, for £100 or so you could also get a weatherproof compact, which might be an equally good investment. If you only intend getting really wet once in a blue moon, you could consider a waterproof single-use camera, which can give surprisingly good results. You'll only be able to shoot prints, and they probably won't be suitable for poster-size enlargements, but you'll have a record of the experience. ◀

Fresh water is bad enough; salt water is even more destructive to cameras, especially electronic ones. This concerns not just surfers and sea-kayakers, but rock-climbers on sea-cliffs and even walkers on cliff-tops – salt spray can

On a day like this there is plenty of salt spray around even on the cliff-tops. You need to balance the potential for wonderful pictures with the risks to precious gear. (Yesnaby Castle, Mainland, Orkney Islands)

drift a long way. Always carry the camera in a pouch, not just slung round your neck. As soon as possible, clean off your gear with a clean soft cloth moistened in fresh water. This means cleaning all surfaces, not just the lens or filter. Then allow the camera to dry thoroughly, preferably in a warm dry place.

If you need to change lenses or film when it's wet, be very, very careful. Give the camera every bit of shelter you can. Get familiar with your equipment; if you can change lenses or load a film blindfold, then you can do it in the shelter of your rucksack or under a jacket. This is worth prac-tising at home, but with most cameras really isn't that difficult.

Cold

Getting cold can impair your performance, and can be just as problematic for cameras. The commonest problems are with batteries, so once again there's something to be said for the good old mechanical camera. An alternative is to keep the camera under your clothes, only pulling it out when you're ready to shoot. This is a lot more comfortable with a compact than an SLR with a bulky lens. However, conden-sation on lenses and viewfinders can be a problem, so simply shoving the camera next to your skin isn't recommended. Some sort of light case or covering will make things more comfortable for you too.

The light appears warm but the temperature in shade was below -20 Celsius. (Jyvaskyla, Finland)

If you have a high-spec SLR you may be able to purchase a separate battery pack, which connects to the camera through a cable. You can keep the batteries warm and still carry the camera round your neck. But it's expensive, the battery pack adds weight, and the cable's one more bit of clutter. This solution will probably appeal only to the professional and the very dedicated. It makes more sense to keep spare batteries in an inner pocket so they stay warm. Lithium batteries are generally considered best for cold conditions, if you can track them down in the right size for your camera.

Extreme cold may bring all sorts of other problems. Many cameras, especially the mechanical types, will go on functioning down to around –20 degrees Celsius. This sort of temperature is rare in Britain, but commonplace in the winter months in many countries, including large chunks of Europe and North America. In the Arctic and Antarctic, and at high altitudes, such temperatures can be encountered at any time of the year. When it's colder than this, special lubricants may be needed to stop everything seizing up.

Metering problems
Cold usually means frost or snow, and lots of white stuff around can cause problems for many metering systems. See the advice on exposure under 'Mountaineering' on p.127; also Chapter 3 and Appendix I.

In extreme cold, film can become brittle so winding on with extra care is recommended. Try and avoid exposing the film to any sudden temperature changes. ◀

Blowing snow and spindrift has a nasty habit of getting into everything, including your camera-pouch; such conditions should be considered as both cold and wet.

Wind

Hurricanes and tornadoes regularly kill people. Much lesser winds can be life-threatening if you're teetering along an exposed mountain ridge, or in a dinghy off a rocky lee shore.

From the strictly photographic point of view, high winds can yield great dramatic images, and of course activities like sailing need at least a breeze. But anything from a fresh breeze upwards can create certain problems. The most obvious is the increased risk of camera shake.

If you can hand-hold a 50mm lens at 1/60 sec under calm conditions, it may be a good idea to give yourself an extra margin in rough weather. Up the shutter speed to 1/125 or even 1/250 as the wind gets up.

A tripod probably isn't the answer. No tripod on earth will stay put in a tornado, and only a really heavy one is likely to be much use in a Force 8. There are definitely times when you're better off hand-holding (see Chapter 3). Don't rule out alternatives such as monopods, bean-bags and flat rocks.

But if you are using a tripod, the following can help:

- *Don't extend the legs too far*
- *Splay the legs wider than normal, if you can*
- *Weight the tripod down with your rucksack*
- *Stand upwind to give it some shelter (without blocking the camera's view!)*
- *Wait for a momentary lull*

Heat

Batteries don't mind the heat – at least at temperatures you can survive in – but film does. Short-term exposure is unlikely to be a great problem, but long periods at high temperatures mean that the film will deteriorate. Modern films are generally pretty stable, but it still pays to keep your film, both exposed and unexposed, as cool as possible.

Keeping film in the fridge overnight is not a bad idea, but avoid sudden temperature changes. Ripping a chilled film from its plastic canister in a temperature of 45 degrees Celsius usually results in condensation, which can ruin every shot. Try to give the film an hour or so to warm up before opening the canister.

Dry heat is usually more comfortable for people than heat coupled with high humidity, and the same goes for cameras and lenses. In hot, damp conditions you can get all sorts of bugs infesting your gear, fungus growing on lens coatings, and so on. The usual advice is to keep everything in sealed bags as much as possible, with lots of silica gel. ▶

Portraying heat
How do you actually show how hot it was? The environment in a shot may suggest the temperature, but this can be misleading: you can be roasting on a glacier and freezing in a sandy desert. Rippling heat haze and mirages do indicate heat, but people provide many of the best clues, wrapping themselves against the sun, seeking out any patch of shade, taking a drink, or just sweating!

Dust

After sea water, dust, sand and grit are among the most insidious and corrosive enemies of delicate equipment. All kinds of environments can be susceptible: deserts and beaches are just the most obvious. In extreme conditions, like a sandstorm, the opportunity to get a great shot is directly at odds with the risk of the camera swallowing some nasties. A weatherproof camera, or a rain-guard, could be just as much use here as in the rain.

The times of greatest risk are obviously when changing lenses and when changing films. If you know you're going out in a sandstorm it could be a good move to put a fresh film in, then pick one lens and stick with it. A zoom lens might seem to be a good idea, but these are mechanically more complicated than prime lenses so there's more to go wrong. You won't be able to see far so a wide-angle lens is probably your best bet.

Was this shot worth taking? As a warning to others, perhaps. Between the dust and the vibration, this jeep-ride spelt doom to my zoom lens...
(Shigar valley, Karakoram, Pakistan)

EXTREME SPORTS

Climbing
Bouldering and one-pitch climbing have obvious attractions for the outdoor photographer:

- *The walk-in is often, though not always, short*
- *You don't have to be part of the climbing team, so you'll have a much wider choice of shooting angles*
- *It isn't even always necessary to be a climber yourself: many crags offer easily reached vantage points*

But if you're shooting from the top, don't get so involved that you forget where you are. There are quite a few recorded cases of photographers absentmindedly stepping into space!

It's surprising how often you can shoot from the ground. Many crags lie at an angle across a slope, so by walking up the slope you can often look across a section of the crag.

Bouldering even allows you to take pictures when you're on your own, if your camera has a self-timer. Many self-timers have a fixed 10-second delay, which doesn't give you a lot of time to get into position. If you can adjust the time-lag you'll have more options, but if you overestimate you could find yourself hanging around in a strenuous position for longer than you want. It may take a few attempts to get the timing right. This method doesn't allow the precise timing that's needed to capture dynamic moves. This really takes

two people, and often three – one to climb (or pose), one to act as 'spotter', one to take the shots.

Outcrop climbing sometimes gives opportunities to take pictures while belaying (if you can do so safely), but there's the usual problem with shots looking straight up or down. If there's someone else to do the belaying, outcrops give you lots of freedom to move around, so use it.

The repetition and rehearsal that goes into many sports climbs may give you lots of chances to photograph 'the move'. Still, it's always a good idea to be prepared for the unexpected, whether it's an unscheduled fall, or a first-time cruised ascent.

Multi-pitch rock-climbing usually involves the photographer as part of a climbing team. In a team of two you have the problem of combining photography with belaying. You can take shots one-handed, but it increases the risk of

Outcrop climbing gives the photographer freedom to seek out unusual angles. Fill-in flash brightens the depths of the crack.
(Jonathan Westaway, Cave Crack, (VS), Widdop, Yorkshire)

Sometimes less is more. Selective focusing concentrates attention on the hands.
(Jonathan Westaway, Pickpocket (VS), Rylstone, Yorkshire)

Get the timing right

The great problem with taking photos as part of a climbing team is that you're usually looking either straight up or straight down, at the soles of the leader's feet, or the top of the second's head. Timing helps; wait for those moments when the leader looks down or the second looks up, and for sideways moves. Your eyes should light up when the route includes a diagonal pitch or a traverse. Nor do you need to confine yourself to photographing your own team. You'll often get better angles on people on nearby routes.

camera shake. A bigger question (especially for your partner) is whether you can belay one-handed! This almost invariably means grabbing a shot quickly, keeping the braking hand on the rope at all times.

A shot that's taken quickly doesn't mean one that's taken without thought; you can be thinking constantly about the best places to grab a shot, how you'd like to frame it, and so on. Decisions about exposure, maybe even about focusing, can be taken even further in advance, once you're tied on and set up at the belay but before your partner starts climbing. Where you position yourself on a stance must always be dictated by safe and effective belaying, but with this proviso you may want to think about your position in relation to photographic angles too.

While a team of three is slower, it certainly increases the photographic opportunities. You could even rotate leads, and take turns with the camera. ◀

An obvious question is how to carry the camera. On long routes you may carry a rucksack anyway. This makes the

Many of the best opportunities occur when you can look across at a climber rather than up or down. (Julia Westaway, Sobrenada (VS), Eagle Crag, Lake District)

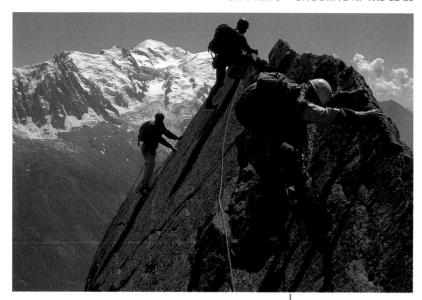

camera less accessible, but as you'll be photographing from stances this isn't crucial. Carrying the camera on its neck-strap is not a good idea. Even if you shove it round your back out of the way it can get tangled with your gear, and all too easily slide round to the front at precisely the wrong moment. This can spoil your balance and certainly makes the camera very vulnerable. A padded pouch is the sensible answer, either on a separate waistband or attached to your harness. A separate belt is better, so the camera can be slid round out of the way when you're actually climbing. Round your back means it won't get in the way, except on tradi-tional chimney pitches, when it can easily be slipped to one side. ▶

Mountaineering. While there's usually no great pressure of time on a four-pitch Welsh VS, it's a different story on a serious Alpine route. Not to mention the fact that you can be dealing with extreme cold on those pre-dawn starts and extreme heat at the other end of the day, and, if you're unlucky, most of the other weather problems too!

Nowhere does 'light, fast and simple' make more sense. If you're counting the grams, forget about big lenses – but good lenses are still important. Brilliant Alpine light can be a stern test of resistance to flare. And you will want to shoot into the light. Lens hoods protect against knocks and reduce the risks of flare. Remember that UV or skylight 1B filter, too. These should be good quality, preferably multi-coated, and must be kept clean.

This shot had to be 'grabbed' very quickly as I was belaying two partners, but the framing and other details, were worked out in advance. (Judith Brown, Ian Nettleton and unknown leader, South Ridge of La Chapelle de Gliere, Chamonix. Mont Blanc behind.)

Take care

Dropping the camera could be costly for you and dangerous for anyone underneath. You can clip the camera strap to a gear loop or sling, or replace the strap altogether with a bit of cord or climbing tape. If you're carrying the camera on a waist-belt, be sure the fastening's secure.

*Taking photographs
in snow*
Scenes with lots of snow
will fool almost any meter.
Remember that meters tend
towards grey, so you'll need
more exposure, not less,
usually between one and
two stops. An alternative, as
ever, is to take a reading
from a mid-toned area and
lock it with half-pressure on
the shutter button. Mid-tones
could be the part of the
glacier that's still in shadow,
sunlit rock, or blue sky.

On a hard route the lightness, simplicity and one-handed use of a compact may be irresistible. Many people still prefer the versatility of an SLR. A mid-range zoom lens seems an obvious choice, but cheap zooms are susceptible to flare, while zooms in general are more vulnerable to dust and impact. There's a lot to be said for a fixed lens. Bearing in mind the scale of the environment, a 28mm or even a 24mm could be the best choice. This will do a great job for approach shots of the peak, and for views from the route and from the summit. For action shots, its main value will be when the action's really close to you, but you can get some great atmospheric shots with strategically placed small figures.

There are some very good 17–35mm zoom lenses around. One of these would be an excellent choice if you can accept the moderate extra bulk and weight. You'll want to take a bit more care of it, too. An elderly 28mm lens might be expendable, a brand new zoom surely isn't.

If you're really concerned about weight but don't want to sacrifice control or quality, take a serious look at 35mm *rangefinder* cameras (see Chapter 2). The choice is small compared to the SLR and compact markets, and none are exactly dirt cheap, but they have a lot to offer. ◀

Pre-dawn starts might suggest using fast film, but there's only a short time when it would be useful. When it's really dark you can't hand-hold anyway, while as soon as the sun is up conditions may be too bright. With compacts, especially, the limited shutter speed and aperture range can soon lead to overexposure. Fast films also give duller results, diluting the intensity of the mountain scene.

It's generally better to stick to a medium-speed film, and take the night shots with flash (at close quarters, of course). Once there's enough light to see the landscape around you, you can think about more distant shots. Keep your eyes open for flat rocks where the camera can be braced for long exposure times. If they're not quite level, even things up with a glove or strap under one side of the camera. As the light improves, an ice-axe or ski-stick can do duty as a monopod. You can get a walking-pole whose top contains a camera mount, and you can also get camera attachments which clamp on to an ice-axe. These may be the only way to get the whole team in the picture for summit shots with the self-timer, but otherwise there's little gain over just using the axe or pole as a brace, supporting the lens firmly with the wrist-loop.

Cycling – road and mountain

Cycling photography usually means getting off the bike. This doesn't mean that your companions have to get off theirs as well! Shots of people posing with bikes or, worse still, the old cliché of 'bike leaning on wall with great view behind', don't say much about cycling. But getting shots of your companions usually means riding well ahead. It always takes longer than you think to stop, put the bike down, and get the camera out. You'll need cooperative companions, but try not to overdo it.

Taking pictures while riding is not recommended. Looking through the viewfinder to do so is sick-making as well as incredibly dangerous. Shooting 'from the hip' is just dangerous.

Some people take shots of themselves or other riders with a camera mounted somewhere on the frame or forks, triggered from the handlebars with a long cable-release. The mount needs to be totally secure and solid, but with some form of padding for the camera. Vibration will shake loose

By not framing too tightly a shot can say more about the surroundings as well as the activity itself. Pre-focusing on the principal subjects still gets the shot sharp where it really matters.
(High Raise, with High Street behind, Lake District)

Carrying your camera

When carrying anything on a bike, lower is better. A back pocket is OK for a compact, and you can carry an SLR in a waist-pouch, but if you need to carry more than this it's better on the bike, not on you. A handlebar bag will take an SLR and moderate zoom lens but not much more. The next item would probably be a flashgun, possibly even if the camera has built-in flash.

all sorts of screws and other components. It's a good way to wreck a camera, so if you're still keen to try it, use an old one!

You'll need to preset focus and exposure. Vibration can still cause focusing rings and so on to shift: they may need taping in place. Unless the camera has a winder or motor-drive, you'll need to stop after each shot to wind on. For shots of yourself the favourite place for the mount is low on the front forks, and you'll need a really wide-angle lens.

Photographers covering major races use motorbikes, but they don't drive themselves! Shooting from the pillion is no mean skill, and requires great understanding between driver and 'passenger'. These races are on closed roads and under controlled conditions. Don't try it in general traffic. Realistically, our cycling shots will be done from a stationary position. ◀

Cycling involves higher speeds than most outdoor sports, with obvious exceptions like downhill skiing (though possibly not in my case!), and therefore higher shutter speeds are usually needed to stop the action – if that's what you want to do. But cycling also lends itself very well to techniques like panning or mixing flash and daylight (see Chapter 4).

Panning blurs the background, which doesn't mean you can't give an impression of the setting. Perhaps it's a pity about the photographer's shadow. (Helvellyn, Lake District)

Gill scrambling provides plenty of chances to get wet. This is close enough to the water to give a good feel for it but far enough back to avoid splashes on camera or lens.
(Bernie Carter, Dungeon Ghyll, Lake District)

Watersports

Any outdoor activity can involve getting wet. In some cases, like gill scrambling and canyoning, it's inevitable. But activities which are based on or in the water involve the most sustained exposure to wet conditions. There's still a basic difference between just getting wet and actually going underwater.

Getting wet

Sailing, kayaking, windsurfing and so on don't always entail getting totally soaked. However, a capsize can put you under water. This is very bad news if the camera's not ready for it!

As long as you're sure you aren't going to capsize, then the necessary precautions are pretty much as set out on p.119. In very calm conditions you may be able to dispense with them altogether. But whereas you may accept a few splashes as part of the game, your camera may not be so tolerant.

131

When the sea's this calm you probably can risk shooting with a non-waterproof camera. Even so, beware of splashes. Water dripping from the paddle provides the only evidence of movement in this shot. (Robson Bight, off Vancouver Island, British Columbia, Canada)

When there is water around – and how often are the bottom-boards of a dinghy or the inside of a kayak bone dry? – there may be no dry place to put the camera between shots. If it isn't actually waterproof, it needs protection in a waterproof housing or dry-bag.

In a dinghy or kayak your viewpoint is very close to water level. The horizon is very close, cutting off the base of distant hills. If you're not careful all your shots may consist of little more than water and sky. For the best shots, wait till you're really close to shore

You can only vary this perspective by getting out of the boat, on an accessible cliff, island, or bridge. If you want to take the chance to get some shots of your companions, make sure they know what you're about. On larger boats you'll have more options. Adventurous photographers sometimes get great shots by climbing the mast, but check with the skipper first.

Going underwater

Many 'waterproof' cameras will survive immersion to a depth of a metre or two, but check the specifications first! Basic underwater housings, of a flexible construction, are good to about 10m, which is more than enough for any sane person when snorkelling or diving without breathing gear.

At such depths (at least in clear water) there's still a fair amount of natural light around, and you can usually manage without flash. Even when it seems really bright, there'll be

considerably less light 10m down than at the surface. But because water resists movement much better than air, you'll find that your hands are effectively steadier and you can use a slower shutter speed than you can up top.

The occasional underwater photographer should steer clear of flash. A built-in unit, or any flash mounted close to the camera lens, will illuminate every bit of suspended matter in the water – if it doesn't just light up the interior of the housing! In crystal-clear water, with an underwater camera, you may escape these problems, but flash range will be even more limited than on the surface.

At greater depths, you'll need either a true underwater camera or a more sophisticated rigid housing. These have to match specific cameras, so they're only available for a few, usually professional, models. They still tend to cost more than the camera itself. Light levels fall off rapidly too, and flash quickly becomes essential. And so does specialist advice. ▶

Going underground

Caves are often wet and dirty. They frequently involve crawling through confined spaces or dangling on ropes and ladders. Oh yes – and they're dark.

All this makes caves particularly challenging for photography. But because it's so different from the everyday surface environment, it's all the more important to have a record. And if you can come back with some shots that convey the fascination and the beauty of it, you may start to persuade a few people that you aren't, after all, totally mad. ▶

Looking after your gear is still important. It needs the best possible protection against impacts, dirt and water. Fully waterproof cases or dry-bags are usually needed, and cameras and lenses will need further padding inside them. Even so, this is the last place to take your shiny new auto-focus SLR. A good old-fashioned, metal-bodied, mechanical camera will handle the conditions much better. It will also lend itself to the technique described below for taking photos of larger chambers.

The quickest and easiest way to get photos as you go along is with on-camera flash. This is subject to all the usual limitations: limited range, harsh lighting and 'red-eye'. With built-in flash there's not much you can do about these. At least the results will bear some resemblance to the light from your own headlamp.

A flash with a bounce head allows more subtle lighting in small passages, but as dark rock is a poor reflector, you'll need a powerful gun. Extras like diffusers, or a sync lead that

Specialist supplier
Most camera shops will stock one or two weatherproof compacts and maybe a rainguard. For a full range of underwater housings and cameras, the place to go is Cameras Underwater, East Island Farmhouse, Slade Road, Ottery St Mary, Devon EX11 1QH. Tel: 01404 812277; fax 01404 812399. www.camerasunderwater.co.uk

Safety first
Your safety and that of your companions comes first. Apart from obvious things like not falling down a shaft when you step back to reframe, bear in mind that taking photos in caves can be time-consuming. Too many stops are annoying and mean that by the end of the trip everyone's that bit more tired. However, where ladders or Single Rope Technique are involved there will be times when others are rigging or climbing the pitch, when you may be able to shoot without delaying anyone.

allows you to take the flash off the camera, will improve the lighting but it all means more gear and more delay.

That old mechanical camera probably won't have 'smart' flash, but you can still use an automatic flashgun in its 'A' mode. This is quite simple: with the camera on manual, set a shutter speed of around 1/60th or 1/30th sec. The aperture will depend on distance to your subject and speed of film, but f/8 is usually a good standby. Make sure you set the same aperture – and the same film speed – on the lens and and on the flash. And finally, don't forget to focus!

A single flashgun is useful for taking photos of your companions, and for small formations, but won't give a bigger picture of the environment. And if there are crawls, or pitches, or it's just wet, you'll need to unpack and repack camera and flash for each shot. A waterproof compact which you can slip inside your overalls would get round these objections, but still won't be any use for shots of larger chambers.

You can also take photos just using the light from head-lamps, but the exposure times will be quite long. If you have the time, this can work very well for formations and will look better than on-camera flash. You can do pictures of people this way too, but they'll have to keep still. It's equally essential to keep the camera dead still. If you don't want to carry a tripod, a bean-bag sometimes works very well, or simply bracing the camera firmly against a rock wall or ledge (not a

Several carbide lamps provide the illumination for this shot, which required the 'model' to keep very still for over half a minute. The camera was braced against a rock wall. (Andy Bradbury, Cueva de Canes, Picos de Europa, Spain)

fragile stalactite). The more of you there are, the more head-lamps and the brighter the light, but don't expect exposure times better than half a second unless you're using fast film.

For decent shots of larger passages, chambers or shafts, a single flash just won't be sufficient. However, you can get stunning shots of such spaces. The key is Painting with Light, more soberly called 'Open Flash Technique'. It sounds grand, and doesn't need a lot of fancy gear, but it does require time. It also helps greatly if there are two or more of you. This tech-nique is also useful out of doors at night, and for dark interiors.

In simple terms, you stand the camera on a tripod, lock the shutter open (you'll probably need a cable release), and walk around with the flashgun, firing it with its test button. As you move around, successive flashes illuminate different areas and you build up a complete picture. You can use the flash on auto, as above. It sounds simple enough, but there are a few complications:

- *It takes time for the flash to recharge after each firing*
- *A long series of flashes may take several minutes to complete, which will allow any residual light to record on the film. This might defeat the object of using the flash in the first place*
- *If the space is completely dark this won't be a problem – but then how do you see what you're doing?*
- *A headlamp will leave a trail of light as you move around between flashes*

The simplest solution is to cover the lens between flashes. This is why two people are needed: one to move around with the flash, one to stay with the camera and cover the lens between times.

It can look quite odd to see the same person appearing in several places, though in caving photos this is often unavoid-able and most people are used to it. If you are holding the flashgun, even pointing away from the camera, it's quite likely that you will appear as a silhouette. Sometimes you can hide yourself from the direct view of the camera, perhaps behind a large stalagmite or boulder.

In a chamber with a high ceiling, even multiple flashes just won't reach, and you will be left with pools of darkness. It's best to frame the picture to exclude most of these areas.

In reality, this technique isn't particularly difficult, and the results can be immensely effective. It does, however, require thought and planning, and time. You need to work out in

Practise outdoors

An outdoor adaptation of this technique could be used for a shot of an expedition campsite. When it's almost totally dark, set the camera on a tripod and lock the shutter open, then walk round firing the flash inside each tent in turn. Just make sure all the occupants know you're coming round!

advance where and how often you may want to do it, and make sure your companions are happy with the time factor.

It is a bit hit-and-miss, and takes some practice before you can even approximately anticipate the outcome. However, a wide variation in results can still look acceptable; they'll probably just mean that the pools of light will be larger or smaller. If you'd like to try it, the usual advice applies – practise first. You can do a dry run in your cellar, or in any dark room, but make sure it's really dark.

The larger the space, the more flashes you'll need. It's a good idea to try with small – room-sized – spaces first, where two or three flashes will suffice.

There's just one final problem: who's going to carry the tripod? ◄

During a long time exposure, with the camera on a tripod, my partner walked right through the shot, wearing a head-torch and carrying another. The lights are bright enough to record on the film but the person doesn't register at all. (Cathedral Quarry, Little Langdale, Lake District)

TREKKING

'Trekking' implies travel on foot, but you can also trek on bikes, on horseback, by kayak, or on skis. A trek is any multi-day trip in a more or less remote environment, carrying everything you need – with or without porters or pack animals. If you smash a lens or run out of film halfway through, there's no camera shop just round the corner. While saving weight is bound to be important, it's even more vital to have gear that's utterly reliable. A more rugged camera may weigh a few extra grams, but a camera that doesn't work is pure dead weight.

Venturing into new and unfamiliar environments can give you a whole raft of new things to deal with. Don't make photography another of them. It's tempting to buy a new camera for that 'trip of a lifetime', but you're better off sticking with the one you know and understand. But it would be a good idea to have it checked and serviced before you go. Camera servicing always seems expensive, but neglecting it can prove even more costly, not to mention heartbreaking. ▶

Planning and preparation are crucial. Few treks are undertaken at a moment's notice, or planned 'on the back of an envelope'. If you're getting your camera(s) serviced, allow plenty of time. Work out exactly what you need to take. Pack it, weigh it, and think again. It's tempting to take 15 different lenses to cover every eventuality, but who's going to carry them? In any case, back-up for the absolute basics takes priority. It's no use having a 300mm lens in your

Spare equipment
However reliable your camera, accidents can happen. No camera is going to survive being dropped down a 1000m ice-slope or into a glacial torrent. Carrying a spare is sensible, but expensive if you don't have an old camera lying around. It's worth discussing this with the rest of your team, especially if two or three of you have the same make of camera. One of you will probably have a second camera body which can be 'team spare' – and if not, you can share the cost. You may be able to pool other gear, such as long lenses, cleaning kit, or tripod, and share the extra weight.

Trekking: the people you meet are part of the story. And some shots do need a little explanation. It could be a chair back he's making but is actually a pack-frame, on which a porter will soon be carrying a 25-kilo load. (Balti carpenter, Foljo, Braldu Gorge, Karakoram Mountains, Pakistan)

pack if you no longer have a functioning camera to put it on.

'Absolute basics' really means four items:

- *Camera*
- *Lens*
- *Film*
- *Batteries*

If you don't have all of these you're in trouble. Individually or collectively you need spares for all of them. When it comes to lenses, if your basic everyday lens is a standard zoom like a 28–80mm, a prime lens somewhere in this range makes a good back-up. I'd always pick 28 or 35mm but others may prefer something longer. A 50mm macro adds an extra dimension. It is infinitely more important to have this back-up than extra lenses of extreme focal length.

Some traditional mechanical cameras (the Nikon FM2 is the most notable example) will keep going without batteries. The only function which is lost is exposure metering. If this should happen, remember the 'Sunny 16' rule (see Appendix I), although in very bright environments such as a sunlit glacier it could well be 'Sunny 22' or even 32. Of course you should still carry spare batteries for such cameras – they're very small and light. For anything else, you must have

Balti porters resting.
(Above the Braldu Gorge,
Karakoram Mountains,
Pakistan)

spares. You may need a particular size of coin to open the camera's battery compartment: bring one, and keep it safe. Spare batteries are no good if you can't change them. This is the sort of thing that reduces grown men to tears – I speak from bitter experience!

Photographic survival kit for trekking.

Work out how much film you'll need. Then double it. You may be shooting all day, every day, for several weeks or months. One 36-exposure roll a day is a modest allowance: it translates to two or three shots an hour. If the result is more than you can possibly afford, or carry, then you'll have to ration yourself. Start on day one; it's all too easy to go trigger-happy at first. Everything may look new and strange, but much of it will start to seem commonplace very quickly. Coca-Cola signs in remote villages are not that unusual. Unfortunately.

As far as possible, stick to the type of film you know. Many environments, from the Himalayas to the Sahara, offer light that's generally brighter than we're used to at home. 100 ISO film will cover most eventualities, but if you're into big landscapes, consider something slower. You can always push the film if you need to shoot a few rolls in poor conditions. It's crucial to mark such films clearly, so that they can be correctly processed. It's important to be able to identify all your exposed film. Many cameras with a built-in winder will rewind the film right back into the cassette, which is a foolproof way of distinguishing exposed film.

Take the film out of its cardboard cartons. It will occupy less space, and weigh marginally less, too. It's a bit less waste to pack out in the wilds, and improves the chance of getting your films checked by hand at airports. And incidentally, when flying from the UK, film and batteries must go with you in cabin baggage. Regulations are different in other parts

Carrying your gear

Anything which you expect to need during the day goes round your neck, round your waist or on your back. You can't get at it in a porter-load or on the back of a mule. That's the place for back-up gear, and that 300mm lens that you're only going to use for the total eclipse. If you're serious about photography on this trip then you will end up carrying more than some of your companions. You'll probably regret it many times during the trek, but feel superior afterwards!

of the world, so check in advance, but never let your film go through the high-strength X-rays used on hold baggage.

Having covered the four essentials, the rest is merely very, very important. Some kit for keeping your gear clean is almost a fifth essential. The minimum is a soft brush or 'puffer brush' for getting dust out of cameras, and a supply of clean cloths or tissues for cleaning lenses and filters. Keep the kit itself clean in sealed plastic bags. A very small toolkit could also save you a lot of grief. The most useful item is a small, jeweller's type screwdriver for all those tiny screws on cameras and lenses. ◀

The following checklist isn't necessarily a rundown of everything you must take, but everything you need to consider taking:

* *Main camera body*
* *Spare camera body or compact camera*
* *Default lens, (for example, 28–80mm)*
* *Back-up lens (for example, 35mm)*
* *Film*
* *Batteries*
* *More film*
* *More batteries*
* *Other lenses: wide-angle; telephoto*
* *Lens hoods; spare front and rear lens caps*
* *Camera rain-guard*
* *Filters: UV or skylight filter (attached to each lens); polarising filter; neutral density graduated filter; warm-up filter (81B)*
* *Cleaning gear: brush; cloths/tissues*
* *Toolkit*
* *Flashgun*
* *Carrying gear: camera pouch and waist-belt; padded cases for other items; plastic bags, preferably reseal-able, for film, batteries, cleaning gear, and so on*
* *Camera support (from): tripod; monopod; bracket for ice-axe or trekking pole; bean-bag*
* *Insurance – does it properly cover all your gear?*

At the planning stage you can also start to think about the sort of shots you'll want to take. Great set-piece views will be obvious, but trekking is an all-encompassing experience. For those days, weeks or months it is your life, and you'll want to record all its aspects. It can be worth having a mental, if not written, list of possible subjects. But treks are also about unexpected and surprising experiences, so preconceived ideas are a starting point, not a straitjacket.

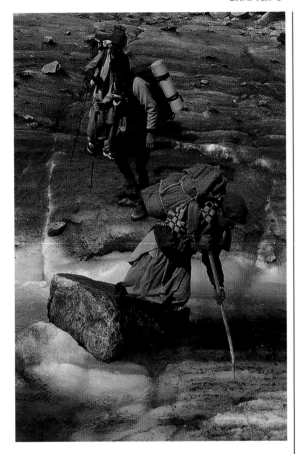

Trekking: crossing a stream on the Biafo glacier. Observe the differing footwear of porter, trekker and guide.
(Karakoram Mountains, Pakistan)

Treks are about people as much as about places; team-mates, porters, guides, local people you encounter, that famous climber comatose in a Kathmandu bar. Think about whether you want portraits of the team, and whether you want them to be staged or candid. It could look a bit odd if you get back home and one of the team is missing from your portrait gallery, so make sure you've got everyone.

Vary the scale. However stunning each shot may be individually, an unbroken series of scenic views quickly brings on stunning view fatigue in the most avid viewer. Besides, such views are only one part of the trek experience. Details – a flower in a crevice, crystals in rock – give more feeling for the environment. Other details, from mundane stuff like the food you ate and even slightly gruesome stuff like blisters, help to remind you, and inform those who weren't there, what the whole experience was like. A rounded portrait includes the highs and the lows!

C You can take a compact camera on a trek and get very good results as long as you avoid the point and shoot mentality. However, the limitations of the compact are bound to be exposed at times. The decision is yours, bearing in mind what you can and can't do with the camera and what you may want to do out there.

As a back-up, or for summit day, the compact may come into its own.

When you get back, since it may be a once-in-a-lifetime experience and accidents can happen, you may want to send your film for processing in several separate batches, perhaps even to separate labs. ◀

Digital trekking

This seems tempting (if only because you don't need to carry hundreds of rolls of film), but you will need bags and bags of batteries, and lots of removable media. Anyway, few digital cameras are robust enough. In the present state of technology I just wouldn't risk it.

A possible exception is if you're on a large mountaineering expedition with a fixed base camp. With porter support or even jeep transport to this point you can consider a solar-powered set-up, including a laptop to which you download your shots after each foray up the peaks, and a satellite phone so you can update the expedition website every day. This sort of set-up is now commonplace for commercial expeditions on Everest. It obviously demands a large budget, and with that much valuable kit at stake you'll want your base camp permanently staffed.

FINAL THOUGHTS

In May 1996 David Breashears and Robert Schauer filmed at the summit of Everest with an IMAX camera weighing 20kg, supported on a monopod that itself weighed 4kg. Because of the speed at which the oversize film rips through the camera, they only had 90 seconds shooting time. And you think you've got problems?

In his book *High Exposure*, Breashears describes the process in detail, including the 15-item checklist that they went through before each shot. It's about as far from 'point and shoot' as you can get.

Most of us will never even get near the summit of Everest, and we'll want all our camera gear put together to weigh less than their monopod. But wherever we find our own extremes, there's one thing we can have in common with them. Gear may be limited and time precious, but we can still think about what we are doing. 'Look to each step,' said Whymper. We might add, 'Look to each shot'. They may be the hardest shots to get, but they are also the most precious.

CHAPTER 7
Putting it all together

Integrating photography into your outdoor life is a personal thing. Only you can decide how important photography is, how much you are willing or able to carry, and how far you are willing to compromise your other objectives.

You can invest in photography in many ways. Investing pots of money isn't necessarily as rewarding as investing time, thought and energy. This could mean being willing to experiment a bit, for instance by exploring the different exposure modes of your camera. It could even mean reading this book more than once! There's plenty that you can do to help you get more from your photography, and you can do a lot of it when you're stuck indoors.

One of the most important themes which should have emerged by now is anticipation. This can be seen in both long-term and more immediate senses.

In the longer term anticipation really means planning and preparation. Presumably you don't pack your rucksack exactly the same way for every trip. In relation to photography, too, you'll want to think about where you're going, what you'll be doing, and what types of shots you might be looking for. This will influence which camera you take, if you've more than one; perhaps a compact or an SLR. It will

Trekking: the gloomy background helps the trekker stand out, despite being relatively small in the frame. It's easy to see why we were not travelling on the glacier at this point! (Above Biafo glacier, Karakoram Mountains, Pakistan)

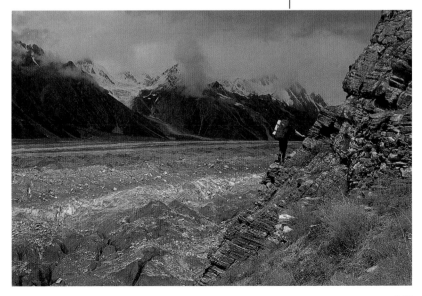

also determine whether it's worth lugging a long lens or tripod. The eternal question, of course, is 'Have I got enough film?'

In the more immediate sense, anticipation means keeping the photographic part of your mind constantly ticking over. What's round the corner? Is Reinhold about to fall off? Will that walker ahead suddenly be lit up as they reach the skyline? Anticipation means being one step ahead, 'seeing' the shot before it even happens. A well-prepared photographer may look as if they're just 'pointing and shooting', but there's a world of difference in what goes on inside the head – and usually in the results they get.

THE LEARNING CURVE

However good this book, or any book, you don't learn solely by reading. You learn by doing, and above all you learn what's right for you. But this only works if you're aware of what you're doing, and can remember it when you look at the results. Whenever you try something new or different, take a note. A mental note will do, if you're sure your memory's good enough.

Finding time to look carefully at your results is a vital part of the learning process. You can learn as much from your 'failures' as from your 'successes'. It's important to be realistic about what 'success' means. A roll of 36 back from the lab will not stack up to a selection of shots from books

Technical flaws don't always make a shot worthless. Some might even feel the obvious flare adds to this shot! (Above the Cirque de Gavarnie, French Pyrenees)

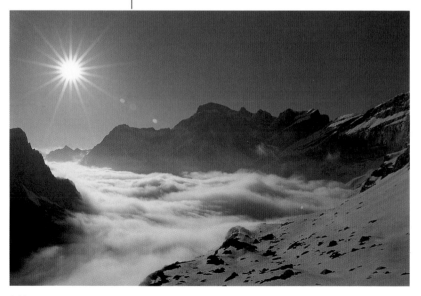

and magazines. Most of these are produced by professionals, who can take as long as they need to get the shot. Very often, the shots will be set up rather than 'just happened'. Above all, you only ever see their best shots!

Should you even be making this comparison? Unless you have aspirations to be a professional, or make a serious assault on some major competitions, you aren't actually competing with anyone. The main question, always, is whether your photos say what you wanted them to say.

Be critical, then, but temper it with common sense. Technical perfection isn't the be-all and end-all. Technical blemishes are worth noting, especially if you can do better next time, but don't automatically condemn a shot to the waste bin.

A little detachment helps when reviewing your shots. You may have been in a particularly wonderful location just as the light was doing magical things. If the shot 'comes out' at all, it may be good enough to reawaken your memories of that magic moment. But the real question is: is it good enough to show someone else what got you so excited? ▶

KEEPING IT SIMPLE

Point and shoot is not good enough. Remember, it's a state of mind, not a question of what camera you have. Whether your camera cost £20 or £2000, whether you operate totally manually or trust to luck and automation, the

Printing decisions
If you shoot prints, and you're consistently disappointed with their general quality – if every shot on the roll looks a bit flat – try getting them printed somewhere else. Cheap and not-so-cheerful printing is one of the commonest causes of disappointing results. It makes little sense to spend hundreds of pounds on a camera, maybe hundreds more on trips into the great outdoors, and then try and save a few pence on developing and printing which doesn't do justice to your shots.

Trekking: easier going on the upper part of the Biafo glacier (Karakoram Mountains, Pakistan)

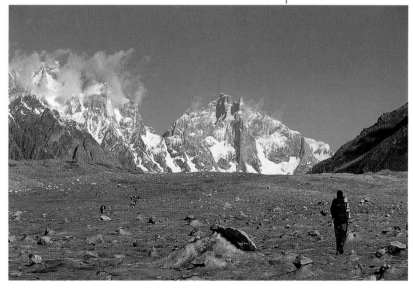

absolutely crucial decisions remain: what to point at and when to shoot. They demand as much thought as you can possibly spare.

However, if you want photography to be an integrated element of your outdoor life, not to totally dominate it, there's a balance to be struck. Technical perfection is a fine thing to aim for, but don't let it become an obsession. The spirit of your photos is always the most important thing. Getting the technical stuff right should help you convey that spirit, not overwhelm you.

If you feel bogged down in technicalities, don't hesitate to go back to basics. Put the camera back onto auto-exposure. It will still give decent results most of the time. Try and stay alert for tricky lighting situations, especially very high contrast, where you might need to override or bracket exposures. Play around with manual control when the pressure's off and you've time and energy for experimentation.

Don't think you have to think of everything every time. Home in on what really matters. This depends on what you want to say with any given shot. For instance, in broad landscape shots, depth of field is important, which means using a small aperture. Shutter speed is a secondary consideration. If manual mode seems too complicated, try aperture-priority. 'Landscape' or 'depth' modes on some cameras do roughly the same job, though less precisely, but they'll still work well enough most of the time, so if you really just want to concentrate on framing the shot, go for it.

KEEPING AND SHOWING YOUR WORK

What happens next? Once you've got the shots back, or downloaded them to your computer, and given them a critical once-over, will they just languish in a literal or virtual shoebox?

Shoebox syndrome defeats the whole object of taking pictures. At the least you'll want to look at them again yourself, and you'll probably also want to share them with other people. There are many ways of doing this, most of them interactive. Other people's responses will tell you which shots really work – which is also part of the learning curve.

Prints
Handing round a sheaf of prints straight out of the packet is all very well, but it means everyone has to endure your duff shots and repeats, and it probably also means getting fingerprints on your better shots.

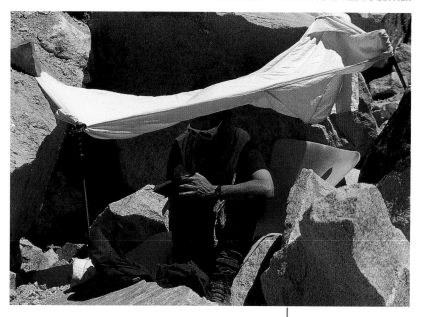

The obvious thing to do with prints is to put them in an album. For some reason this sounds corny – memories of naff wedding albums, perhaps. But it needn't be. A well-put-together photo album can be like a lavishly illustrated book. Captions can help tell the story. You can incorporate other material, such as maps, pressed flowers, even Peruvian bus tickets. There's no rule that says you can't overlap prints, or take the scissors to them.

Putting prints on the walls is also an obvious possibility. A montage of small prints can work very well, but there are usually one or two stand-out shots which deserve greater prominence. It can be worth looking for a professional lab (try Yellow Pages and the back pages of the photo magazines) and paying a little extra for a hand print. While clip-frames are cheap and cheerful, there's no doubt that a good print looks even better in a proper mount and frame. The right colour of mount and rim can really enhance the image, and somehow the whole package just seems to carry extra conviction.

Trekking: an improvised shelter gives some shade from the fierce sun. Shots like this provide variety and are just as much part of the story as a stunning view (Pat Cossey, Sim Gang, Karakoram Mountains, Pakistan)

Slides

We've all endured bad slide shows. Thinking about what was wrong with these can help you get it right. A few basic principles are listed over the page:

- *A clear narrative, theme or structure*. If you're telling the story of a single expedition, a chronological approach normally works fine, but there are alternatives. These are even more pertinent when you've made several trips to an area. You could, for instance, start with low-level walks, move on to passes and hut-approaches, and wind up with harder routes on the big peaks

- *A time limit*. Leave your audience wanting just a little more, without feeling short-changed. An hour is more than enough in most cases, especially when you're sandwiched between dinner and last orders. If you've a major story to tell and you know the audience is really interested, you might stretch it to two 45-minute sessions with a break in between. The sound of snoring is usually an indication that you've gone on too long...

- *Pace*. Don't try and cram in too much. Too many slide changes will give people headaches and frustrate those who actually want to see your pictures. Ten seconds on screen is enough for basic 'filler' images but if explanation and background are needed, or there's simply a lot to see in a shot, you can stretch to half a minute or more

- *Variety*. Colour, light, time of day, mood, scale, subject; these are all sources of variety. Your trip to the Dolomites may have produced a dozen stunning views of the Tre Cime di Lavaredo, but don't include them all. (Monte Paterno's much prettier anyway!) Two or three will be plenty, especially as they'll inevitably crop up in the background of other shots

- **Quality**. Try not to include anything you'll have to apologise for. Don't include anything that's obviously under- or overexposed, or out of focus, unless there's a very good reason. If it's a genuine shot of a yeti, different standards apply! Audiences will make greater allowances if you're recounting an epic retreat in a blizzard rather than a summer stroll on the South Downs. Even so, keep flawed shots to a minimum and don't leave any of them on the screen too long. They hurt the eyes
- **Preparation**. Do a dress rehearsal if possible, so you know roughly how long you're going to take. You shouldn't need a written script, but you'll have a better idea what to say and when. And you'll get all the slides the right way round!

Three shots showing variations of scale. (Moeraki Boulders, South Island, New Zealand)

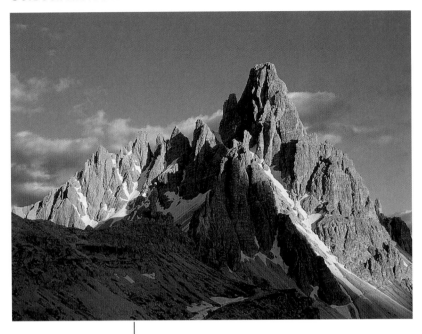

A very simple 'mountain portrait'. Warm evening light shows up the many ridges and buttresses, while the shadow of a cloud de-emphasises the relatively dull foreground. (Monte Paterno, Dolomites, Italy)

Computer

Whether images are digitally originated or scanned from film, a properly calibrated monitor can display them to good advantage. 'Slide-shows' are easily set up to run from the hard drive. There's a wide choice of software to do this, including shareware and freeware applications. Typically there's little more to it than loading the images into a specific folder. They may run in the order you loaded them, or you may have to number them.

It's less easy to run a slide-show on the Web. You can display shots sequentially by making a series of links allowing people to click on 'Next'. It could be better to create a screen of thumbnails, 12 or 15 at a time, from which people can call up larger versions of each image by clicking the thumbnail. Only your best friends are going to sit through hundreds of your shots.

Broadband connections are still the exception rather than the rule, so it's important to keep file sizes small. You'll probably need to make copies of your images and optimise them for the Web. Save them to display at the required size at 72dpi, and always save photographic images as JPEG files, with medium compression. Large images don't just take ages to download; they also expose you to the risk of copyright theft. It may be useful to consult a Web designer.

Selection

A common theme, however you display your images, is editing. Less, or rather fewer, is almost always more.

Editing doesn't just mean picking the 'best' images. The 12 best individual shots aren't necessarily the best to tell the story of your trip. Remember the elements discussed in relation to slide-shows: narrative, structure or theme, variety.

The editing process is both tricky and fascinating. It helps you take a fresh view of your own work, and really think about how it works for others. It should also feed back into your future shooting: perhaps next time you'll try to get a few more close-up shots, or candid portraits of your companions, for instance.

Publication

Why not? Many specialist magazines get most of their material from activists rather than professional photographers. If you've been somewhere or done something interesting, and got some decent photos, you'll stand a good chance. You may not get paid a fortune, but it all helps to pay for the next trip, or at least for the film for the next trip.

A few pointers:

- **Check first**. *Look at a few issues of any magazine you're thinking of sending stuff to. Somewhere in the small print it should say how they prefer to receive material. Look at their style and content, too. If you enquire first, most magazines will supply detailed guidelines on what they want and how they want it. Don't repeat what they've recently published. If they've just carried a piece on cycling the Karakoram Highway, they won't want yours on the same subject – even if yours is definitely better. It's tough, but there it is*
- **Send words** *as well as pictures. If you can't write 1500 words yourself, enlist one of your team-mates*
- **Send slides**. *Some magazines will accept prints, but usually with reluctance; they simply don't reproduce as well. Many refuse them point-blank. Don't send slides in little plastic boxes: use clear filing sheets*
- *Some magazines now accept **digital files**, if they're of good enough quality. You'll definitely need to check first to establish the correct file size, format, and so on. They'll almost certainly want hard copies too*

- *Whatever form you send your images in, **don't send too many**; 20 or 24 is normal, which will fit on one slide filing sheet. But if you've only a dozen really strong shots, send a dozen. Don't pad your selection with inferior shots: they'll weaken the overall impact. Remember the principles of editing: structure, variety, quality. Each slide should have your name on the mount, and a title or brief caption. These are repeated, with longer versions if required, on a separate caption sheet*
- *Always enclose **return postage***
- *Don't expect an **answer** right away. Editors are busy people. If you've heard nothing after two or three months, a polite letter, call or email is in order*

It pays to be suspicious...
Be very wary of competitions which state that work cannot be returned, or that copyright passes to the promoters. These are usually a way for someone to get excellent pictures on the cheap. Even if the prizes look generous they'll cost the organisers a lot less than paying a professional or a picture library for comparable material. If your pictures are good enough for a major company to use them in its promotions, they should pay you the going rate. Read the rules again, not just carefully but suspiciously.

Competitions and distinctions

There are endless competitions in the photographic comics and elsewhere, often offering marvellous prizes. You may think you've no chance, but a high proportion of entries don't actually fulfil the brief of the competition. Read the rules carefully. If your picture is technically competent, reasonably attractive, and fits the brief, you're in with some kind of a chance. The odds are a hell of a lot better than the Lottery anyway! Conversely, if it's technically superb and breathtakingly gorgeous, but doesn't fit that particular brief, it won't win. ◀

Another possibility is to pursue distinctions like those offered by the Royal Photographic Society. This will cost you money but gives you a standard to aim at. The letters LRPS (Licentiate), ARPS (Associate) and FRPS (Fellow) are recognised throughout the world. These distinctions are awarded (or not!) entirely on the strength of a set of images, which makes them ideal for active photographers. You can enter prints or slides, but not a mixture, and you won't have to write anything apart from titles.

KEEPING IT SAFE

Having invested a lot of time, money and effort in getting some good shots, you'll want to make sure they don't get lost, damaged or faded. Piling everything in a shoebox really isn't the way to achieve this!

Slides
If you buy slide film process-paid, you'll get the mounted slides back in little plastic boxes. These are fair enough as a way for the lab to send the slides to you, but as a means of

storing a sizeable collection they leave a lot to be desired

It's far better to use clear plastic filing sheets, which hold 20 or 24 slides. You can get these from most decent camera shops, or by mail order. These take up a lot less room, and make it much easier to find a particular slide. A small collection can be stored in ring binders or box files; several thousand slides will fit into one drawer of a filing cabinet.

Proper hanging files in cabinets also provide good storage conditions for the long-term stability of your images. Generally speaking cool dry conditions with some circulation of air (but not a howling gale) are to be preferred. Don't store your slides in the kitchen or the bathroom, or a damp cellar! You can replace a print, if you've kept the negative, but the slide is the original, and therefore precious.

Storing slides in this way makes it easy to find a specific shot whenever you need to. It's even easier with a basic catalogue or index. Simply tagging each filing sheet with a brief note of area and date is a big help. You can go all the way to a full computerised database if you want. The bigger your collection, the more use this is – and it's something to do on the dark winter nights. The downside, of course, is that putting information into a database is one of the most boring tasks known to humankind, though this will give you a strong incentive to chuck out all your substandard shots. The pain goes away after a while.

Prints

Most of the above applies to prints, too. The wallets in which you first receive them aren't particularly handy for storage. As well as albums, there are sheets for ring binders and filing cabinets. These will hold four postcard-sized prints on each side.

If you shoot print film, you'll also have negatives to look after. Prints are replaceable; negatives aren't. Filing each set of negatives alongside the relevant set of prints is one way, and makes it easy to locate the one you need, but if the prints are in albums that get passed around this exposes the negatives to risk of loss or damage. Filing them separately is safer and if you give each film a simple reference – for example, Lapland 2001/1 – retrieval is still easy. Many processors give you an index print alongside the full size ones. If you file these all together it's even easier to track down any specific shot.

Digital

Once you've loaded the shots you want to keep onto your hard drive, you can reuse the removable media. The image

Digital back-up

If you do shoot digital originals, or you do your own scanning, it makes sense to save back-ups regularly to CD, Zip disk, or whatever you find best. This is essential if you shoot digital; if you shoot on film then the original negative or slide serves as a 'back-up'.

on the hard drive is now unique. Like any other file on your computer, it should be backed up. There's a real plethora of storage options, but CD remains one of the best for long-term stability, as well as one of the cheapest .

If you shoot initially on film, some processing labs can now provide copies of your shots on CD. This sounds like a great deal, but of course all your shots will be transferred, and as it won't be a rewritable CD you'll be stuck with the duds. It probably makes more sense to select a batch of your best shots and get them transferred to a proper Photo CD. While apparently more expensive, it could save you money in the long run. ◀

FINAL THOUGHTS

What is a better photograph? A better photograph is, above all, one that pleases you.

Other people's responses to your photographs can be helpful, especially if you aspire towards competitions, distinctions or publication. In the end, though, they're your photographs and what's most important is whether they work for you, not only the day you get them back, but after a lapse of time. Do they take you back? A truly successful photograph doesn't just show what things looked like, but also suggests the sounds and smells and tastes and textures – and, in some cases, the tired legs and the blisters and occasional fear – which made up the total experience of 'being there'.

The magic of slide film (which neither prints nor digital images can quite match) is that you can hold in your hand the actual image that was captured at the original moment. If 'being there' is important, then nothing beats this sense of direct connection. However, slides aren't for everyone. The sense of connection is not so tangible with prints or digital images, but can still be preserved. It argues strongly against any manipulation that substantially changes the original image.

Competitors in mountain marathons, adventure races and similar extreme events frequently don't bother to carry a camera. It's often said that some of them aren't really interested in their surroundings. This may be unfair, but it's certainly true that when you're racing against the watch you can't stop for a few moments to contemplate.

And yet, people who push themselves to the limit in the outdoors frequently speak of the experience in almost mystical terms. It clearly can inspire deep feelings and a deep relationship with the environment. So can photography.

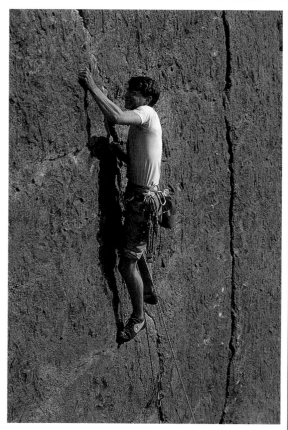

Involved in the outdoors! A static shot in the sense that there is no obvious movement, but there is still tension.
(Jason Clay, Cracked Actor (E2), Trowbarrow, Lancashire)

The common factor is engagement. Climbing a hard pitch or kayaking a wild stretch of white water demands total involvement and concentration. But, though your life may not depend on it, photography can be equally intense and involving. By focusing your mind more sharply on where you are, it can be another way of enhancing your contact with your surroundings. Photography certainly isn't the only way to do this; you can paint, write poetry, observe wildlife, or simply meditate. But photography does integrate especially well into an active outdoor life.

One of America's greatest landscape photographers, Ansel Adams, faced a choice as a young man. He could also have made a career as a concert pianist. His mother urged him to this path, arguing that, 'The camera cannot express the human soul'. This is a common misconception, based on the fact that a camera is a mechanical instrument (but then so's a piano, surely?). People who don't understand photography seem to think it is merely a recording medium,

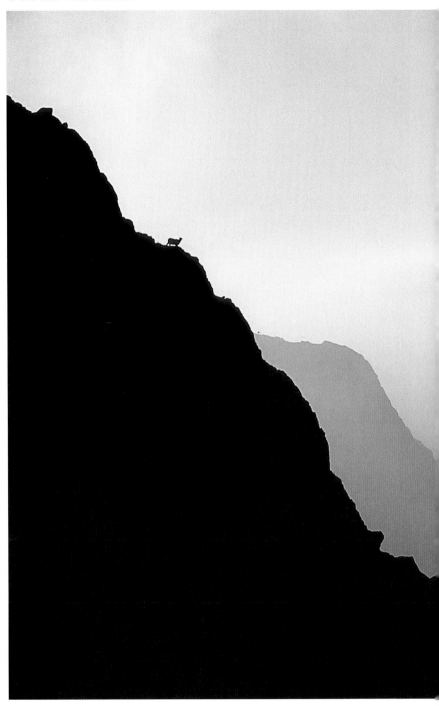

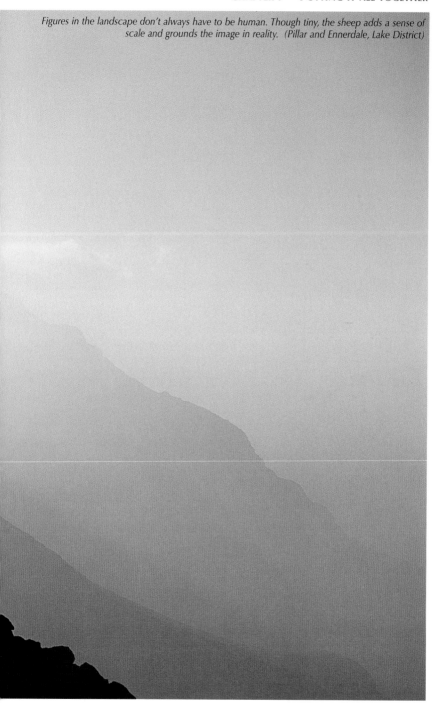

Figures in the landscape don't always have to be human. Though tiny, the sheep adds a sense of scale and grounds the image in reality. (Pillar and Ennerdale, Lake District)

The horizon doesn't have to be across the middle of the frame. It's the sky that matters, so fill the frame with it. However, most meters probably expect the horizon to be somewhere near the middle; unorthodox framing may require a little more thought about metering, too. (Langthwaite, Lancashire)

as if any two people in the same place at the same time would get the same photographs.

It should be obvious by now that this is simply not true. The two basic decisions, what to point at and when to shoot, are profound and powerful ones. Not to think about them is selling photography short. More important, it's selling yourself short. The camera – any camera – can do a great deal more than simply record some of what you saw. It can capture a great deal of what you felt and what it all meant. Photography can give you a lot. But you have to give photography a little, too.

APPENDIX I
Exposure: a manual for the manually inclined

Many materials are sensitive to light and react to it with visible changes. Some things fade, like cheap curtains, others get darker, like human skin. Try wandering around on a glacier on a sunny day without sunblock... or, preferably, just imagine what would happen. The burning of exposed skin is, in effect, a slow and painful way of taking a photograph of your clothes. You can see why the word 'exposure' came into use.

The first photographic materials were more sensitive than skin, but not by much. The first recognisable photograph required an exposure time around eight hours. As technology progressed, the times came down, first to minutes and then to seconds. Even so, portrait sitters often had their heads clamped in place – no wonder their expressions are so often stiff, even pained!

With such long exposure times, cameras didn't need shutters. The exposure was made by removing the lens cap, counting or timing with a watch, and then replacing the cap.

Today's films are thousands of times more sensitive – faster – than those of a century ago. Exposure times in daylight are tiny fractions of a second. However, the principle hasn't changed. The word 'exposure' still makes sense because we are still doing exactly what the pioneers did: exposing a sensitive material to a controlled amount of light. When we talk about 'getting the exposure right', what we mean is ensuring that the right amount of light reaches the film.

Even the fastest hand can't remove and replace a lens cap in under half a second, so modern cameras use a shutter instead. *Shutter speed*, therefore, is one of the ways in which we can regulate the amount of light actually reaching the film.

The other is *aperture*. This is just another word for opening. If you open the curtains a few centimetres you let a little light into the room; if you throw them all the way back you admit a lot more. The principle is as simple as that. It's arcane-looking numbers like f/16 that deter so many people.

These aren't gobbledygook. They are a logical way of describing how big the aperture actually is. Strictly, it should

159

never be written f16 but always f/16: f divided by 16 ('f' means focal length). These numbers are *fractions*, which is why f/2 is a large aperture and f/16 is a small one.

The aperture of a lens is not a slit, like that in a pair of curtains. It is circular, or approximately circular. If you double the diameter of a circle you increase its area four times. The aperture numbers relate to the diameter of the circle, not its area, which is why we don't have a neat series – f/2, f/4, f/8, and so on – but instead the more cumbersome f/2, f/2.8, f/4, f/5.6, f/8.

The amount of light coming in depends on the area of the circle. Each step in the series means that the area – the aperture – is either doubled or halved, and therefore the amount of light reaching the film is also doubled or halved. Because larger numbers mean smaller apertures, at f/2.8 half as much light reaches the film as at f/2.

On traditional cameras with a shutter speed dial, the shutter speeds are also in a series that doubles or halves the time at each step: 1/8, 1/15, 1/30, 1/60, and so on. Admittedly, 1/15 is not exactly half of 1/8, but it's near enough.

In other words, a change of one step in either aperture or shutter speed changes the amount of light admitted by a factor of two. Traditionally, this is called a change of one *stop*. If you shorten the shutter speed by one stop, the amount of light reaching the film is halved. If you make the aperture smaller by one stop, the result is exactly the same. Since a change of one stop makes a distinct difference to the result on film, it's a convenient unit of measurement.

Photographers use the term 'stops' even more widely. If the light gets brighter by a factor of two, we call this an increase of one stop. To keep the brightness of the picture the same, we now have to reduce the exposure by one stop. We can do this by adjusting either aperture or shutter speed: the effect is exactly the same, at least as far as the brightness of the picture is concerned.

We can also adjust aperture and shutter speed, in opposite directions, while keeping the overall exposure the same. There is a whole series of possible combinations of the two settings. With 100 ISO film on a sunny day you may well get:

Aperture	f/16	f/11	f/8	f/5.6	f/4	f/2.8	f/2
Shutter-speed	1/125	1/250	1/500	1/1000	1/2000	1/4000	1/8000

If your camera lets you set aperture and shutter speed manually, and you've a few spare frames at the end of a film, you could try setting a few of these combinations. Just make sure the light doesn't change while you're doing it. If you use slide film, you should see that the brightness of the shot is the same each time. If you use print film you're at the mercy of whoever does the printing, but the prints should all match in brightness. (If they don't, check the negatives.)

There will be differences between the different shots. Any movement will look different at different shutter speeds, while depth of field changes with the aperture. These are the main factors which will influence our choice between the various possible combinations.

Measuring light

The common term 'exposure meter' is a misnomer. They are *light meters*. In most cases what they measure is reflected light, and the strength of reflected light depends on two factors: (a) the strength of the light source (usually the sun); (b) how much of it is reflected. Snow, white sand, and so forth, reflect much more of the light which hits them than dark soil, stone, pine forests, and so on. But no meter knows this. No meter, however sophisticated, can measure anything but how much light it receives.

Having measured the light, meters may then translate their readings into exposure suggestions. They can only do this because certain assumptions are built in to their calculators. Simple meters assume that the light is being reflected from an 'average' subject. Subjects which are darker (less reflective) or lighter (more reflective) will deceive the meter.

A classic case which will have given grief to most outdoor people at some stage is a photograph of a snowy scene. Snow is highly reflective, which is why we see it as 'white'. But meters don't know whether they're looking at a snowdrift, a grassy knoll, or a heap of coal, and will try to average them all to a middling tone. The result is the dreaded 'grey snow syndrome'.

Sophisticated matrix-type meters will get their recommendations right much more of the time, but can still be fooled by scenes full of very light or very dark tones.

This is why it's important not to take a meter reading as gospel, but to interpret it. In manual mode, it's easy to give a little more or less exposure as necessary. In an automatic mode, you can use exposure compensation. To avoid 'grey snow syndrome', give more: to avoid 'grey coal syndrome', give less.

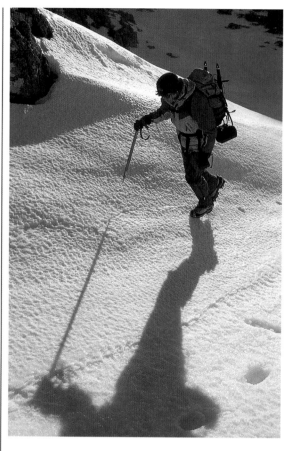

Most of the shot is brightly-lit snow, which will fool most meters into under-exposing. A meter reading from the shadows, or from an area of more average tone, avoids this. (Bernie Carter, Aonach Dubh, Glencoe)

But how much more or less? This is where it really helps to remember that what the meter actually measures is light.

There are other ways to get a meter reading apart from pointing the camera at the scene you intend to photograph. Most of them aim to get a more accurate idea of the brightness of the light itself, uninfluenced by how much or little the scene reflects.

One obvious way to do this is to measure the light directly. This is usually done with a separate, hand-held meter called an *incident light meter*. While this is a very accurate method, it's another piece of kit to carry. It also falls down when you don't have access to the light falling on your subject. If you're in a shady valley but your main subject is a sunlit peak, you have a problem.

A second possibility is to point the meter at a subject that reflects an average amount of light. A precise way to do this is to use a grey card. A proper photographic grey card

reflects 18% of the light it receives. But you can always find something suitable: a rock, your jacket or rucksack, even your skin, though Caucasian skin is usually too light unless you have a good tan. But again, it doesn't work if your 'grey card' is in shade and your main subject is in sunlight. Strictly speaking, a blue sky is scattered light, not reflected light, but it often approximates to a middle tone.

Some cameras have spot metering. This measures the brightness of a very small central area of the viewfinder. It's still essential to meter from an area of average tone, but since it only needs to be small it's almost always possible to find such an area somewhere in the subject or its surroundings. Used correctly, spot metering is very accurate and flexible, and doesn't require you to carry any extra kit.

You can even manage without a meter at all. The brightness of the sun itself doesn't vary greatly. When it's reasonably high in a clear sky the light level is pretty much constant. This gives us an extremely useful rule of thumb known as the 'Sunny 16 Rule'.

This states that, with an aperture of f/16, the shutter speed required is the one closest to the ISO film speed. For 100 ISO film, the closest available speed on most cameras would be 1/125th sec. This is accurate enough to be a handy fall-back if your meter packs up. It also serves as a check: if you're out in bright sunlight and your settings are way off what the rule suggests, this should start alarm bells ringing. Have you set the wrong film speed? Is the meter or the battery about to fail?

Selective focusing and the largely dark background help these poppies stand out. The overall balance of the shot is quite dark and could have fooled most meters, but exposure was taken for a sunlit subject. 70-200 mm zoom lens. (Near Torla, Spanish Pyrenees)

A simple test of any meter. Simply altering the balance of bright sky and dimmer foreground in the shot caused the meter to suggest significantly different exposures. This series was taken with a centre-weighted meter but it's worth trying a similar experiment with any meter, no matter how 'smart'. (White Moss, Lake District)

Or have you just inadvertently taken a reading in shadow?

At high altitude, the light can be stronger and Sunny 16 becomes more like Sunny 22 or 32. Something similar happens in snowy environments, with a lot of extra light bouncing around.

While this rule has saved many photographers from disaster, it should be seen as a guideline, not as gospel. It must be reiterated that it only applies to subjects in clear direct sunlight, and that it only works when the sun is well above the horizon. The old adage 'from two hours after sunrise to two hours before sunset' is a good guide, at least in temperate latitudes.

Simply setting the camera to manual doesn't, by itself, give you total control. If all you do is point the camera at the scene and set shutter speed and aperture according to the camera's recommendations, you're still deferring to the meter. Control comes when you can interpret the meter readings and make your own judgements. You can also take control in an automatic mode by using exposure compensation.

Flash exposures

Flash can be used as the only source of light, as in caving shots and at night. In general outdoor photography it is more often used for fill-in.

Most modern SLRs and some compacts manage flash exposure very well indeed, whether with built-in flash, or with a separate *dedicated (TTL) flashgun*. If you're truly happy with the results you get from your flash shots, you may never need to take it off auto. Still, if you want to go on being happy, there are some things you need to know.

The amount of light a flash can deliver depends on distance. To be precise, it depends on the distance from the flash to the subject. This limits the range that any flashgun can illuminate. The low power of most built-in units, especially in compacts, makes this range very limited. You can find this information in the instruction book, but it certainly won't be more than a few metres. It does depend on film speed, too.

You need to know what this range is, because there's no point in trying to take flash shots of anything more distant. If a subject is slightly too distant it will be underexposed; beyond that it won't register at all.

If you want to take more control, or you have no alternative because either your camera or flashgun is not fully auto, there's a bit more that needs to be understood.

A typical flash fires in around 1/1000th of a second. It doesn't matter, therefore, if the camera's shutter stays open for half a second or half a minute. It can't gather any more light from the flash. To that extent, shutter speed is immaterial. However, shutter speed does still matter, in two ways.

First, if you set too fast a shutter speed, the shutter may not be fully open when the flash fires. On most SLRs the

fastest speed you can use with flash is 1/60, 1/125 or 1/250 sec. It may be marked in a different colour on the shutter speed dial, or with an 'X', and the instruction book will certainly tell you.

Apart from this, shutter speed is immaterial, as long as the flash is the only source of light. However, total darkness is rare. We're only likely to encounter true darkness underground, and then only if we switch off all our caving lamps. In any other situation, while shutter speed is immaterial as far as the flash is concerned, it does make a difference to the way any other light is recorded. This is the basis of control when we mix flash and daylight.

Shutter speed is immaterial, but aperture isn't. This is worth remembering even if you rely on auto flash metering. If you're using aperture priority and set a small aperture, the flash range will be even more limited. Changing to a slower lens also reduces the flash range.

If you are using flash as the main light, the main factors that affect exposure are: the power of the flash itself; flash to subject distance; aperture; and film speed. This doesn't mean you have to start solving equations with four variables!

For one thing, all but the most basic flashguns have an *automatic* setting. When the gun's own simple meter thinks enough light has been reflected back it will kill the flash – it might give a burst of flash lasting only 1/2000th sec, for instance. Like most light meters, it can be fooled if the subject is much darker or lighter than average, or if it isn't central. With this proviso, using an auto flash gun is quite simple; you just need to check that the flash and camera are set to the same film speed and aperture.

Very basic *manual* flashguns lack this facility, or you may want to work manually for more precise control. Even the most basic flashguns normally have a simple look-up table on the back. This might tell you, for instance, that if you are using ISO 100 film and an aperture of f/8 the illumination will be correct at a distance of 3m. Anything much nearer will be overexposed, anything much further away will be underexposed. If your subject is nearer, you can either use a smaller aperture, or reduce the flash output. There may be a half- or quarter-power setting. If its output is fixed a common way to reduce output is with a white handkerchief. One thickness over the flash head reduces the output by about one stop; folding the handkerchief reduces it further.

Once you understand how to control flash used as a main light, mixing flash with daylight is not much more complicated.

The primary reason for mixing flash and daylight is for fill-in. Here flash is secondary to the daylight exposure. All we want to do is to put a little light back into the shadows, enough to reveal some detail, but not to light them as brightly as the sunlit areas. We don't want the subject fully lit by flash but, in effect, somewhat underexposed, probably by about two stops.

A fully dedicated flashgun may manage this by itself, but a more basic auto flashgun needs a little help. A simple method is to set different apertures on lens and flash. If your exposure for the general sunlit scene is 1/60 at f/16, set f/8 on the flashgun. It should now deliver one quarter of the light that would be needed to fully illuminate the subject.

With a manual flashgun, if the subject is at the right distance to be fully illuminated at the aperture we want to use, we need to reduce the flash output in one of the ways described above.

Sometimes we might want the flash to be the main light on the subject while still allowing the background to register. Now flash is primary, so it makes sense to start by thinking about the flash exposure. Having determined a suitable aperture, we can then play around with shutter speed to alter how bright the background may appear.

For example, if we want to shoot at f/11, with 100 ISO film, a shutter speed around 1/250th sec would be necessary for a fully sunlit background. Unfortunately not all cameras allow such high shutter speeds with flash. And if

Flash and daylight are easily distinguished in this shot, as the light from the flash has a limited reach. The foreground is lit only by flash so lens aperture is the only camera control for exposure. A longer or shorter shutter speed would allow more or less light to register in the background. (Rowten system, Kingsdale, Yorkshire)

we wanted to underexpose the background a bit, to make the subject stand out, we'd need 1/500th sec, which is even less likely to be available.

To get round this we could set a smaller aperture, but unless the flash is very powerful this will only be possible with subjects at very close range. A simpler alternative is to wait until the ambient light is less bright, or simply move to somewhere shadier. You could shoot in a forest, for instance, rather than in the open.

APPENDIX II
Buying a camera: some dos and don'ts

DON'T buy from all-purpose electrical 'superstores', mail order, or from the Web, unless you already know exactly what you want.

DO buy from a real camera shop, where the staff know about photography and you can get hands-on with a number of different cameras.

DO shop around if possible. If there's more than one camera shop within reach, compare prices and advice.

DON'T just walk in and say, 'I want a new camera'. Have a clear idea what you want to do with it, now and in the longer term.

DO go digital, if you're sure it'll do everything you want, and you don't mind that it'll be out of date next month. Otherwise, stick with film. In which case:

DON'T buy any format other than 35mm – unless, after reading this book, you have a very good reason for a different choice.

If lightness and simplicity are paramount, **DO** consider a good 35mm compact.

If lightness and simplicity are paramount, but you don't need full automation, **DO** consider a 35mm rangefinder.

Otherwise, **DO** buy an SLR.

DO consider buying used equipment. You'll get twice as much camera for your money. Stick to reputable makes and check compatibility with current lenses and other accessories.

DON'T blow every cent on the 'best' camera around. Save at least half your total budget for lenses and everything else you may need.

DO compile a 'shopping list'. This may include any or all of: lenses, lens hoods, filters, some form of camera support, and some means of carrying it all. Oh yes, and film.

DON'T assume you have to buy a kit, outfit or 'bargain superdeal'. Any serious camera shop will sell camera bodies and lenses separately. If they don't, go somewhere else.

DON'T rush to spend more money on an 'extended warranty'. It won't cover you against theft, or dropping the camera down a rock-face. For these you need *insurance*.

DO study the checklist over the page. You may not need all the features listed, but what you want now may not be what you want in two or three years' time. Will the camera's capabilities expand with you?

CHECKLIST

ESSENTIAL FEATURES

- *Solid, well-made and reliable*
- *Feels comfortable in your hands*
- *Wide range of lenses and other accessories available at reasonable prices (from independent companies like Sigma, Tamron & Tokina as well as from the camera maker)*
- *Well-known 'mainstream' maker*
- *Maker has commitment to continued production of compatible equipment*
- *Viewfinder image is bright and crisp. (For a direct comparison between the viewfinders of different cameras ensure they are fitted with lenses of the same aperture)*
- *Aperture and shutter speed displayed in viewfinder*
- *Alternative to programme mode. Could be manual, aperture-priority or shutter-priority, preferably all three*

DESIRABLE FEATURES

- *Manual focusing is easy: lenses have usable manual focus ring*
- *Manual and semi-manual exposure control is easy, without removing your eye from the viewfinder*
- *Depth of field preview*
- *Matrix metering*

OPTIONAL FEATURES
(some users will find these essential or highly desirable)

- *Spot metering.*
- *Through-the-lens flash metering (with dedicated flash gun)*
- *Fast winder*
- *Aperture-priority mode (especially for landscape photography)*
- *Shutter-priority (especially for action photography)*
- *Built-in flash*

WASTE OF SPACE
(not worth an extra penny!)

- *'Panoramic' feature*
- *Multiplicity of programme modes*

APPENDIX III
Further reading

General
Ang, Tom. *Digital Photography* Mitchell Beazley 1999. ISBN 184000178X
Angel, Heather. *Outdoor Photography* Silver Pixel Press 1998. ISBN 1883403413
Norton, Boyd. *The Art of Outdoor Photography* Robert Hale 2002 (2nd edition).
ISBN 0709060947

Landscape
Coe, Chris. *The Art of Landscape Photography* Fountain Press 1998. ISBN 0863433375
Waite, Charlie. *The Making of Landscape Photographs* Collins & Brown 1993.
ISBN 1855851490

Action
Hilton, Jonathan. *Action Photography* RotoVision 1997. ISBN 2880462754

Wildlife & close-up photography
Gomersall, Chris. *Photographing Wild Birds* Watson-Guptill Publications 2001.
ISBN 0817464166
Harcourt Davies, Paul. *The Complete Guide to Close-up and Macro Photography*
David & Charles 2001. ISBN 0715308009
Rouse, Andy. *Photographing Animals in the Wild* Fountain Press 1999.
ISBN 0863433626

At the edge
Achey, Jeff. *Guide to Climbing Photography* Stackpole Books 2000. ISBN 0811727289
Campbell, Charles. *The Backpacker's Photography Handbook* Amphoto Books 1994.
ISBN 081743609X
Howes, Chris. *Images Below* Wild Places Publishing 1997. ISBN 0952670119
Koehler, Annemarie, and Koehler, Danja. *The Underwater Photography Handbook*
New Holland Publishers 1998. ISBN 1853686417

Inspiration
Adams, Ansel. *Yosemite and the High Sierra* Ansel Adams 1994. ISBN 0821221345
Breashears, David. *High Exposure* Canongate Books 2000. ISBN 086241962X
Rowell, Galen. *Mountain Light* Sierra Club Books 1996. ISBN 0871563673

LISTING OF CICERONE GUIDES

NORTHERN ENGLAND
LONG DISTANCE TRAILS
- THE DALES WAY
- THE ISLE OF MAN COASTAL PATH
- THE PENNINE WAY
- THE ALTERNATIVE COAST TO COAST
- NORTHERN COAST-TO-COAST WALK
- THE RELATIVE HILLS OF BRITAIN
- MOUNTAINS ENGLAND & WALES
 VOL 1 WALES
 VOL 2 ENGLAND

CYCLING
- BORDER COUNTRY BIKE ROUTES
- THE CHESHIRE CYCLE WAY
- THE CUMBRIA CYCLE WAY
- THE DANUBE CYCLE WAY
- LANDS END TO JOHN O'GROATS
 CYCLE GUIDE
- ON THE RUFFSTUFF -
 84 BIKE RIDES IN NORTH ENGLAND
- RURAL RIDES NO.1 WEST SURREY
- RURAL RIDES NO.1 EAST SURREY
- SOUTH LAKELAND CYCLE RIDES
- THE WAY OF ST JAMES
 LE PUY TO SANTIAGO - CYCLIST'S

LAKE DISTRICT AND
MORECAMBE BAY
- CONISTON COPPER MINES
- CUMBRIA WAY & ALLERDALE
 RAMBLE
- THE CHRONICLES OF MILNTHORPE
- THE EDEN WAY
- FROM FELL AND FIELD
- KENDAL - A SOCIAL HISTORY
- A LAKE DISTRICT ANGLER'S GUIDE
- LAKELAND TOWNS
- LAKELAND VILLAGES
- LAKELAND PANORAMAS
- THE LOST RESORT?
- SCRAMBLES IN THE LAKE DISTRICT
- MORE SCRAMBLES IN THE
 LAKE DISTRICT
- SHORT WALKS IN LAKELAND
 BOOK 1: SOUTH
 BOOK 2: NORTH
 BOOK 3: WEST
- ROCKY RAMBLER'S WILD WALKS
- RAIN OR SHINE
- ROADS AND TRACKS OF THE
 LAKE DISTRICT
- THE TARNS OF LAKELAND
 VOL 1: WEST
- THE TARNS OF LAKELAND VOL 2:
 EAST
- WALKING ROUND THE LAKES
- WALKS SILVERDALE/ARNSIDE
- WINTER CLIMBS IN LAKE DISTRICT

NORTH-WEST ENGLAND
- WALKING IN CHESHIRE
- FAMILY WALKS IN FOREST OF
 BOWLAND
- WALKING IN THE FOREST OF
 BOWLAND

- LANCASTER CANAL WALKS
- WALKER'S GUIDE TO LANCASTER
 CANAL
- CANAL WALKS VOL 1: NORTH
- WALKS FROM THE LEEDS-LIVERPOOL
 CANAL
- THE RIBBLE WAY
- WALKS IN RIBBLE COUNTRY
- WALKING IN LANCASHIRE
- WALKS ON THE WEST PENNINE
 MOORS
- WALKS IN LANCASHIRE WITCH
 COUNTRY
- HADRIAN'S WALL
 VOL 1 : THE WALL WALK
 VOL 2 : WALL COUNTRY WALKS

NORTH-EAST ENGLAND
- NORTH YORKS MOORS
- THE REIVER'S WAY
- THE TEESDALE WAY
- WALKING IN COUNTY DURHAM
- WALKING IN THE NORTH PENNINES
- WALKING IN NORTHUMBERLAND
- WALKING IN THE WOLDS
- WALKS IN THE NORTH YORK
 MOORS BOOKS 1 AND 2
- WALKS IN THE YORKSHIRE DALES
 BOOKS 1,2 AND 3
- WALKS IN DALES COUNTRY
- WATERFALL WALKS - TEESDALE &
 HIGH PENNINES
- THE YORKSHIRE DALES
- YORKSHIRE DALES ANGLER'S GUIDE

THE PEAK DISTRICT
- STAR FAMILY WALKS PEAK
 DISTRICT/STH YORKS
- HIGH PEAK WALKS
- WEEKEND WALKS IN THE PEAK
 DISTRICT
- WHITE PEAK WALKS
 VOL.1 NORTHERN DALES
 VOL.2 SOUTHERN DALES
- WHITE PEAK WAY
- WALKING IN PEAKLAND
- WALKING IN SHERWOOD FOREST
- WALKING IN STAFFORDSHIRE
- THE VIKING WAY

WALES AND WELSH BORDERS
- ANGLESEY COAST WALKS
- ASCENT OF SNOWDON
- THE BRECON BEACONS
- CLWYD ROCK
- HEREFORD & THE WYE VALLEY
- HILLWALKING IN SNOWDONIA
- HILLWALKING IN WALES VOL.1
- HILLWALKING IN WALES VOL.2
- LLEYN PENINSULA COASTAL PATH
- WALKING OFFA'S DYKE PATH
- THE PEMBROKESHIRE COASTAL
 PATH
- THE RIDGES OF SNOWDONIA
- SARN HELEN

- SCRAMBLES IN SNOWDONIA
- SEVERN WALKS
- THE SHROPSHIRE HILLS
- THE SHROPSHIRE WAY
- SPIRIT PATHS OF WALES
- WALKING DOWN THE WYE
- A WELSH COAST TO COAST WALK
- WELSH WINTER CLIMBS

THE MIDLANDS
- CANAL WALKS VOL 2: MIDLANDS
- THE COTSWOLD WAY
- COTSWOLD WALKS
 BOOK 1: NORTH
 BOOK 2: CENTRAL
 BOOK 3: SOUTH
- THE GRAND UNION CANAL WALK
- HEART OF ENGLAND WALKS
- WALKING IN OXFORDSHIRE
- WALKING IN WARWICKSHIRE
- WALKING IN WORCESTERSHIRE
- WEST MIDLANDS ROCK

SOUTH AND SOUTH-WEST
ENGLAND
- WALKING IN BEDFORDSHIRE
- WALKING IN BUCKINGHAMSHIRE
- CHANNEL ISLAND WALKS
- CORNISH ROCK
- WALKING IN CORNWALL
- WALKING IN THE CHILTERNS
- WALKING ON DARTMOOR
- WALKING IN DEVON
- WALKING IN DORSET
- CANAL WALKS VOL 3: SOUTH
- EXMOOR & THE QUANTOCKS
- THE GREATER RIDGEWAY
- WALKING IN HAMPSHIRE
- THE ISLE OF WIGHT
- THE KENNET & AVON WALK
- THE LEA VALLEY WALK
- LONDON THEME WALKS
- THE NORTH DOWNS WAY
- THE SOUTH DOWNS WAY
- THE ISLES OF SCILLY
- THE SOUTHERN COAST TO COAST
- SOUTH WEST WAY
 VOL.1 MINEH'D TO PENZ.
 VOL.2 PENZ. TO POOLE
- WALKING IN SOMERSET
- WALKING IN SUSSEX
- THE THAMES PATH
- TWO MOORS WAY
- WALKS IN KENT BOOK 1
- WALKS IN KENT BOOK 2
- THE WEALDWAY & VANGUARD WAY

SCOTLAND
- WALKING IN THE ISLE OF ARRAN
- THE BORDER COUNTRY -
 A WALKERS GUIDE
- BORDER COUNTRY CYCLE ROUTES
- BORDER PUBS & INNS -
 A WALKERS' GUIDE

- CAIRNGORMS, WINTER CLIMBS 5TH EDITION
- CENTRAL HIGHLANDS 6 LONG DISTANCE WALKS
- WALKING THE GALLOWAY HILLS
- WALKING IN THE HEBRIDES
- NORTH TO THE CAPE
- THE ISLAND OF RHUM
- THE ISLE OF SKYE A WALKER'S GUIDE
- WALKS IN THE LAMMERMUIRS
- WALKING IN THE LOWTHER HILLS
- THE SCOTTISH GLENS SERIES
 1 - CAIRNGORM GLENS
 2 - ATHOLL GLENS
 3 - GLENS OF RANNOCH
 4 - GLENS OF TROSSACH
 5 - GLENS OF ARGYLL
 6 - THE GREAT GLEN
 7 - THE ANGUS GLENS
 8 - KNOYDART TO MORVERN
 9 - THE GLENS OF ROSS-SHIRE
- SCOTTISH RAILWAY WALKS
- SCRAMBLES IN LOCHABER
- SCRAMBLES IN SKYE
- SKI TOURING IN SCOTLAND
- THE SPEYSIDE WAY
- TORRIDON - A WALKER'S GUIDE
- WALKS FROM THE WEST HIGHLAND RAILWAY
- THE WEST HIGHLAND WAY
- WINTER CLIMBS NEVIS & GLENCOE

IRELAND
- IRISH COASTAL WALKS
- THE IRISH COAST TO COAST
- THE MOUNTAINS OF IRELAND

WALKING AND TREKKING IN THE ALPS
- WALKING IN THE ALPS
- 100 HUT WALKS IN THE ALPS
- CHAMONIX TO ZERMATT
- GRAND TOUR OF MONTE ROSA VOL. 1 AND VOL. 2
- TOUR OF MONT BLANC

FRANCE, BELGIUM AND LUXEMBOURG
- WALKING IN THE ARDENNES
- ROCK CLIMBS BELGIUM & LUX.
- THE BRITTANY COASTAL PATH
- CHAMONIX - MONT BLANC WALKING GUIDE
- WALKING IN THE CEVENNES
- CORSICAN HIGH LEVEL ROUTE: GR20
- THE ECRINS NATIONAL PARK
- WALKING THE FRENCH ALPS: GR5
- WALKING THE FRENCH GORGES
- FRENCH ROCK
- WALKING IN THE HAUTE SAVOIE
- WALKING IN THE LANGUEDOC
- TOUR OF THE OISANS: GR54
- WALKING IN PROVENCE
- THE PYRENEAN TRAIL: GR10
- THE TOUR OF THE QUEYRAS
- ROBERT LOUIS STEVENSON TRAIL
- WALKING IN TARENTAISE & BEAUFORTAIN ALPS
- ROCK CLIMBS IN THE VERDON

- TOUR OF THE VANOISE
- WALKS IN VOLCANO COUNTRY

FRANCE/SPAIN
- ROCK CLIMBS IN THE PYRENEES
- WALKS & CLIMBS IN THE PYRENEES
- THE WAY OF ST JAMES LE PUY TO SANTIAGO - WALKER'S
- THE WAY OF ST JAMES LE PUY TO SANTIAGO - CYCLIST'S

SPAIN AND PORTUGAL
- WALKING IN THE ALGARVE
- ANDALUSIAN ROCK CLIMBS
- BIRDWATCHING IN MALLORCA
- COSTA BLANCA ROCK
- COSTA BLANCA WALKS VOL 1
- COSTA BLANCA WALKS VOL 2
- WALKING IN MALLORCA
- ROCK CLIMBS IN MAJORCA, IBIZA & TENERIFE
- WALKING IN MADEIRA
- THE MOUNTAINS OF CENTRAL SPAIN
- THE SPANISH PYRENEES GR11 2ND EDITION
- WALKING IN THE SIERRA NEVADA
- WALKS & CLIMBS IN THE PICOS DE EUROPA
- VIA DE LA PLATA

SWITZERLAND
- ALPINE PASS ROUTE, SWITZERLAND
- THE BERNESE ALPS A WALKING GUIDE
- CENTRAL SWITZERLAND
- THE JURA: HIGH ROUTE & SKI TRAVERSES
- WALKING IN TICINO, SWITZERLAND
- THE VALAIS, SWITZERLAND - A WALKING GUIDE

GERMANY, AUSTRIA AND EASTERN EUROPE
- MOUNTAIN WALKING IN AUSTRIA
- WALKING IN THE BAVARIAN ALPS
- WALKING IN THE BLACK FOREST
- THE DANUBE CYCLE WAY
- GERMANY'S ROMANTIC ROAD
- WALKING IN THE HARZ MOUNTAINS
- KING LUDWIG WAY
- KLETTERSTEIG NORTHERN LIMESTONE ALPS
- WALKING THE RIVER RHINE TRAIL
- THE MOUNTAINS OF ROMANIA
- WALKING IN THE SALZKAMMERGUT
- HUT-TO-HUT IN THE STUBAI ALPS
- THE HIGH TATRAS

SCANDANAVIA
- WALKING IN NORWAY
- ST OLAV'S WAY

ITALY AND SLOVENIA
- ALTA VIA - HIGH LEVEL WALKS DOLOMITES
- CENTRAL APENNINES OF ITALY
- WALKING CENTRAL ITALIAN ALPS
- WALKING IN THE DOLOMITES
- SHORTER WALKS IN THE DOLOMITES

- WALKING ITALY'S GRAN PARADISO
- LONG DISTANCE WALKS IN ITALY'S GRAN PARADISO
- ITALIAN ROCK
- WALKS IN THE JULIAN ALPS
- WALKING IN SICILY
- WALKING IN TUSCANY
- VIA FERRATA SCRAMBLES IN THE DOLOMITES

OTHER MEDITERRANEAN COUNTRIES
- THE ATLAS MOUNTAINS
- WALKING IN CYPRUS
- CRETE - THE WHITE MOUNTAINS
- THE MOUNTAINS OF GREECE
- JORDAN - WALKS, TREKS, CAVES ETC.
- THE MOUNTAINS OF TURKEY
- TREKS & CLIMBS WADI RUM JORDAN
- CLIMBS & TREKS IN THE ALA DAG
- WALKING IN PALESTINE

HIMALAYA
- ADVENTURE TREKS IN NEPAL
- ANNAPURNA - A TREKKER'S GUIDE
- EVEREST - A TREKKERS' GUIDE
- GARHWAL & KUMAON - A TREKKER'S GUIDE
- KANGCHENJUNGA - A TREKKER'S GUIDE
- LANGTANG, GOSAINKUND & HELAMBU TREKKERS GUIDE
- MANASLU - A TREKKER'S GUIDE

OTHER COUNTRIES
- MOUNTAIN WALKING IN AFRICA - KENYA
- OZ ROCK – AUSTRALIAN CRAGS
- WALKING IN BRITISH COLUMBIA
- TREKKING IN THE CAUCASUS
- GRAND CANYON & AMERICAN SOUTH WEST
- ROCK CLIMBS IN HONG KONG
- ADVENTURE TREKS WEST NORTH AMERICA
- CLASSIC TRAMPS IN NEW ZEALAND

TECHNIQUES AND EDUCATION
- SNOW & ICE TECHNIQUES
- ROPE TECHNIQUES
- THE BOOK OF THE BIVVY
- THE HILLWALKER'S MANUAL
- THE TREKKER'S HANDBOOK
- THE ADVENTURE ALTERNATIVE
- BEYOND ADVENTURE
- FAR HORIZONS - ADVENTURE TRAVEL FOR ALL
- MOUNTAIN WEATHER

Cicerone's mission is to inform and inspire by providing the best guides to exploring the world

Since its foundation over 30 years ago, Cicerone has specialised in publishing guidebooks and has built a reputation for quality and reliability. It now publishes nearly 300 guides to the major destinations for outdoor enthusiasts, including Europe, UK and the rest of the world.

Written by leading and committed specialists, Cicerone guides are recognised as the most authoritative. They are full of information, maps and illustrations so that the user can plan and complete a successful and safe trip or expedition – be it a long face climb, a walk over Lakeland fells, an alpine traverse, a Himalayan trek or a ramble in the countryside.

With a thorough introduction to assist planning, clear diagrams, maps and colour photographs to illustrate the terrain and route, and accurate and detailed text, Cicerone guides are designed for ease of use and access to the information.

If the facts on the ground change, or there is any aspect of a guide that you think we can improve, we are always delighted to hear from you.

Cicerone Press
2 Police Square Milnthorpe Cumbria LA7 7PY
Tel:01539 562 069 Fax:01539 563 417
e-mail:info@cicerone.co.uk web:www.cicerone.co.uk